ENCYCLOPEDIA

OF

ACRYLIC

TECHNIQUES

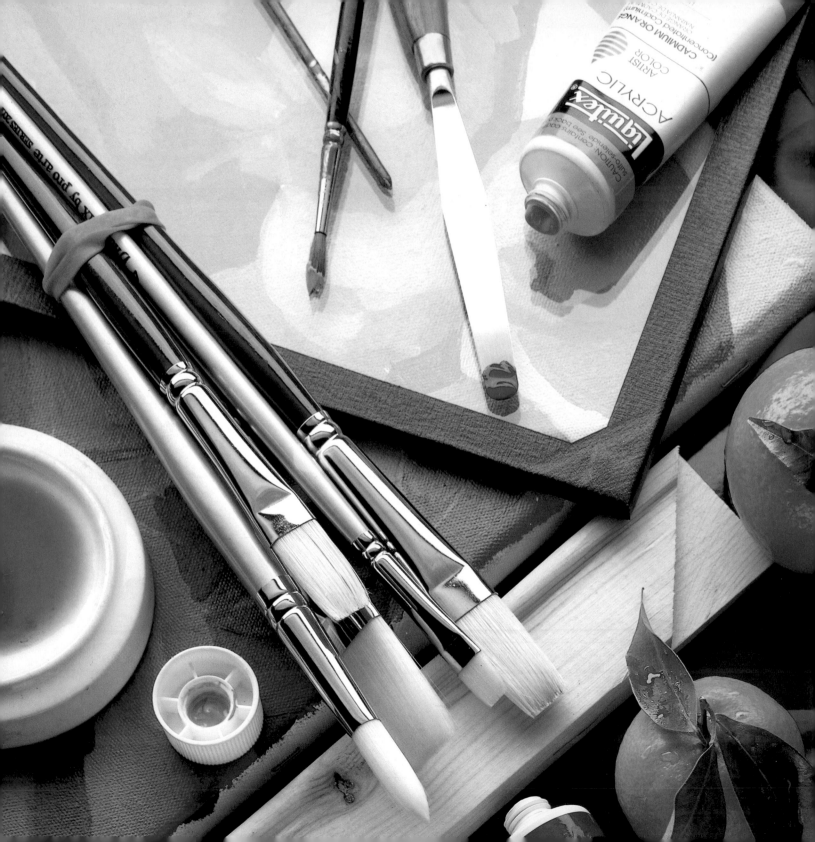

THE
ENCYCLOPEDIA
OF
ACRYLIC
TECHNIQUES

HAZEL HARRISON

SEARCH PRESS

A QUARTO BOOK

Published in paperback 2001 by
Search Press Ltd
Wellwood
North Farm Road
Tunbridge Wells
Kent TN2 3DR

Reprinted 2002, 2003, 2004, 2005, 2006

ISBN 0 85532 961 0

British Library Cataloguing in Publication Data

Harrison, Hazel
Encyclopedia of Acrylic Techniques
1. Title
751.426

This book was designed and produced by
Quarto Publishing plc
6 Blundell Street
London N7 9BH

Senior art editor Amanda Bakhtiar
Designer Tony Paine
Photographers Paul Forrester, Chas Wilder, Les Weis
Picture researcher Laura Bangert
Senior editor Sally MacEarchen
Copy editor Mary Senechal
Picture manager Giulia Hetherington
Editorial Director Sophie Collins
Art Director Moira Clinch

Typeset by West End Studios, East Sussex
Manufactured by Eray Scan Pte. Ltd, Singapore
Printed by Star Standard Industries (Pte.) Ltd, Singapore

INTRODUCTION

Acrylic paints are the newest of all the painting media, and understandably there is still some hesitancy about them among both amateur and professional painters. This is partly prejudice and partly ignorance. Acrylics are viewed by some as "synthetic" imitations of "real" paints – meaning oils and watercolours – while others don't use acrylics because they have little idea of their capabilities.

This book is designed to dispel the doubts and provide the ideas. Although it is true that acrylics can imitate other paints, they have their own character too, and you can achieve many beautiful and unusual effects with them. They are perhaps the most versatile of all paints, which is why they attract artists who enjoy experimental work and like to extend their visual vocabulary. But they are ideal for beginners too, for the simple reason that you can overpaint as much as you like without muddying the colours or spoiling the paint surface. So whether you are a novice painting for the first time and unsure how to begin, or an artist in search of new techniques and approaches, this book will provide a wealth of ideas and inspiration.

CONTENTS

INTRODUCTION

TECHNIQUES 10

THEMES 82

INTRODUCING ACRYLICS

Acrylic paints are a by-product of the plastics industry, just like the emulsion paint we use on our walls. They are also an emulsion. All paints are made with pigments – that is, the actual colours, which may be natural or chemically synthesized – and so are acrylics. The pigments used for acrylics, with a few exceptions, are the same as those used for oils, watercolours and pastels; what makes them different is the binder.

Pigments, which are tiny particles, do not dissolve; they are suspended in and bound with a medium. Oil colours are bound with oil, and watercolours with gum arabic, but acrylics are bound with a colourless water emulsion of polymer resin (polymer resins are also used to make transparent plastics). It is this that makes acrylic so tough – the resin, once dry, acts as a form of plastic coating, which cannot be removed.

Because the paints are water-based, they are thinned by mixing with water, not with oil. They don't, of course, have to be thinned at all – they can be used straight from the tube or jar, or even made considerably thicker by mixing with one of the many mediums specially made for the purpose. With acrylics, you can paint in any consistency you like, which gives acrylic paints what is perhaps their greatest virtue: their amazing versatility.

You can use them in thin washes resembling water-colour, or put on colours with a knife in thick slabs. You can use them thick in one part of a picture and thin in another; you can build up an infinite variety of textures; and you can employ traditional glazing techniques – much easier in acrylic than in oil. They are equally suited to large-scale paintings and small, delicate flower studies or miniatures. They can be used outdoors or in, and combined

Nylon brushes

Bristle brushes

Mediums

Acrylic tube and pot paints

Palette knife

with other painting and drawing media in mixed-media and collage techniques.

Their only possible disadvantage is that they dry very fast. This can be helpful, because it allows you to overpaint without waiting long for an earlier layer of colour to dry, but it does make it more difficult to move paint around on the surface or to blend colours. However, the manufacturers of artists' paints, ever alert to possible shortcomings, have now produced mediums to slow drying time, so the problem has largely been solved.

Painting knives

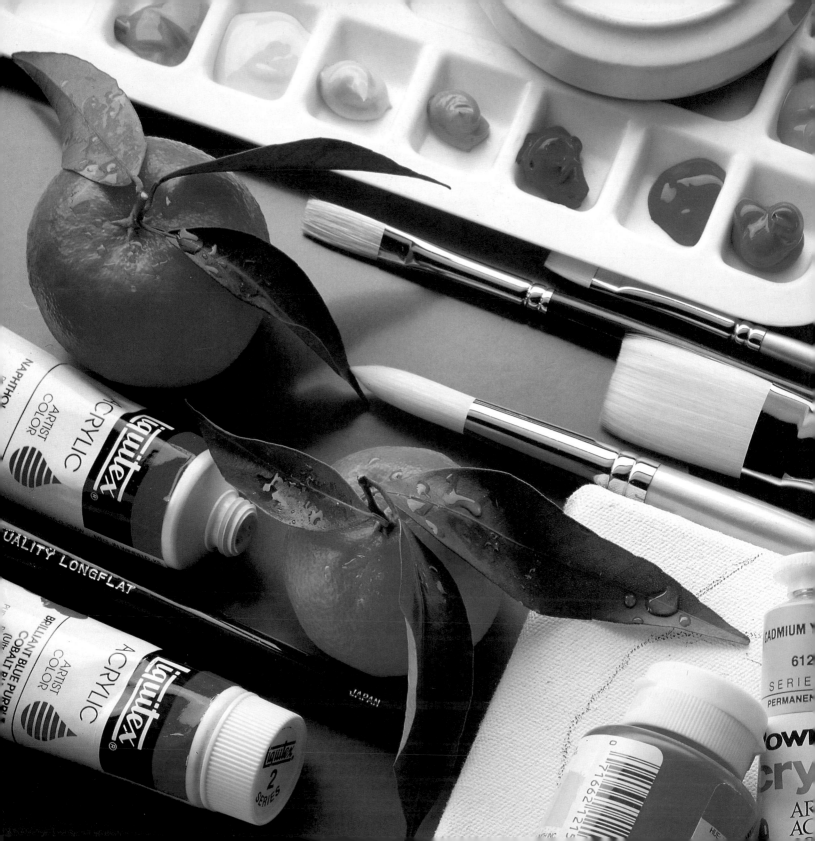

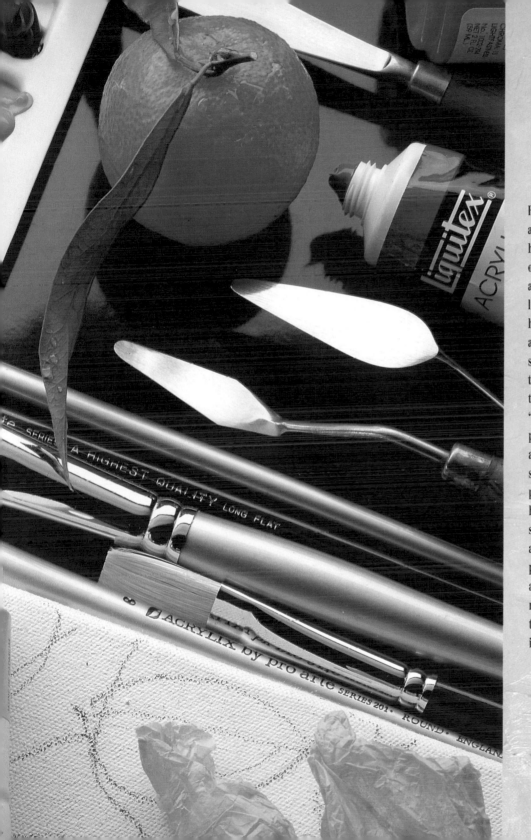

TECHNIQUES

Because acrylic is both a new medium and a highly versatile one, there is no time-hallowed body of techniques as there is for oils and watercolours. This is in a way an advantage, as you don't have to start with a list of "do's and don'ts", but it does make it hard to know how you should proceed. The aim of this section of the book is to provide some advice on how you can use the paints to their best advantage. Some of the techniques listed are traditional ones, "borrowed" from oil or watercolour painting, while others are peculiar to acrylics. You will find practical hints on such basics as choosing the most suitable painting surface, but you will also discover how to make collages, how to create stunning textural effects, and how to mix acrylics with other media, such as ink and pastel. The section is arranged alphabetically for easy reference, but you may find it helpful to begin by looking through all the techniques to gain some idea of the many exciting possibilities.

BLENDING

Blending means merging one colour or tone into another so that there are no perceptible boundaries between them. Because acrylic dries fast and thus can only be manipulated on the painting surface for a short time, it lends itself less readily to blending techniques than other paints. Some artists prefer to exploit the "hard-edged" quality of acrylics and eschew blended-colour effects. However, blending can be done.

The method depends on the kind of painting you are planning. If you are using very thin acrylic and aiming at a watercolour effect, you can blend colours by damping the paper and painting WET INTO WET, which will spread and diffuse the colours so that they run together.

This method is excellent for vague, atmospheric effects, but less suitable for modelling form, when you need more precision. If you want to merge two colours in one area of a picture – perhaps a vase in a still-life painting – lay down the first colour and brush over the edge lightly with clean water so that it is still damp when you put down the next colour.

The thicker you use the paint, the longer it will stay wet, making blending easier, but you can prolong the drying time even further by adding retarding medium to the colours as you mix them (see MEDIUMS). This will allow you to "push" one colour into another.

Blending can also be done by a DRY BRUSH method: laying down an area of flat colour and then working over it lightly with a small amount of paint on a bristle brush.

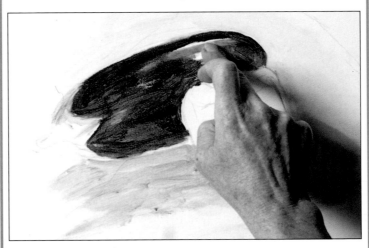

1 The paint has been mixed with retarding medium, and remains wet for long enough to blend one colour into another with a finger. The working surface is canvas board.

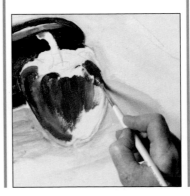

2 Painting the darkest and lightest areas of the aubergine first helped the artist to judge the strength of colour needed for the pepper, which is initially blocked in with brushstrokes following the forms.

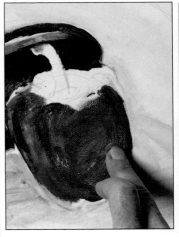

3 Again a finger is used to blend one colour into another. The gradations of tone on the pepper are quite subtle.

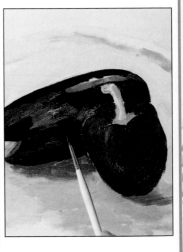

4 Further dark colours are applied to the aubergine. A nylon brush is used throughout, as this is softer than a bristle brush and does not leave pronounced brushmarks.

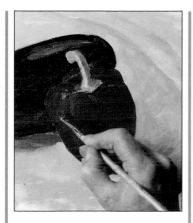

5 Yellow has been added to the basic red mixture to produce a brilliant orange-red, which is now stroked gently onto the side of the vegetable. The retarding medium makes the paint more transparent so that new applications do not completely cover the underlying colours.

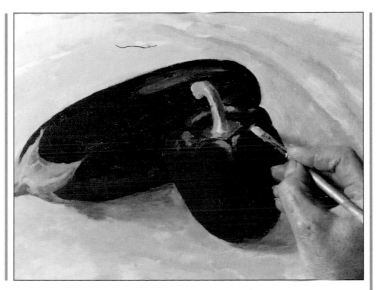

6 For the highlights, which will not need to be blended to any great extent, less medium is used with the paint.

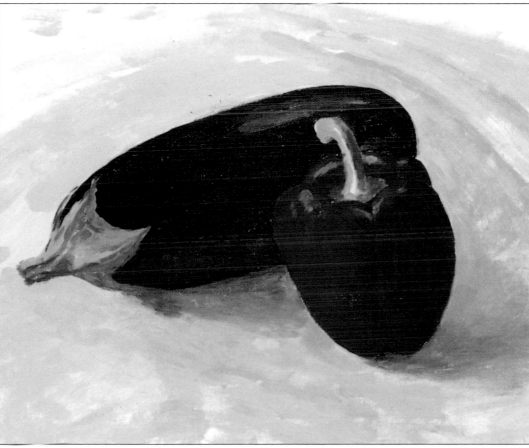

7 The brushmarks are barely visible, and there is no obvious boundary between each colour and tone. Although retarding medium is helpful it needs to be used with caution. On a non-absorbent surface such as primed canvas board the paint remains tacky for some time, and there is a danger of accidentally lifting off small areas of colour.

Broken Colour

The term "broken colour", which refers to any area of colour that is not completely flat, covers a wide range of painting techniques. DRY BRUSH and SCUMBLING, for example, both produce broken-colour effects, as does dragging a thin wash of colour over a rough watercolour paper. In the latter case the paint will adhere only to the raised grain of the paper, producing a slight speckling.

However, broken-colour effects are most often seen in opaque techniques. If you look at landscape painting in thick acrylics or oils you will probably see that any large area of sky, sea or grass consists of many different but related colours. Examine close up a sky which simply looks blue from a distance, and you may be able to identify a wide range of blues, and possibly some mauves, greens and touches of brown as well. These colours all mix "in the eye" to "read" as blue.

Broken-colour effects are often created by working on a COLOURED GROUND which is only partially covered by the paint, or by laying down a layer of flat colour and working over it with other colours. Acrylic is particularly well suited to the latter method, as the first layer of paint will quickly dry.

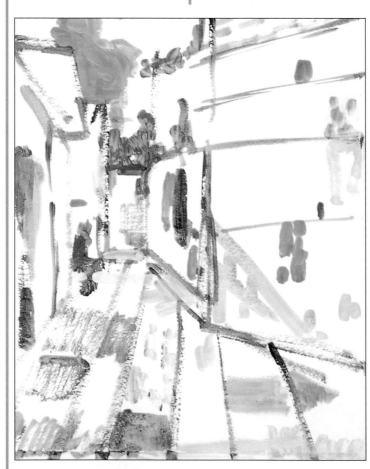

1 The composition is roughly mapped out with a few linear brushstrokes before the artist begins to apply small, separate areas of colour. She is working on heavy medium-surfaced watercolour paper.

2 For the sun-struck white areas of the building, thick paint is used over the earlier thin washes.

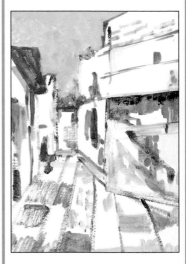

3 Although she is building up the painting with a patchwork of colours, the artist takes care to establish colour relationships, repeating the blues and yellows from one part of the picture to another.

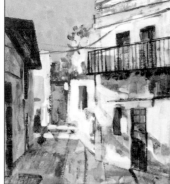

4 In an architectural subject it is important to maintain correct perspective and straight verticals. A piece of spare paper is used as a ruler, with the brush drawn lightly along the edge.

5 Notice how the paint surface varies. On the buildings particularly, transparent washes in the shadow areas contrast with thicker paint, where the grain of the paper has broken up the brushstrokes to give a textural effect.

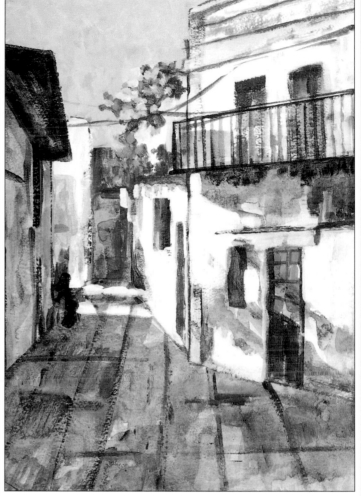

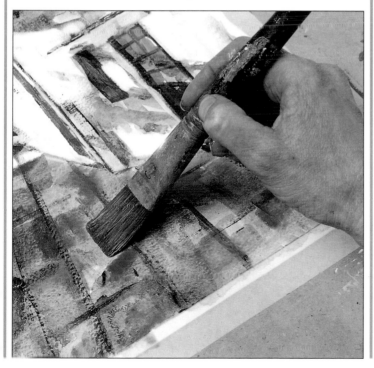

7 In each area of the picture both the colours and the brushwork are nicely varied, and the contrast between thick and thin paint adds to the lively, sparkling effect.

6 The painting is nearly complete, but the foreground is not yet sufficiently strong. A large soft brush is used to lay washes, or glazes, of thinned paint, which create pools of deeper colour.

BRUSHWORK

A good painting, whether a landscape, a still life, a flower painting or a portrait, relies for its success on several factors. One of these is the way the paint is put onto the painting surface.

Inexperienced artists often fail to give much thought to brushwork, which is hardly surprising since the problems of making a subject look convincing require quite enough effort. But it is important to remember that a picture is more than a representation of the world – it is an object in itself, with its own physical presence. Brushwork is not just the "icing on the cake"; it is an integral part of the image.

Apart from creating a lively and attractive picture surface, the way you use your brush can help you describe objects. If you are painting flowers in thick paint, for instance, you can often represent a leaf or petal with one deft flick of the brush. In a landscape you can let your brush follow the direction of a tree-trunk or the furrows of a ploughed field. This will also give your painting a sense of movement and dynamism.

Acrylic paints hold the marks of the brush very well, especially if you thicken them with a bulking MEDIUM, so it would be a pity to ignore this opportunity.

Brushwork can play a part in thin acrylic techniques also. You might use long, linear strokes for hair in a portrait, calligraphic squiggles and broken lines for reflections in a watery landscape, and loose blobs for foliage. It is worth experimenting with a variety of brush shapes to find out what kind of marks each one can make.

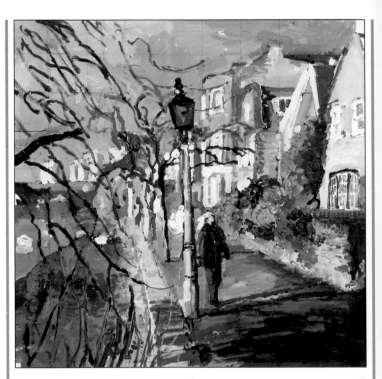

▲ **Gary Jeffrey**
Strand on the Green

Working on primed paper, the artist has used thick, juicy paint, and his energetic and positive brushwork give a feeling of excitement and movement to the composition.

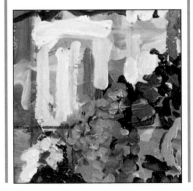

Notice how the brushwork follows the direction of the shapes and forms, with short, multi-directional dabs and blobs used for the foliage and vertical or horizontal sweeps for the architectural details.

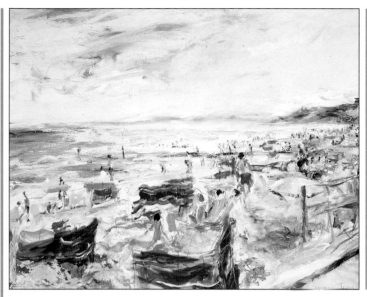

◄ Jacquie Turner
Bournemouth Beach

Equally lively and exciting brushwork is seen in this delightful painting, done on smooth watercolour paper. Here there is a contrast between thick and thin paint, as well as between deft stabs and flicks of the brush and smudged paint – this artist uses her fingers as well as brushes.

In places, the pencil marks of the drawing have been allowed to show through the thin paint, and some further pencil drawing has been done on top, complementing the busy effect of the brushwork.

► Valentina Lamdin
Reflections

No area of this painting, done on canvas, is flat – all the tones and colours have been built up with an intricate network of small brushstrokes reminiscent of the Impressionist painters.

It is vital to maintain consistency of brushwork throughout the painting. The sky here is as heavily textured as the trees and other areas of the picture.

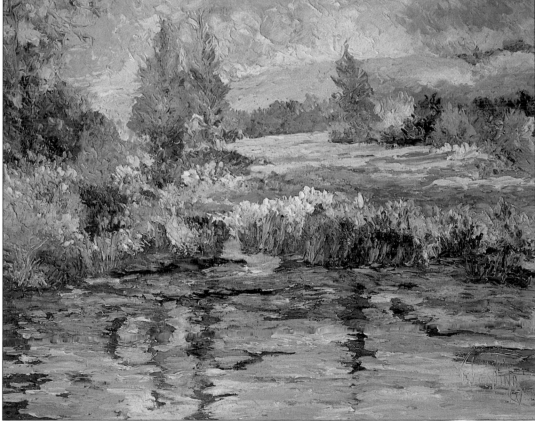

BUILDING UP

The way you proceed with a painting in acrylics depends to a large extent on your individual working method and on how you are using the paint – thick, thin or medium.

If you are exploiting TRANSPARENT TECHNIQUES on paper, you will want to begin with light washes of colour, building from light to dark in the traditional watercolour manner.

Acrylic is probably used most frequently at its tube consistency, perhaps thinned with a little water, but basically as an opaque paint. In this case it doesn't matter very much where you begin or which colours you put down first, because you can overpaint as much as you like without harming the colours beneath.

However, a good general rule for all painting is to block in the most important areas of tone and colour first and then work all over the picture at the same time, always bearing in mind the relationship of the various shapes, tones and colours. It is seldom wise to take one part of a picture to a high stage of finish before tackling another, as this can create a disjointed composition.

If you plan to contrast areas of thick and thin paint, perhaps using IMPASTO for highlights or foreground objects, start thin and build up gradually. Although you can change and correct colours by over-painting, you won't be able to turn a heavily painted area with obvious brush or knife marks into a thin, flat one.

Opaque on paper
1 Working on watercolour paper with a medium (slightly textured) surface, the artist first made an outline brush drawing to establish the placing and shapes of the objects. She now adjusts and clarifies the drawing by painting out incorrect lines with white paint.

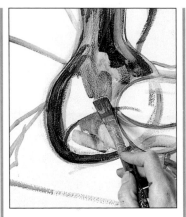

2 With the drawing established, she lays in colour, using water-thinned paint for the carafe to simulate the transparency of the glass. Although the glass has a greenish tinge, it reflects the colour of the background, so a warm brown is chosen.

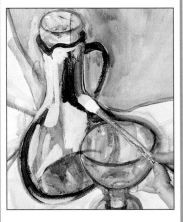

3 The subtle colours of the glass have been built up with a series of transparent washes, with thicker paint, applied with a bristle brush, for the highlights on the carafe. The same paint is used to work into the dark area on the right.

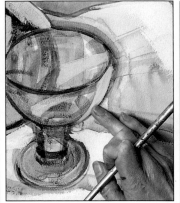

4 Thick paint is again used for the highlight on the side of the glass. Because it threatened to overlap the edge, the artist pushes it into place with her finger.

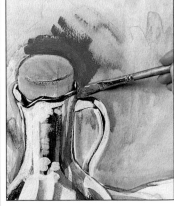

5 The background is strengthened with a thicker application of paint. Using a nylon brush, which is better for precise definition than a bristle one, the artist takes the colour carefully around the edges of the cork and the handle of the carafe.

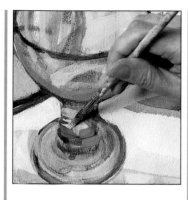

6 The colours of the wine glass are finely nuanced yet quite strong, requiring careful colour mixing. These patches of deep turquoise, like the curve at the bottom of the glass, must also be placed accurately, as they describe the forms. A nylon brush is again used.

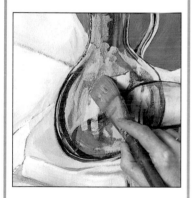

7 In order to achieve the elusive quality of the glass carafe, which is somewhere between green and brown, a glaze of transparent greenish yellow is laid over the original browns and whites (see GLAZING). The glaze is applied with a large soft brush, and the paint is thinned with water alone. A glazing medium can be used, but water is often preferable for large areas.

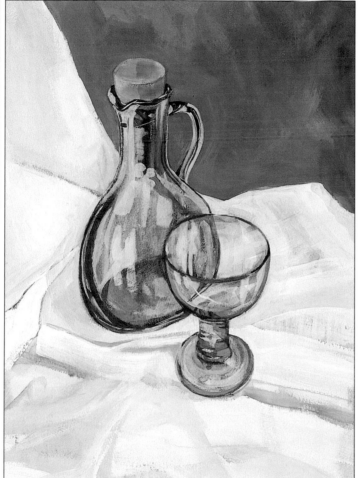

8 The finished painting shows how the consistency of the paint can be varied to suit the subject. On both of the glass objects, opaque highlights overlay transparent washes, while relatively thick paint has been used for the drapery.

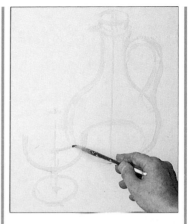

Opaque on canvas
1 A brush underdrawing is made first, using diluted paint in a colour that will tone in with the overall colour scheme. Notice that a line has been marked down the middle of the carafe to ensure that both sides are equal.

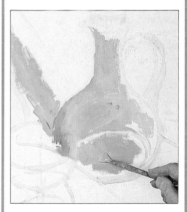

2 This artist's preferred medium is oil paint, and he uses the same techniques for acrylic, beginning with fairly thin but opaque paint and building up gradually.

19

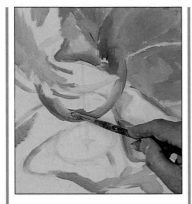

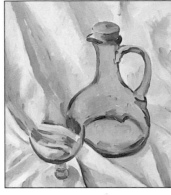

3 He establishes all the main color areas first, working broadly and attempting no precise definition, although he takes care to keep within the lines of his original drawing.

5 The painting is now at the halfway stage, with all the colors blocked in, but no highlights added. These will be left until last, as will the rim of the glass, which is as yet unpainted.

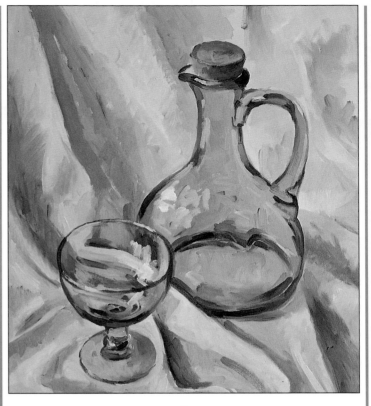

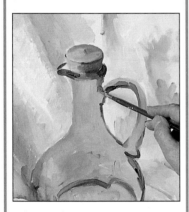

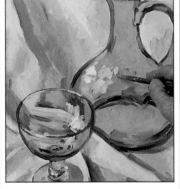

4 A variety of colors has been used for the body of the carafe, and three separate colors for the dark parts of the rim and handle.

6 The glass is now fully defined, the tricky ellipse at the top having been treated with care. The final stage, often one of the most enjoyable in a painting, is adding the highlights, which bring the whole image to life.

7 Thick paint, varied brushwork, and carefully orchestrated colors give a lovely feeling of energy to the subject, and the transparency of the glass is skillfully conveyed.

Transparent on paper
1 As in the previous demonstration, the artist is working on watercolor paper. She does not make an UNDERDRAWING because she intends to use transparent paint throughout and pencil or brush lines could show through in the light areas.

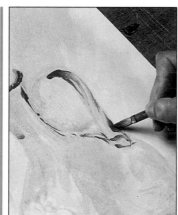

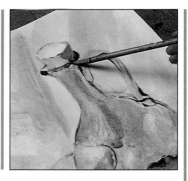

6 The cork and rim of the carafe are now given further touches of definition. Throughout the painting, the artist has used a Chinese brush, which she likes because it is versatile and sympathetic to her way of working.

2 No white is used for mixing the light colors; instead, she works as a watercolor painter does, starting with very pale washes and building up gradually toward the darks by laying one wash over another. Using acrylic in this way requires considerable skill, as mistakes cannot be corrected by overpainting.

4 Due to the effects of light, the contrasts of tone on glass objects can be strong, with abrupt transitions from light to dark. Here, a dark green is used for the rim and handle of the carafe. The paint is still of watercolor consistency, although there is now a higher ratio of paint to water.

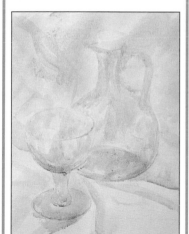

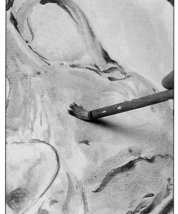

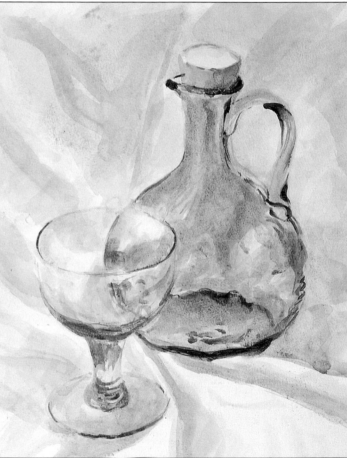

3 At this stage the painting gives the impression of a ghost image. Certain colors will be strengthened as the work progresses, while others will be left as they are.

5 Further washes of watery paint are applied to the body of the carafe, building up the effect of the wavy light and dark areas caused by inconsistencies in the thickness of the glass.

7 The finished painting has all the delicacy and translucency of a watercolor; indeed, a watercolorist might find it hard to believe that it was done in acrylic.

CHARCOAL AND ACRYLIC

Since acrylic paints can be used thinly on paper, very much like watercolour or gouache paint, it follows that you can combine them with any drawing medium you would normally use on paper (see also LINE AND WASH, PASTEL AND ACRYLIC, PENCIL AND ACRYLIC).

Charcoal is in itself a versatile medium, capable of producing both fine lines and rich areas of tone, and by combining it with acrylic you can achieve a wide range of exciting effects.

There are many different ways of working. For a portrait you might map out the composition with charcoal, using it also to block in the background, then paint the face and head before working into this with more charcoal. For a landscape you might begin with loose overall washes of colour and then use charcoal to define details and build up areas of darker tone.

In any mixed-media work it is important to think in terms of a marriage – the media should blend together while retaining their separate identities. Charcoal has a matt surface, so unless you have a reason for aiming at textural contrast it is probably best to keep the paint matt also, thinning it with water rather than with a MEDIUM.

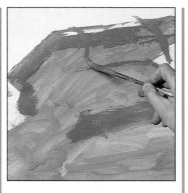

1 The artist begins with loose washes of colour, keeping the paint fairly thin so that he can draw over it with charcoal. He is working on watercolour paper.

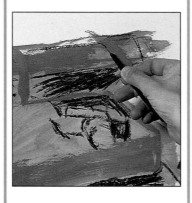

2 A stick of thick charcoal is used to draw over and into the paint, gradually building up definition.

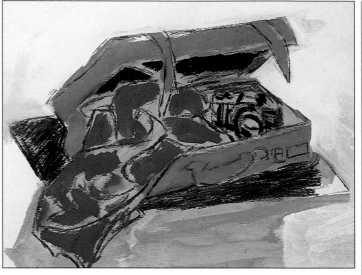

3 When a drawing medium is used with paint it is important to develop both line and colour at the same time. Paint has now been laid around and between the charcoal lines on the patterned fabric.

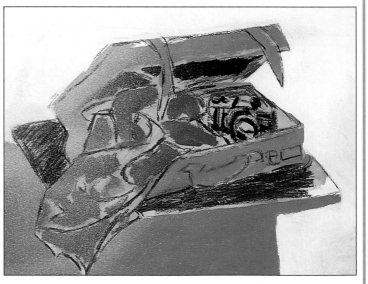

4 With the paint still wet, the whole of the left side of the picture has been sprayed with water, using a mouth diffuser.

5 In this detail you can see the effect of the water spray, which has created a soft, granular texture. The paper was allowed to dry before the artist continued working into the paint with charcoal.

6 When the charcoal drawing on the fabric is complete, a small bristle brush is used to dab in touches of magenta. This brilliant colour provides a balance for the hot colour of the suitcase, which might otherwise have been too dominant.

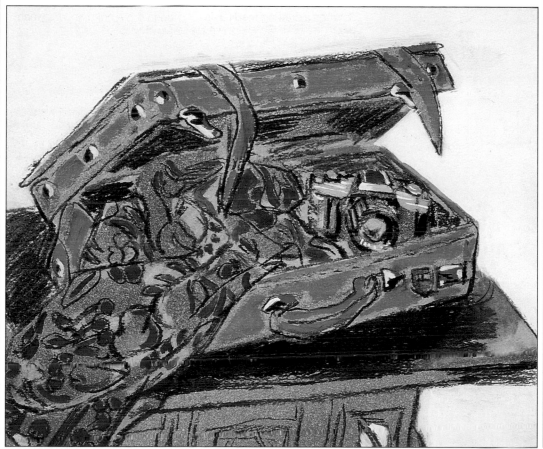

7 Finishing touches were the addition of highlights on the metal fittings of the suitcase and some further charcoal drawing on the table.

COLLAGE

▶ **Mike Bernard**
View of Mousehole

Although this work on paper contains elements of collage, the artist prefers to describe it as a mixed-media painting, because he does not rely on collage alone to produce areas of texture. He has combined collage with pastel, paint and coloured inks, applied with a number of different tools, such as rollers, sponges, toothbrushes, pieces of card and palette knives.

The word collage comes from the French *coller*, to stick, and it describes a picture made by gluing pieces of coloured paper, fabric, photographs, newspaper cuttings – or anything you like – onto a working surface. These can be combined with paint, or the whole composition can consist of glued-on fragments.

Acrylic is the perfect medium for collage work. Both paints and MEDIUMS have powerful adhesive properties, and are capable of securing quite heavy objects to the picture surface. If you use texture paste (as below) and press objects into it – these might be shells, scraps of tree bark, grasses, or even keys, beads or small pieces of jewellery – you can create three-dimensional effects akin to relief sculpture. In such cases a final coat of colourless medium should be used to seal and protect the work.

Alternatively, you can use paint and paper alone, placing the emphasis on two-dimensional pattern and the juxtaposition of colours. Some artists employ a layering technique, gluing on fragments of coloured paper with acrylic medium, covering these with paint and perhaps more medium, then more paper and paint. Others will begin a painting in the normal way and then collage certain areas.

A collage can be as simple or complex as you like; it can be abstract or semi-abstract, realistic or purely decorative. Collage is essentially an experimental technique, so there are no hard and fast rules. One word of warning, however. If you are trying the three-dimensional approach and using paint and medium thickly, work on a rigid support, such as a plywood panel (see SUPPORTS), as otherwise the paint may crack after drying.

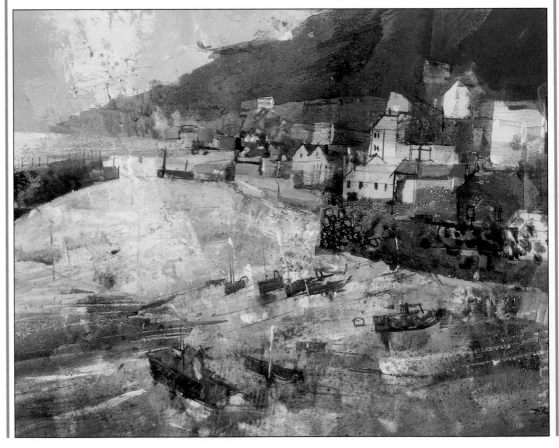

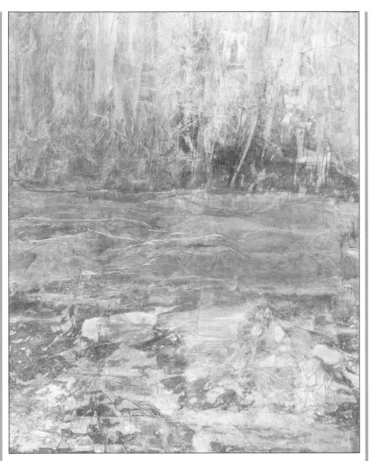

▼ **Jacquie Turner**
Chiswick House Grounds V

Here collage has been used in certain areas of the painting to create additional texture, which is always an important element in this artist's work. Pieces of glued-on tissue paper are combined with acrylic paint and coloured inks, watercolour, gouache and pastel.

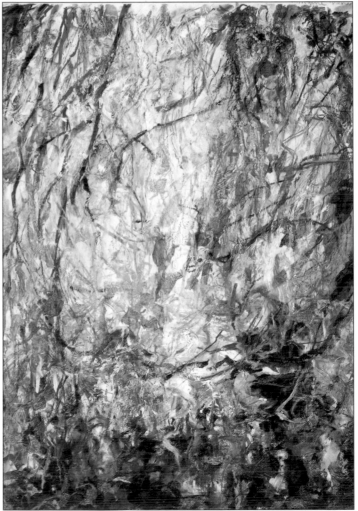

▲ **Jill Confavreux**
Winter Lake

This painting evolved as part of a series on the theme of frozen ground. The working surface was a medium watercolour paper, onto which the artist glued acid-free tissue paper with gloss medium. This texture formed the "ground", over which she painted and poured acrylic glazes, followed by a light scumble of gold and silver oil pastels. These acted as a resist (see WAX RESIST) for further applications of paint, creating some lovely effects.

This detail shows the variety of textural and colour effects produced by this layering method. The final stage was to apply a glaze, cover the whole surface with cling film, and peel it off when the glaze was dry.

COLOUR MIXING

Successful colour mixing – that is, achieving colours that correspond to those you see – is mainly a matter of experience. However, there are some hints which will help you cut down on trial-and-error time.

Primaries and secondaries
Red, yellow and blue are known as the primary colours, which means they can't be made from mixtures of other colours. But each of these colours comes in two or more versions, with different colour biases. If you want a bright secondary colour (the term for a mixture of two primaries), always choose the two primaries which have a bias towards each other. For example, if you want a clear, vivid green, use lemon yellow, which is slightly blue, and phthalocyanine or Prussian blue, both of which are slightly green.

Ready-made secondaries
You don't, of course, have to mix secondaries at all. Paint manufacturers make a good selection of secondary colours, many of which are stronger than the mixtures you can achieve on your palette. It is a common fallacy that all colours can be mixed from the three primaries. You can paint a reasonably satisfactory picture with only three colours – and it's an instructive exercise – but you won't achieve much subtlety of colour.

Light and dark
If you are painting thin, in "watercolour mode", you make colours lighter by using more water. The thinner the paint is, the more of the white paper will show through. For opaque treatments, colours are lightened by adding white. This must be done with caution, however, as white changes the character of some colours.

Black can be used to darken colours, but this can also alter their character. Red mixed with black becomes brown; yellow mixed with black becomes green. However, mixing black with the darker colours, such as blue, dark green and purple, produces good results. Opinions are divided over the use of black – some artists abhor it, while others would never be without it.

Opacity and transparency
One more factor to consider is the relative opacity of the colours you intend to mix. Some acrylic colours are transparent or translucent and others opaque. If you want a transparent mixture or are mixing colours by overlaying them on the picture surface (see GLAZING and TRANSPARENT TECHNIQUES) you must take care not to mix the two types or you will lose the transparency. Certain brands of acrylic, notably Liquitex®, are marked either "opaque" or "transparent" on the tube, but with others you will have to find out through experience. Remember that white is opaque.

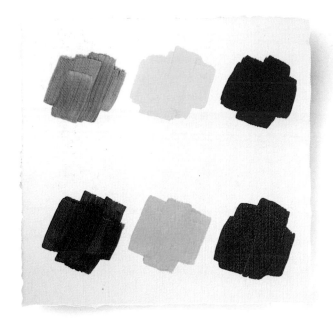

These swatches show a warm and cool version of each of the primary colours. Colour names have not been given as they vary from one range to another.

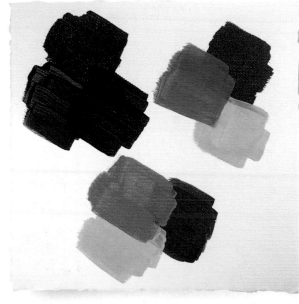

These secondary colours have been produced by mixing the two primaries which are biased towards one another. Muted versions of the same colours can be made by mixing opposite primaries, that is, one warm and one cool.

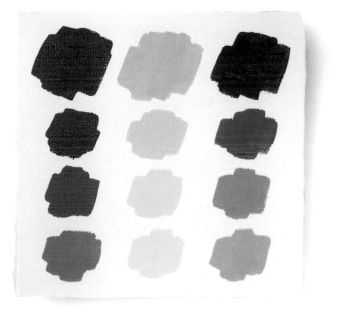

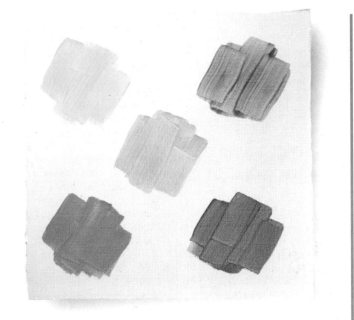

Here one of each of the primary colours (top) is shown mixed with white, first 25%, then 50% and finally 75%. Notice that the red immediately becomes pink, while the other colours remain true to their characters.

Although it is easy enough to mix a range of greens from blue and yellow, or black and yellow, most artists have a few ready made greens, which can be used on their own or to modify other colours.

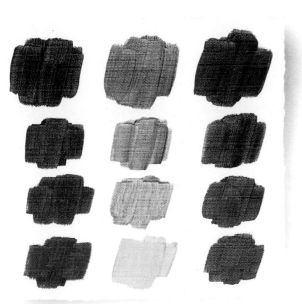

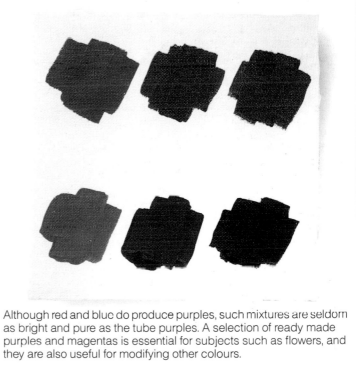

Here the primary colours have been mixed with black. First 100%, then 75%, 50% and finally 25%. While the blue remains recognizable, the red changes to brown and the yellow to green.

Although red and blue do produce purples, such mixtures are seldom as bright and pure as the tube purples. A selection of ready made purples and magentas is essential for subjects such as flowers, and they are also useful for modifying other colours.

COLOURED GROUNDS

Canvases and boards sold for acrylic painting (see SUPPORTS) are usually white, but you may find it helpful to lay on a tint before starting to paint. Some artists like a white surface, particularly if they intend to paint thinly, because the light reflected back through the paint gives the work a luminous quality. Others find a white surface disturbing, as it makes it difficult to judge the relative lightness or darkness of the first colours.

There are no true whites in nature, so the canvas or board is providing an artificial standard. Virtually any colour you put on will look dark in contrast, and you may find you are working in too light a "key". If you tint the board with a mid-tone, you can work up to the lightest tones and down to the darks.

Colouring the ground is easily done – brush some thinned acrylic all over the surface and it will be dry in minutes. Usually a neutral colour is chosen, such as grey, grey-blue or an ochre-brown. Some artists always use the same colour; others choose a different one for each painting.

The colour can contrast with the overall colour key of the painting; for example, a warm brown or yellow for a snow-scene with a predominance of cool blues and greys. Alternatively, you can use a ground colour that tones in with the applied colours.

Artists who work on coloured grounds often deliberately leave small patches of the ground uncovered, whether it is in a toning or a contrasting colour. This helps to give the picture unity, as repeating colours from one area to another "ties" the separate elements together.

1 The most usual choice for a coloured ground is a neutral brown or grey, but for this vivid subject the artist has decided on a striking multi-coloured ground, which she applies with a large soft brush.

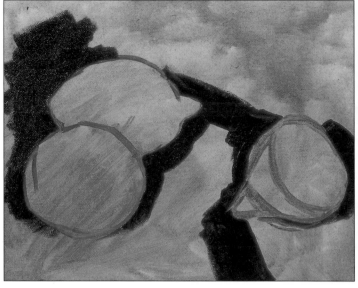

2 The undercolours make it easier to be bold about the darkest tones, and here pure black is used.

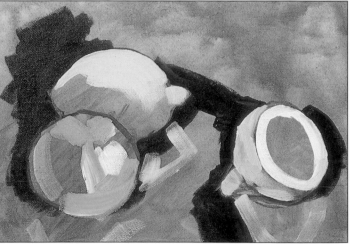

3 The light and bright colours can also be more easily assessed when there is a ground colour, as this provides a middle tone. The reflections have been painted before the black area in front of the fruit; you will see the reason for this in the next step.

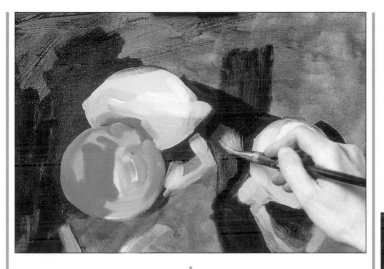

4 The black paint is now applied more thinly, in the form of a transparent glaze which will "knock back" the colours of the reflections without obliterating them. The thin paint also allows some of the ground colour to show through.

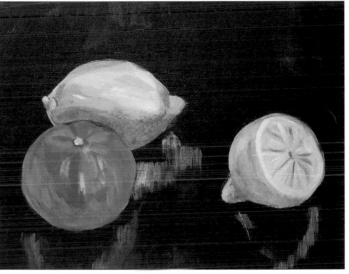

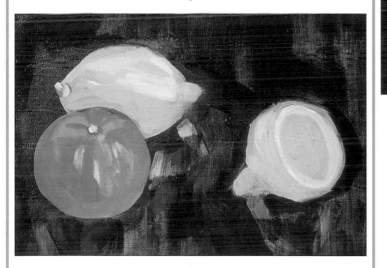

5 At this stage the forms of the fruit have been built up, with some details and highlights added and the colour intensified on the right side of the orange.

6 Final touches were to add a little more colour to the reflections and paint the cut side of the lemon. Notice the way the ground colour has influenced the applied colours, with the black glazes over the blues and violets producing a deep, rich purple, particularly noticeable at the top of the picture.

DRY BRUSH

Dry brush is a technique common to all the painting media, whether opaque or transparent. It simply means working with the minimum of paint on the brush so that the colour below is only partially covered.

You can work dry brush straight onto virgin paper or canvas, but it is usual to work it over a previously laid colour, thus achieving a BROKEN COLOUR effect. The method is much used in watercolour – and acrylic in the "watercolour mode" – for achieving textured effects, such as hair and fur or grass and foliage.

For thin acrylic, you will need to use a soft brush, ideally a square-ended one, with the hairs splayed out slightly. Experiment on a spare piece of paper beforehand; it is important to get exactly the right amount of paint on the brush or it will go on too heavily and spoil the effect.

If the painting is in thick or medium-thick acrylic it is probably best to use a bristle brush; the fan-shaped ones sold as "blending brushes" are useful. You can brush equally thick, fairly stiff paint over the underlayer, or use thin paint over thick, depending on the effect you want to achieve.

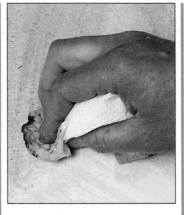

1 The artist is working on canvas, and begins by giving it an overall tint (see COLOURED GROUNDS), spreading well-diluted paint with a piece of kitchen paper.

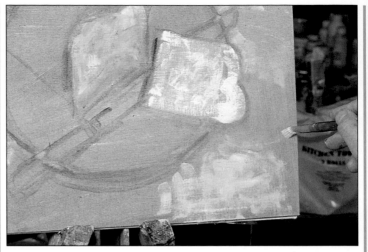

3 The dry-brush method can be restricted to one area of a painting, but in this case the artist wants to achieve a consistent surface texture, so he uses the method for the background and foreground as well as for the loaf of bread.

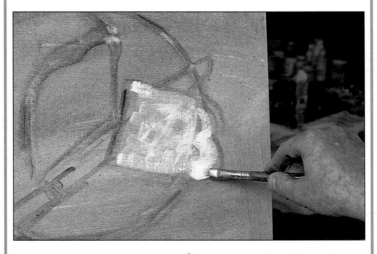

2 Working with a bristle brush, he drags thick paint lightly over the canvas so that some of the warm undercolour shows through.

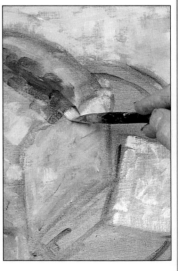

4 The texture of the crusty loaf is accurately represented by successive applications of dry brush. Because acrylic dries so fast, one layer of paint can be laid over another almost immediately

5 The edge at the top of the loaf is crisp and clear, so here juicier paint is used, more heavily applied.

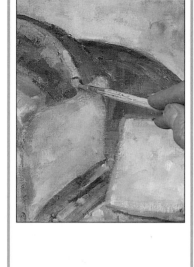

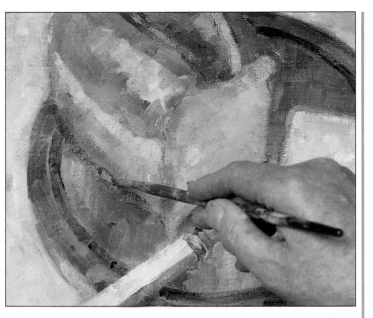

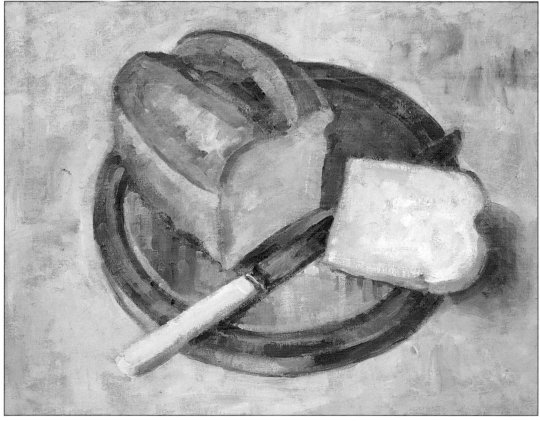

6 On the breadboard, considerable variations of colour and tone have been achieved by laying one colour over another. The dry brush method is now again used for the soft, broken line of shadow beneath the loaf.

7 Dry brushing is an excellent method for suggesting texture, and has also allowed the artist to build up subtle but lively interactions of colour.

EXTRUDED PAINT

The diverse nature of acrylics, together with the large number of specialized MEDIUMS you can use to alter the character and handling properties of the colours, encourages an experimental approach. You need not restrict yourself to conventional brush painting – you can build up layers of solid paint with a knife (see KNIFE PAINTING) and you can squeeze (extrude) the paint onto the working surface from a nozzle.

This method is similar to that used by potters, who create raised patterns by squeezing thinned clay, called slip, onto the surface of plates or bowls. It is also, of course, used by cooks for decorating iced cakes.

You could squeeze the paint straight from the tube, but this will make rather a thick, unsubtle line, so it is best to fit the tube with a nozzle such as the ones used for cake icing. In this way you can draw directly onto the surface. Alternatively you can put the paint into an icing bag, either as it is or thickened with an IMPASTO medium – a practical measure, as otherwise you will use up a lot of paint.

Drawing with a nozzle takes a little practice, since you must be able to control the amount of paint you squeeze out. And it is obviously not a suitable

technique for all subjects – raised patterns would look out of place in a highly realistic painting, but could be very effective in a still life with a strong pattern emphasis, or in a semi-abstract painting where texture is an important element.

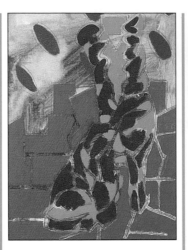

2 By carrying out several stages of painting the artist has given himself a "foundation" on which to begin the extruding. This method needs a decisive approach, since mistakes can't be easily corrected.

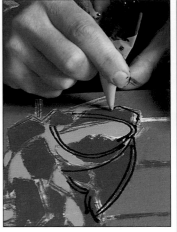

3 Using a piping bag improvised from tracing paper, he begins to outline the toe of the boot with black. He has bulked out the paint by mixing it with impasto medium.

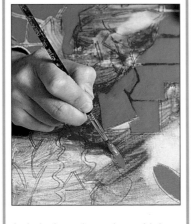

1 A design – based on a high-heeled boot – was worked out in a sketchbook, and guidelines were pencilled on the working surface (a canvas board). The artist now begins to build up the picture with varying consistencies of paint.

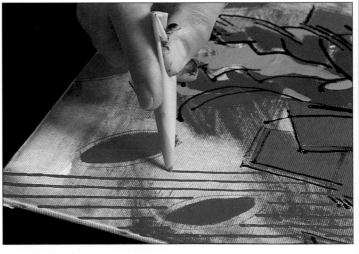

4 Several piping bags are needed to cater for different colours. A new one is now used to draw rows of carefully spaced

diagonal lines, leaving the painted ovals uncovered.

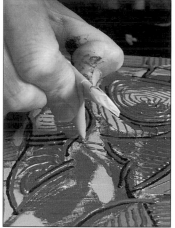

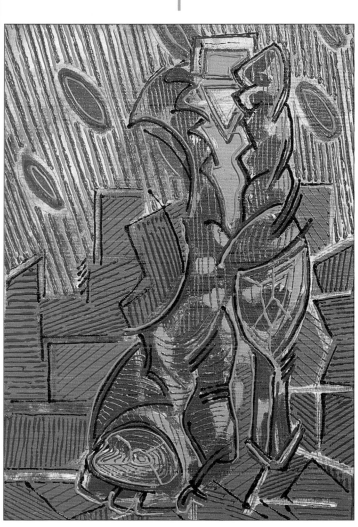

5 The surface is then piped with a network of lines, circles and small dots. Care must be taken not to rest the hand on completed parts of the work, so the board is turned around from time to time.

6 At this stage, the picture is propped up at a distance to assess how much more work needs to be done. The boot clearly requires further attention, as it is less heavily textured than the background.

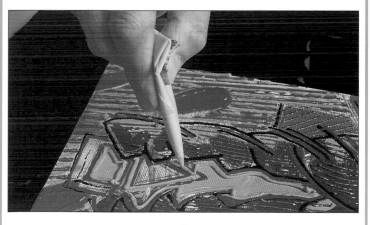

7 The nozzle of the piping bag has been cut to give a thicker trail of paint, and solid orange lines are made inside the earlier red ones.

8 The same orange was used first to outline the boot and then to strengthen the oval shapes in the background. The rest of the boot was built up with a finer network of lines overlaying the original flatly painted colours.

GLAZING

This is a technique first used in the early days of oil painting, when paint was built up in a series of transparent or semi-transparent layers over an UNDERPAINTING. Glazing was a slow method because each layer had to be perfectly dry before the next one was applied. But acrylic paint is tailor-made for glazing techniques because it dries so fast.

The effect of successive veils of colour is quite unlike anything you can achieve with opaque paints, and glazing allows you to build up colours of great depth and richness. Also, because each new application of colour modifies the one below, glazing can be used as a method of COLOUR MIXING. For example, if you glaze yellow over blue, or vice versa, you will have green – but a much more vibrant green than can be produced by a single layer of colour.

Glazing can be done with paint thinned with water alone – this is ideal for large areas where you want to modify existing colours – but the colours will be more vivid and more transparent if you use a mixture of water and either gloss or matt MEDIUM.

The layers need not all be uniformly thin; you can glaze a thin layer over an IMPASTO, or over an area in which you have built up a heavy texture with modelling paste (see TEXTURING). This thin-over-thick approach also has a precedent in oil painting: Titian (c.1477/90-1576) and Rembrandt (1606-69) used transparent glazes over thicker paint, as did Turner (1775-1851), who found it an ideal method for the luminous sky effects he so loved.

1 Working with a soft brush on watercolour paper, the artist has begun with light washes of yellow over a pencil drawing. She now mixes the paint with a little matt medium and applies it more thickly.

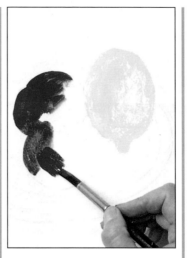

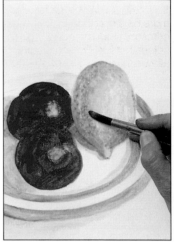

2 The paint is mixed with matt medium throughout, as the picture is to be built up with successive layers of glazes. Notice that the medium makes the paint more transparent.

3 Several layers of semi-transparent colour have begun to establish the forms of the plums, and delicate touches of darker colour are now applied to suggest the texture of the lemon.

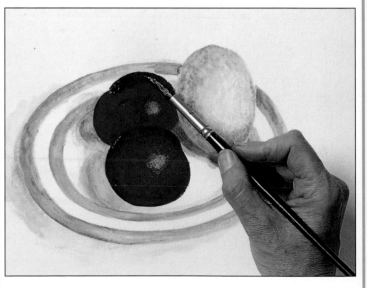

4 A deep, rich purple red is used for the dark area of shadow where the fruit turns away from the light.

5 For the plum in the foreground, more blue is added to the crimson, producing a very deep colour, but it is still transparent, allowing the red to show through.

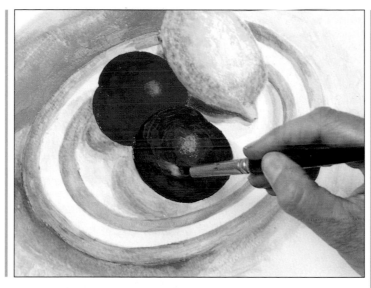

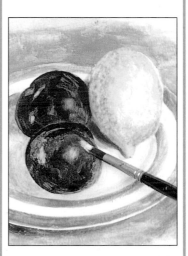

6 The matt medium reduces the "body" and opacity of the white paint, making it ideal for suggesting the light bloom on the plum. The paint is gently pulled over the paper surface in a SCUMBLING method.

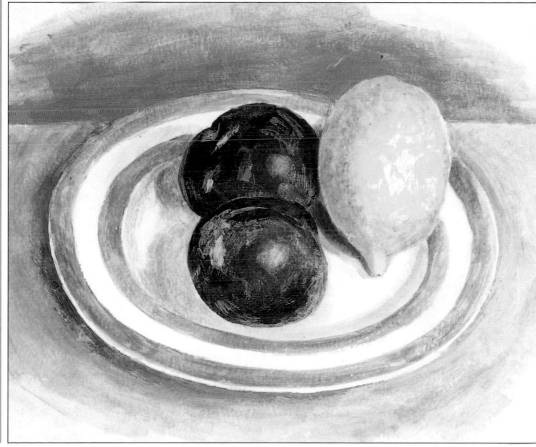

7 The effect produced by this layering technique is very distinctive, with one colour showing through another to achieve subtle and glowing mixes. You can see this particularly clearly on the plums, and on the shadows beside them.

GROUNDS

A ground is a layer of paint or paint-like substance which separates the painting from the SUPPORT (the board, canvas or paper on which you work). It is also known as a "primer". If you buy ready-prepared canvases or boards they will have been given a coat of primer, which is usually acrylic gesso. However, many artists like to do this preliminary work themselves, stretching and priming their own canvases or preparing boards to suit their personal requirements. This allows you to choose the ground you like as well as saving money.

Grounds are used for oil paintings because otherwise the oil would, in time, seep into the canvas and rot it. Strictly speaking they are not necessary for acrylics, but in general a ground provides a pleasanter surface to work on than untreated canvas or board, and reduces absorbency.

Both boards and canvases can be quickly primed with acrylic gesso. One thick coat (as it comes from the jar) will provide a slightly rough surface. If you want a smoother one, the gesso can be thinned with a half-and-half mixture of water and acrylic MEDIUM and sanded between coats. It is not wise to thin it with water alone,

as this could cause cracking.

Some artists like working on bare canvas, which is sympathetic both in colour and texture. If you want to try this, you can lessen absorbency by priming the stretched canvas with matt medium. This can also be used for boards.

If you use acrylic thinly on paper, in watercolour mode, work on watercolour paper, which needs no priming.

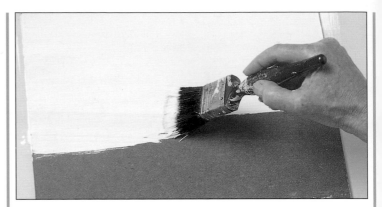

Boards

1 Acrylic gesso is laid on hardboard, taking the brush carefully from one side to another. Use a good household brush or you may find you have hairs in the gesso.

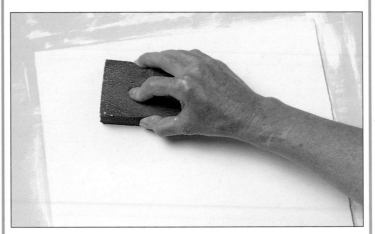

2 Three coats have now been laid on and sandpapered each time. The final coat is once again rubbed smooth. For those who prefer a textured surface the gesso can be applied more roughly, or a sponge can be used to create an overall texture.

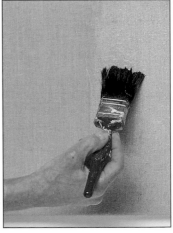

Canvas

Natural canvas provides a sympathetic neutral ground colour, and many artists prefer to retain this by using transparent acrylic medium instead of gesso. The medium should be thinned with a little water and painted on evenly. In this photograph it looks milky because it is still wet, but it dries clear.

IMPASTO

The word impasto describes paint applied very thickly, so that the marks of the brush or painting knife can be clearly seen. Impasto techniques have been used for centuries by oil painters. In many portraits by Rembrandt (1606-69), for example, the paint in the dark areas is thin, while highlights on face, clothing and jewellery are built up in paint so thick as to appear almost carved. Van Gogh (1853-90) exploited the expressive possibilities of the method, using his paint uniformly thick, and varying his BRUSHWORK from sweeps and swirls to short, stabbing strokes.

Impasted paint can be applied with a brush or a painting knife (see KNIFE PAINTING), or even squeezed onto the painting surface (see EXTRUDED PAINT). You can use thick paint all over the picture surface, as Van Gogh did, or reserve it for certain areas. In the latter case, remember that thick paint has a strong physical presence, and will tend to "advance" to the front of the picture, so if you want to create depth, reserve impasto for the foreground or centre of interest. In a still life you might use thin layers of paint for the background and any shadows on the objects, and touches of impasto for highlights or areas of vivid colour.

If you plan large areas of thick paint, you will find it helpful to mix the colours with one of the MEDIUMS made for the purpose. These bulk out the paint without changing its colour – though the palette mixture will dry slightly darker because the medium is white when wet and colourless when dry.

Impasto is frequently combined with GLAZING, which can create exciting effects, as the thin paint sinks into the "troughs" and adheres only partially to the raised areas. Glazing over impasto is another technique borrowed from oil painting, but it is quicker and easier with acrylic because of the faster drying time.

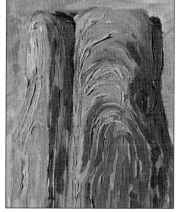

Impasto under glazing
1 Working on primed canvas board, thick paint is applied with a bristle brush over a slightly thinner layer. The paint has been thickened with impasto medium in an approximately fifty-fifty mixture.

Impasto medium
Mixing paint with impasto medium (there are several to choose from) bulks it out without changing the colour. However, the paint does appear to become lighter when you mix it because the medium is white until dry, which can make it difficult to assess the strength of the mixture. It can be best to mix the colour before adding the medium.

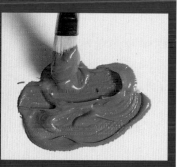

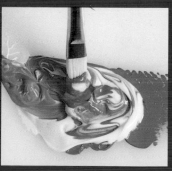

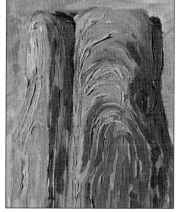

2 In places, the handle of the brush was used to "model" the thick ridges of paint and push them into place. The paint has also been scratched into with the point of a painting knife.

3 A glaze of water-thinned paint is now applied, creating blobs and runnels where it catches on the impasted paint. Any unwanted drips and dribbles can be mopped up with a rag.

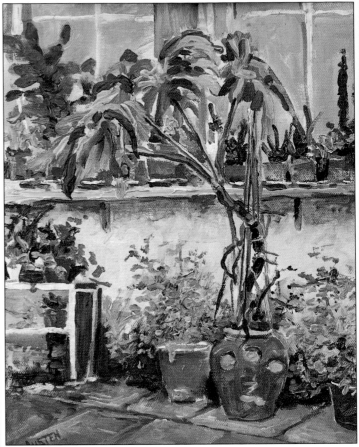

▲ **Don Austen**
Barbara Hepworth's Greenhouse

This painting appears at first to have been painted with a palette knife, but in fact the impasto effect is the result of successive layers of brushwork.

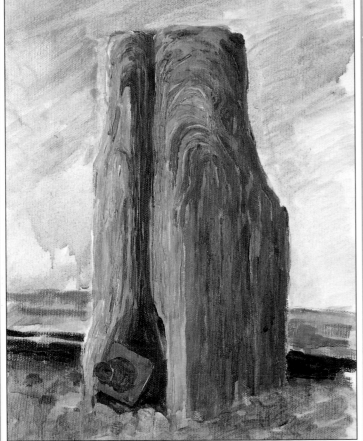

4 The glaze has settled most heavily in the thinner areas between the raised ridges. Now that the glaze is dry the colour is less assertive than it was when wet.

In this detail you can see how the physical presence of thick paint brings it forward in space. The wall and window are relatively thinly painted – you can still see the grain of the canvas – while thick impastos have been used for the edge of the shelf and the leaves of the large plant

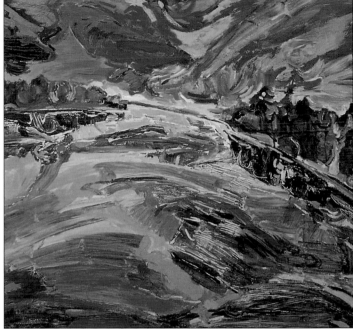

◄ David Alexander
The Sun's Recoiled Glare

This artist paints large-scale works on canvas, and thickens his paint with heavy gel medium. Like many artists who exploit the tactile qualities of really thick paint, he employs various unorthodox painting "tools", among them scrapers, sponges and hardened brushes. Here you can see a contrast of surface textures, with thick swirls of paint in places and SGRAFFITO effects in others.

► Peter Burman
Lavender Fields, Provence

In this painting on board the paint has been used straight from the tube, that is, not thickened with any medium. Often thick impastos are reserved for foreground details but in this case the blue fields have been generalized in order to give prominence to the sunlit group of buildings, which are skilfully described in a few brushstrokes of thick paint.

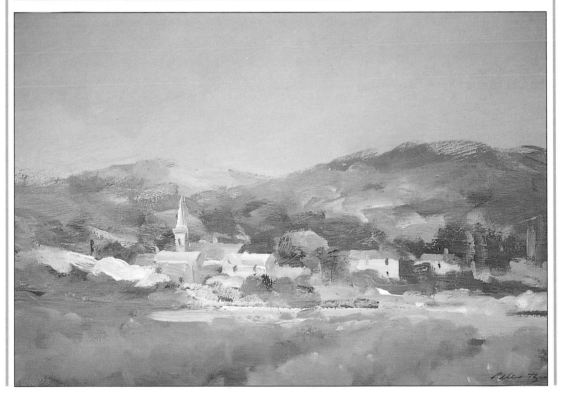

INK AND ACRYLIC

These two media are natural partners, and are particularly suitable for TRANSPARENT TECHNIQUES on paper. Coloured drawing inks (some of which are water-soluble and others shellac- or acrylic-based) are transparent, and have considerable depth of colour, so can be used to reinforce washes of transparent acrylic colour.

Black drawing inks (sometimes called Indian inks) are thicker and more opaque. These can be used in LINE AND WASH techniques with thin acrylic, or painted on with a brush either over acrylic colours or side by side with them. Brush drawing in black ink makes a very positive statement, so this approach is best suited to bold work, with strong areas of colour complementing the dense blacks.

You can also exploit the differences between media by using the acrylics opaquely (see OPAQUE TECHNIQUES) in combination with transparent coloured inks. As in all mixed-media work, there is no fixed way of working; experiment will show the method that works best for you.

1 The subject is quite a complex one, so the artist has made an underdrawing before putting on the colour. She has used water-soluble coloured pencil for this, and is working on smooth-surfaced watercolour paper.

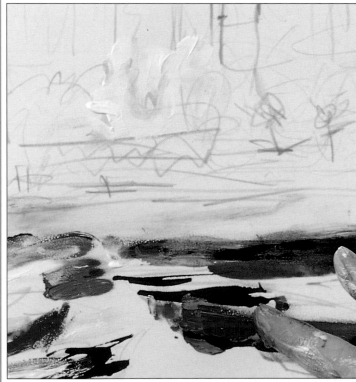

2 She now uses a combination of black ink and paint, pushing the paint around on the surface with her fingers. The ink she has chosen is an acrylic-based one called "liquid acrylic", which is made in a range of colours.

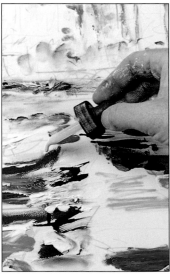

3 Yellow ink is now applied direct from the dropper. A brush or pen can also be used, but the dropper gives a free, impressionistic effect in sympathy with this artist's style.

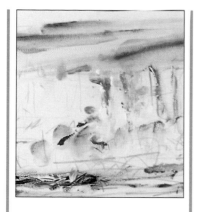

4 She wants a loose effect in the sky also, so she uses a slightly dampened rag to spread marks made with a water-soluble crayon. The smoothness of the paper makes it easier to move colour around in this way.

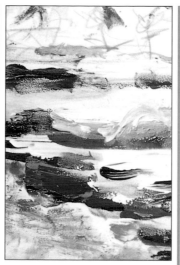

5 In this detail you can see the different surface textures achieved by combining inks with thicker applications of paint. Ink has been used for the purple boat and the black one in the foreground, with brushstrokes of paint overlaying the ink in places.

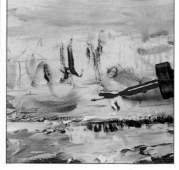

6 Again using ink straight from the dropper, a small, irregularly shaped mark is made to suggest a boat in the background of the picture and echo the reds of the foreground boats.

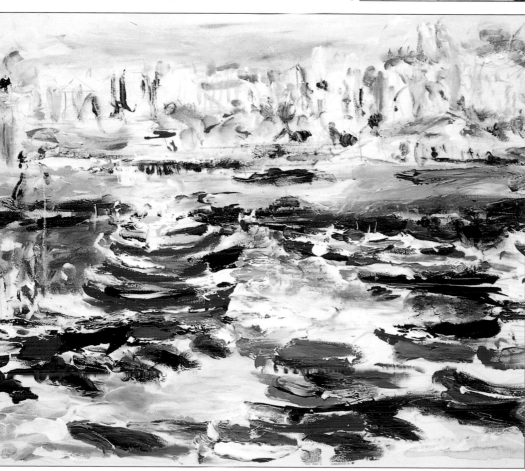

7 Throughout, there has been no attempt at literal description. None of the boats or other features have been dealt with in detail, but the painting successfully conveys the atmosphere of a harbour, with all its colour and movement.

KNIFE PAINTING

An alternative to applying the colour with a knife is to build up a knife-painted underlayer with modelling paste (see TEXTURING) and then use glazes (see GLAZING) or medium-thin paint on top.

2 The first layer of paint is allowed to become touch dry before a second colour is laid on – a hairdryer is helpful here. Using a pointed knife, with the paint at tube consistency, the artist strokes the colour onto the surface.

While paint applied with a brush can be thin, thick or somewhere in between, paint applied with a knife must always be thick.

Knife painting is a form of IMPASTO, but the effect is quite different from that of thick paint applied with a brush. The knife presses the paint onto the surface, giving a flat plane bordered by a ridge where the stroke ends. In a painting built up entirely of knife strokes, these planes and edges will catch the light in different ways, creating a "busy" and interesting picture surface. The marks can be varied by the direction of the stroke and the amount of paint, and you do not have to restrict yourself to the flat of the knife – you can flick paint on with the side to create fine, quite precise lines. As with any impasto method, you will probably need to mix the paint with a bulking medium, or it will not be thick enough to hold the marks of the knife.

The knives sold for applying paint are different from those used for mixing paint on the PALETTE and cleaning up. The former have cranked handles and highly flexible blades, and are sold in a wide variety of shapes and sizes, from small triangular or pear shapes to long, straight ones.

1 A less experienced artist might need to make an underdrawing to act as a guide for the first knife strokes, but here the main shape is blocked in with colour immediately. The artist is working on canvas board.

3 The first application of paint was pushed onto the surface, so it is relatively flat. The brown has been applied more lightly, creating thick ridges with distinct edges.

4 By twisting the knife slightly as he works, the artist allows the point to scratch into the paint, thus combining knife painting with a version of the SGRAFFITO technique. This linearity enhances the overall "edginess" of the image.

5 White paint is now applied with the point of the knife to reinforce the linear element. These triangular knives are capable of surprisingly precise effects.

6 An ordinary straight-bladed palette knife is now used to remove small areas of the still-wet brown paint, suggesting the buttons on the jacket. Thickly applied paint dries slowly and can be manipulated on the surface for a considerable time.

7 Further knife strokes of both black and white paint were added in the final stages to complete the definition of the jacket.

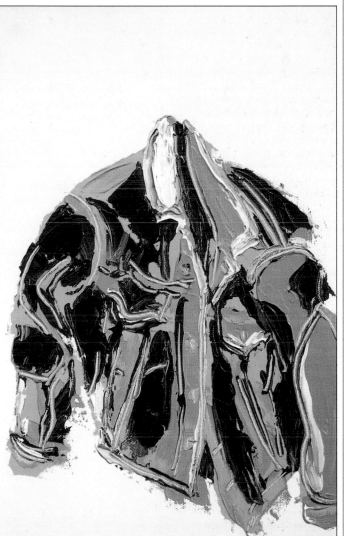

LINE AND WASH

Because acrylic can imitate both oil paint and watercolour, many of the old techniques can be adapted to the new medium. Line and wash, a traditional watercolour technique, is one example. It dates from the 17th century, before watercolour had really come into its own as a painting medium, and was used mainly to lay flat washes of colour over pen drawings.

Since that time, however, artists have used line and wash in more inventive and expressive ways. The problem with the traditional method of making the drawing first and adding the colour is that the two mediums can fail to "gel", and it is difficult to avoid the effect of a coloured-in drawing. It is usually better to develop the line and colour simultaneously, so that you are constantly aware of the relationship you are creating between the two.

The kind of pen you choose will depend on the effect you want. Some line and wash drawings are fragile (the technique is much used for flower studies) and others are bold. Experiment with different pens, from fine nibs to fibre- and felt-tipped pens or even ballpoints – an underrated drawing implement. You might also try using water-soluble ink, which will spread when wet colour is laid on top, creating soft, diffused effects.

The paint for the washes should be kept thin, or it may detract from the effect of the drawing, so it is best to choose transparent pigments (see COLOUR MIXING and TRANSPARENT TECHNIQUES). It can be thinned with water alone, or with a mixture of water and MEDIUM.

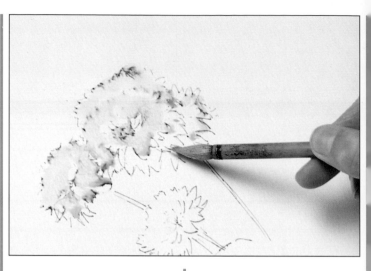

2 With the paint thinned to watercolour consistency, she touches in colour with the tip of a Chinese brush. Because the ink is water-soluble, the wet paint spreads it slightly, giving a soft effect.

1 Using a fine-pointed reservoir pen, and working on smooth cartridge paper, the artist draws the shapes of the flowers, keeping the lines light.

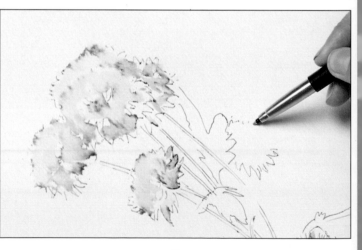

3 Further details are added with the pen, again using a light touch to avoid the effect of a "filled in" drawing.

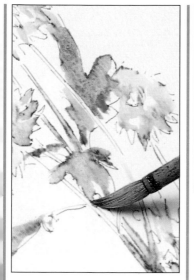

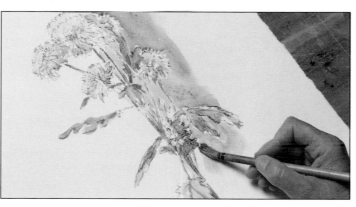

6 A light wash is laid over the background and taken carefully around the edges of the flowers.

4 Green washes mix with the blue ink to create an impression of delicate shading on the leaves.

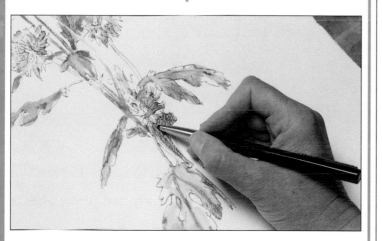

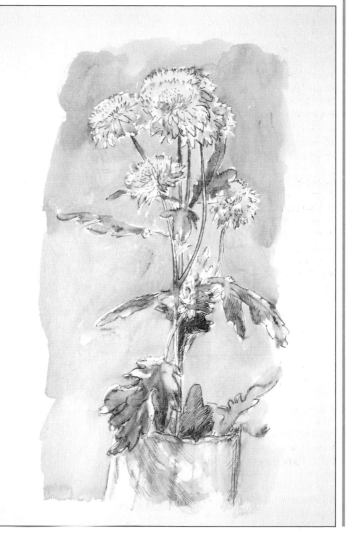

5 The pen is now used in a more positive way to draw into the leaves with diagonal strokes of hatching and cross-hatching.

7 To provide a context for the flowers as well as some colour contrast, the background wash was extended, and the top of the vase sketched in lightly in pen.

MASKING

It is extremely difficult to paint a completely clean edge or a perfectly straight line; the brush almost always wobbles or the line meanders askew. It can help to hold your brush against a ruler, but even then paint tends to slip underneath. So it is better to use masking tape.

Masking techniques are often used by abstract painters who want crisp, hard-edged divisions between shapes, but they have their uses in representational painting also. Suppose you are painting a white building using TRANSPARENT TECHNIQUES and want to keep the paper clean for the white areas. To avoid any slippage over the edges, all you need to do is stick on some masking tape and remove it when you have painted the background.

Or you might be using OPAQUE TECHNIQUES to paint an interior with a window frame, and you could use masking tape to create a sharp division between this and the view outside. In a combination of thick and thin paint, you may want some areas of textured IMPASTO with distinct edges – perhaps for a patterned fabric. Masking tape can be stuck down over thinly applied paint, so you could lay on the thin colour first and then cut pieces

of masking tape to fit around each shape, thus allowing you to work freely without losing the clarity of the edges.

Masking tape can be used on paper or canvas, providing it is not too heavily textured, in which case the tape will only adhere to the raised grain, allowing paint to slip beneath.

1 Thin red and yellow paint is streaked onto the surface (canvas board) and allowed to dry before masking tape is applied.

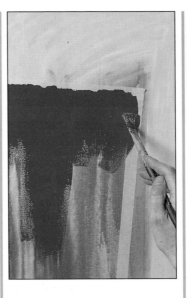

2 The contrast between opaque, flatly applied paint and thinner, rougher applications is to be one of the features of the painting. The brilliant red is applied with a soft brush, which evens out the brushstrokes.

3 The tape is peeled off carefully, leaving a crisp edge. It must be removed before the paint is dry, since dried acrylic forms a plastic skin, which will come away with the tape.

4 The red paint has been dried with a hairdryer, more tape applied, and the area between painted in blue before the tape is again removed. It would be virtually impossible to achieve this thin, straight, slightly tapered line by any method other than masking.

5 To provide a contrast to the flat area of red, thin purple paint is flicked onto the surface and allowed to run down in dribbles. The artist is working with the board upright on an easel to encourage such effects.

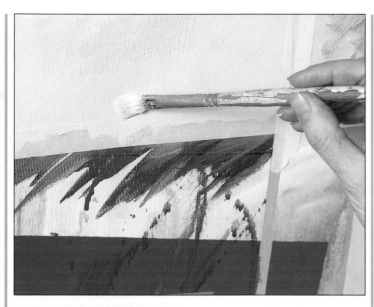

6 Because the purple paint was thin it had seeped under the masking tape. The hard edge was reinstated by painting over it first in white and now in yellow.

7 The final stage is a thick application of green over parts of the red, applied with a painting knife (see KNIFE PAINTING).

8 To achieve a contrast of shapes and edge qualities as well as of texture, the final green layer was masked at the top only, and then drawn out to form a series of irregular shapes.

MEDIUMS

Paint straight from the tube (left).
Overlaid with gloss medium (right).

Paint straight from the tube (right).
Overlaid with matt medium (left).

It is not essential to mix any medium at all with acrylic paint; you can use it straight from the tube or jar, thinned with a little water as necessary. However, if you want to explore the full creative possibilities of acrylics, you will need to become familiar with the appropriate mediums, and find out what they can do. The mediums shown on these pages are from the Liquitex® range, but other manufacturers produce similar ones.

As you will see, some of the products are called varnishes and others mediums. Generally speaking, a varnish is applied after painting, as a protective coating or to alter the nature of the surface – from matt to glossy or vice versa. A medium is mixed with the paint to achieve a particular characteristic that the paint lacks. For example, paint can be made more transparent, thicker and more opaque, or be given specific textures. However, varnishes can also be used as mediums, and there is one that doubles for both functions (gloss medium and varnish).

The mediums and varnishes are a suspension of solid plastic particles in water, which refract light and are thus milky in appearance; they become clear as they dry. Mixing paint with

Paint straight from the tube (left).
Mixed with heavy gel medium (right).

Paint straight from the tube (left).
Overlaid with iridescent medium (right).

any of the mediums causes it to look lighter than it will when dry, on the painting surface.

When using any medium or varnish, always read the instructions on the jar, as incorrect use can cause clouding of colours, or cracking.

Gloss medium and varnish
To achieve a glossy surface, give the picture a final coat of this, or mix it with the colours as you work. It increases transparency, and is useful for GLAZING.

Matt medium
When added to paint, this increases transparency, and can be used for matt glazes. Its adhesive qualities make it useful for COLLAGE. It is also a good primer for canvases (see GROUNDS).

Matt (satin) varnish
Produces a low-sheen surface which brings out dull colours. It can be mixed with gloss medium and varnish for semi-gloss effects. Too many coats may cloud the colours.

Gel medium
This is a gloss medium which can be mixed with tube paints to increase the intensity and transparency of colours. It can

be applied in multiple layers to create heavy glazes, but is not suitable for thick, one-layer glazes, as water can be trapped within the film of particles and retain the milky appearance.

Matt gel
Similar to gel medium but dries to a matt finish. The more gel you use the more transparent the colour becomes. A good adhesive for collage work.

Heavy gel medium
Also glossy, this is similar to gel medium, but thicker, and therefore good for IMPASTO work with knife or brush.

Opaque gel medium

This high-density extender is the one to use for really thick IMPASTO work, as it increases paint volume as well as giving extra body. If 50 per cent or less medium is used, the colour will remain the same; more will reduce colour strength. It produces a semi-matt surface, but varnish can be applied after painting if gloss is required.

Retarder

This slows drying time by several hours, and is helpful if you use thick paint and want to move it around on the surface. The thicker the paint, the longer the extension of drying time. Retarder is of no use for acrylic in the "watercolour mode", as water affects its performance.

Iridescent medium

This "fun" medium produces a whole range of metallic colours, which become more reflective as they dry. It works best with the transparent colours (see COLOUR MIXING), though you can use opaque ones also. It is particularly well suited to COLLAGE and mixed-media.

Paint mixed with blended fibres, a texturing medium

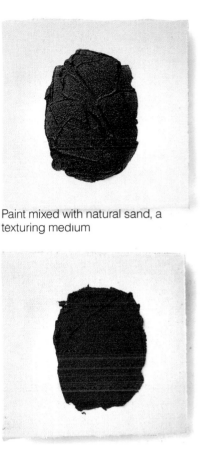

Paint mixed with natural sand, a texturing medium

Paint mixed with resin sand, a texturing medium

Paint mixed with ceramic stucco, a texturing medium

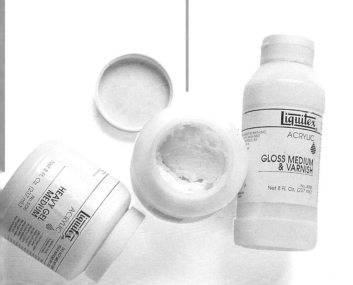

Modelling paste

This putty-like substance is used to build up under-textures and relief effects, but you must work on a rigid SUPPORT or there is a strong risk of cracking. It can be mixed with substances such as sand or sawdust to create textures, and you can achieve a variety of effects by pressing objects into it while still wet. It is ideal for relief COLLAGE, as it will hold quite heavy objects securely. Modelling paste can be mixed with paint, but the thick result could be hard to handle.

Flow-aid medium

This is a flow enhancer and water-tension breaker, which improves the levelling properties of the paint and makes it easier to apply areas of flat colour. It also increases absorption, and is useful for painting on raw canvas, which tends to repel water-soluble paint. It is also useful for watercolour techniques as it helps the colour to flow.

Texture gels

There are four textures: sand, resin sand, blended fibre and ceramic stucco.

MONOCHROME TECHNIQUES

It can sometimes be useful to work without colour at all – just black and white paint, and grey made by mixing the two. This is an exercise often given to art students to help them work out the tonal structure of a subject – that is, the relative lightness or darkness of each colour. When you are painting in the normal way, you will naturally be most concerned with identifying the colours you see and deciding which paint colours you should mix to match them. If you are restricted to monochrome you will be forced to evaluate the tones. For example, in a landscape you will have to decide whether the sky is lighter or darker than a foreground tree, and in a portrait whether the shadowed area of a face is darker or lighter than the background.

Usually, a good deal of trial and error is involved in this work, which is why acrylic is so well suited to it – any mistakes can be overpainted immediately. It can be helpful to work on a mid-toned grey paper, as this gives you a "key" against which to judge both the lights and darks, but you can use ordinary white cartridge paper if you prefer.

Or you can work on canvas or board, making a finished work in monochrome rather than simply carrying out a drawing exercise. Although we tend to think of paintings in the context of colour, it is surprising what a complete statement can be made in terms of tone alone – black and white photographs are often more expressive than coloured ones, and a charcoal drawing can be more powerful than a multi-coloured painting.

1 The composition is mapped out on watercolour paper with a brush drawing in black, and the darkest area is painted first.

2 The black background provides a key for the middle tones. The table top is initially established as one flat area of grey, which will be amended later. Because acrylic allows you to make changes by overpainting, it can be easier to build up from dark to light.

3 The candlestick is darker than the table top, so the tones of the table top were adjusted before work could begin on the candlestick. Monochrome methods involve constant assessment of one tone against another.

4 The painting is now virtually complete, with the area on the right of the vase defined as shadow, and the form of the vase built up with subtle variations of tone.

5 A monochrome painting can be pleasing in its own right as well as providing a valuable exercise in analysing and manipulating tones. It can also be used as an UNDERPAINTING, as in this case, where the artist has applied a series of transparent glazes (see GLAZING) over the whole picture area.

MONOPRINT

Monoprinting, although technically a form of printing, is in some ways more allied to painting. In printmaking proper, a series of identical or near-identical impressions is taken from the same image, while monoprint, as its name implies, is a "one-off" method.

The procedure is simple, and no special equipment is required. A painting – which should be fairly simple and bold – is made on a piece of glass or some other non-absorbent surface. Paper is then laid on top, gently rubbed with your hand, a roller or a spoon, and lifted off. Most of the paint will have been transferred from the original surface to the paper, making the print.

Monoprinting can be done with oil paints, printing inks, acrylics, or even watercolours. With acrylics you will have to bear in mind the short drying time. If the paint has begun to dry before you put the paper on it will obviously not make a satisfactory print, so you may find you need to mix it with retarding medium (see MEDIUMS).

You will also need to experiment to find the right consistency of paint; it needs to be fairly thick and juicy, but not so thick that it smudges when you press down the paper.

Unless, of course, you want a blurred effect, or would simply like to see what happens – the method is never entirely predictable.

You can add a linear element to the original painting by scratching into the paint with an implement such as a brush handle. These incised lines will appear as white on the print. Or you can work into the print itself with more paint, or with pastels, charcoal or inks (see CHARCOAL AND ACRYLIC, INK AND ACRYLIC, PASTEL AND ACRYLIC). Monoprint is a frequent basis for mixed-media work.

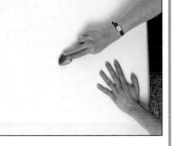

2 Cartridge paper is then laid over the painting and rubbed with a spoon to transfer the colour to the paper The pressure can be varied to create different effects.

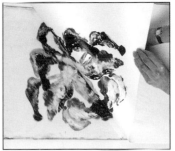

3 The paper is now lifted carefully away from the glass. At this stage it can be replaced and rubbed again if it has not absorbed sufficient colour, or it can be damped to encourage the paint to spread.

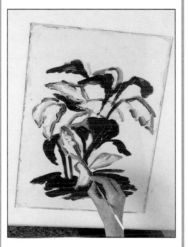

Single print
1 Working rapidly to prevent the colours from drying out before the printing stage, the artist paints the image on a piece of heavy glass. Each area of colour is kept separate.

4 However fast you work you will find that some of the paint has begun to dry and will print incompletely, but this can produce interesting results; you can see this "dry-line" effect on the stems of the plant. The variations in the area of red at the bottom were produced by scribbling on the back of the paper with the handle of the spoon at the printing stage.

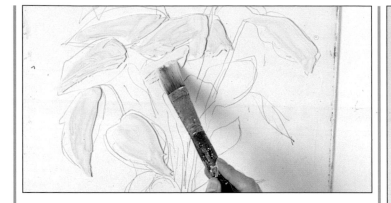

Four-stage print

1 This print is to be more elaborate, with each printing registered (aligned), so a drawing is first made and placed beneath the glass to act as a guide.

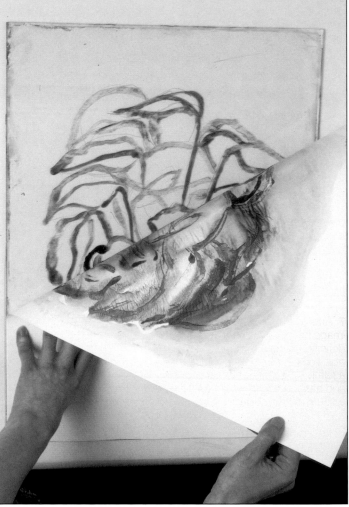

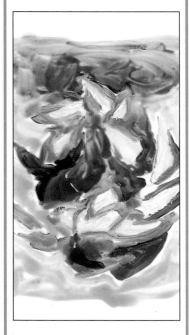

3 A print is taken in the same way as before, by placing the paper over the glass and rubbing with a spoon. In this case, however, the paper is precisely aligned to the lower left corner of the glass, thus ensuring a correct register for the later printing stages.

2 The first painting stage, which will establish the base colours for the print, is now complete.

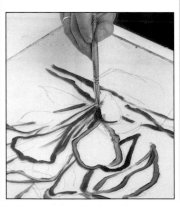

4 With the pencil drawing left in exactly the same position as before, a brush drawing is made, outlining the shapes of the leaves and stems.

5 This is then printed over the first stage, with the paper again carefully aligned to the corner of the glass.

6 For the third printing, which will define the shadows, Payne's grey paint alone is used. Once again the artist follows the pencil guidelines.

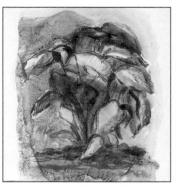

7 After the third printing, the image has more depth and definition while retaining a pleasing softness. Payne's grey is a relatively transparent pigment, and has strengthened the earlier colours without obliterating them.

8 The final stage is the addition of highlights, for which selected areas are painted in a cream colour, used fairly thickly.

9 In this detail of the final printing stage you can see how the pressure on the paper has squashed out the thick creamy paint, creating an intriguing texture of tiny ridges.

10 The mottled textures and fluid runs of colour are typical of the monoprint method. A print can be worked into further if desired, either with more paint or with a drawing medium such as pastel or charcoal.

OIL AND ACRYLIC

Mixtures of oil and acrylic must be handled with care, as oil and water are incompatible. This does not matter if the oil colour is used over the water-based acrylic, but if water-based paint is applied on top of oil, cracking will occur. This might not be immediately apparent; if you use the acrylic thickly it could seem to be going on normally, but it would be unlikely to stand the test of time.

However, acrylic can be used quite safely for the first stages of a work to be completed in oil. This can save a good deal of time for any picture to be built up in layers over an UNDERPAINTING, as the first applications of colour will dry much faster than oils.

You can also cover any kind of acrylic TEXTURING with oil paint, or contrast areas of acrylic with areas of oil. Such methods could be useful in COLLAGE work, where a lively picture surface produced by contrasting textures is often a feature.

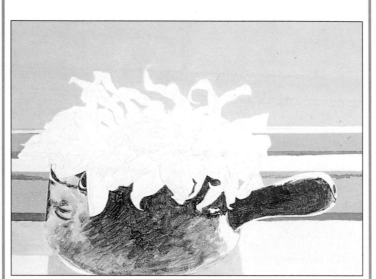

1 Broad areas of tone and colour can be established very quickly with an acrylic underpainting. The paint has been used flatly for the background, as the textures are to be built up with thicker brushstrokes of oil paint.

2 The artist has now begun to apply oil paint over the acrylic. The sunflower was not underpainted, but reserved as white canvas in order to increase the brilliance of the yellows.

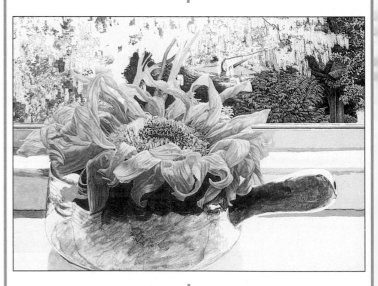

OPAQUE TECHNIQUES

An opaque colour is one that is not transparent or translucent, that is, one that can completely cover another colour. Opaque paint does not have to be thick; the tube or jar colours used alone or even thinned with a little water will give an opaque, smooth, matt finish.

Acrylics lend themselves to opaque methods, and since any errors can be corrected by overpainting, they are probably the best starting point for beginners.

There are, however, a few points to remember. As mentioned in COLOUR MIXING, some pigments are not by nature opaque; they are sometimes transparent or semi-transparent. If you use these pigments – perhaps because the right colour does not exist in an opaque version – you may have to mix in a little white or other opaque colour. Using too much MEDIUM will sacrifice some of the paint's opacity.

Remember also that acrylic dries slightly darker, because the medium in which the pigment is suspended is white when wet but colourless when dry. This does not normally matter, but may affect colour-matching if you intend to use DRY BRUSH or SCUMBLING methods over an existing dried colour.

▶ **Peter Burman**
Studland

Both the paintings shown on this page make use of opaque paint, but they are very different. Burman's technique is like that of an oil painter; indeed without prior knowledge it might be difficult to say which medium had been used. He works on hardboard given a slightly textured ground by the application of acrylic gesso in sweeping, uneven brushstrokes – you can see the effect of this where the dark area of foliage meets the sand. He uses the paint fairly thickly, alternating juicy brushstrokes (the foreground) with DRY BRUSH methods (the sea).

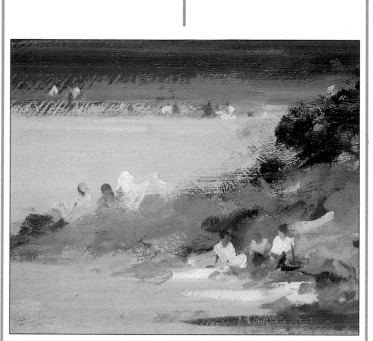

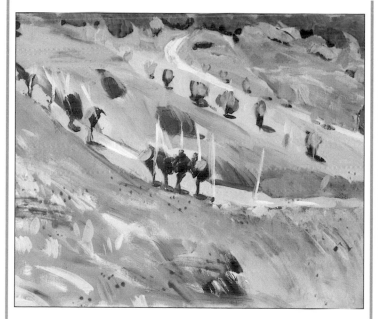

◀ **Jane Strother**
Tuscany landscape

This painting, on paper, shows a contrasting approach, with the paint used mainly at the consistency of thick gouache (opaque watercolour), to which acrylic bears some resemblance. The artist has also exploited the paint's versatility by introducing occasional touches of transparent colour – in the foreground you can see brushstrokes of watery red paint laid over the opaque blue-greens. In addition, she has employed a SPATTERING technique to suggest red flowers.

PALETTE

The word palette has two related meanings in painting. A palette is the object on which you mix your paints, and by extension, the range of colours an artist normally uses.

Most artists who specialize in one subject area will use roughly the same colours all the time, occasionally adding one or two as occasion demands – a portrait painter, for instance, might use a new colour for a certain skin type. Sometimes, however, artists will completely change their palette, perhaps abandoning sombre colours for vibrant ones or vice versa.

A starter palette
The choice of colours is largely a personal one, arising from particular pictorial interests and methods of working. For instance, an artist who works in TRANSPARENT TECHNIQUES will certainly use more transparent pigments (see COLOUR MIXING) than one who paints entirely in OPAQUE TECHNIQUES, and for COLLAGE work, the palette may include a selection of iridescent and metallic paints.

However, although it is not possible to recommend the "ideal" palette for everyone, some guidance can be given to those starting in acrylics, and as you gain in knowledge you can increase your range. The suggested starter palette shown here is from the Liquitex® range, but all the colours have equivalents in other makes of paint. The names may not be the same, though, so if in doubt, seek advice in your local art shop.

The mixing surface
You can use any surface as a palette, providing it is non-absorbent. The wooden palettes used by oil painters are not suitable, as you will be unable to remove the paint once dry. There are two special types of palette sold for acrylic work: one is white plastic, which can be easily cleaned, and the other is the "Staywet" palette shown opposite. This is especially good for outdoor work, where fast-drying paint can be a problem. The paint remains damp and malleable while you are working, and if you put on the plastic lid after a working session you will find the colours still usable a week or two later.

Starter palette
Suggested primary colours (top) are: **1** Cadmium red light **2** Cadmium red dark **3** Alizarin crimson **4** Cadmium yellow deep **5** Lemon yellow **6** Phthalocyanine blue **7** Ultramarine **8** Cobalt blue. Suggested secondary colours (bottom): **1** Viridian **2** Chrome oxide green **3** Payne's grey **4** Cadmium orange **5** Yellow ochre **6** Burnt sienna **7** Raw umber **8** Black. Note that these colours are not mixed but come straight from the tube.

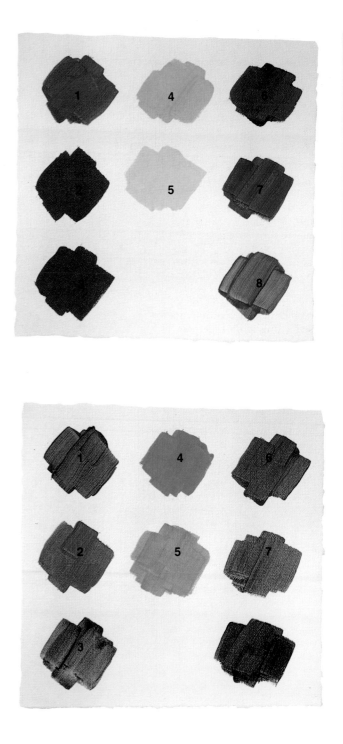

Staywet palettes don't give much room for mixing, however, and many artists prefer improvised palettes, such as a sheet of glass or formica, where there is no restriction on size. If you work on a small scale, or use acrylic mainly in the watercolour mode, you could use plastic or china watercolour palettes, or even old china or tin plates.

Whatever type of palette you decide on, try to arrange the colours in some sort of order, or you may make mistakes when mixing. The darker colours in particular are hard to tell apart in concentrated form, and you could find yourself picking up black when you wanted blue. It doesn't matter which order you choose so long as it has a logic and you can remember it.

Mixing

For thick applications of paint, such as IMPASTO and KNIFE PAINTING, it is best to mix the colours with a palette knife. You can use brushes, but if they become clogged with paint they are difficult to clean – indeed they can be ruined.

For thin and medium-thin methods, which use less paint, it is easier to mix with brushes, but be sure to wash them well afterwards, or put them in water immediately so that the paint doesn't harden. You will find you need to wash your brushes constantly when doing acrylic work, so always have plenty of water to hand.

Plastic palette

Staywet palette

Mouth diffuser

Plate glass, edges bound with tape for safety

Plant spray

When spraying chemicals be sure to follow manufacturer's i...

PASTEL AND ACRYLIC

Like many mixed-media techniques, a combination of pastel and acrylic can either exploit the differences between the component media or unite them into a homogeneous whole.

An example of the latter approach is the technique employed by some pastel artists of making an acrylic UNDERPAINTING. Sometimes the whole of this is worked over in pastel, and sometimes parts are left as they are. Because it is difficult to cover an entire surface with pastel strokes, this practice avoids the possibly distracting effect of white paper showing where coverage of pastel is light. It is also a means of achieving BROKEN COLOUR and colour contrasts; small areas of, say, a blue underpainting showing through an application of red or purple pastel can create wonderfully vibrant effects.

Sharper media contrasts can be achieved by starting with acrylic thinned to a watercolour consistency mode and drawing on top with pastel or oil pastel. In such cases it is probably best to relegate the pastel to a secondary role, using it perhaps only to define an area of pattern or enhance some detail.

However, the two media can also be used hand in hand. Both acrylic paint and acrylic matt or gloss MEDIUMS are excellent fixatives for pastel, so you can build up a painting by a layering method: applying some paint and pastel, then covering the pastel with medium or paint and laying on more. Wet paint or medium can cause the pastel colour to spread slightly, but this gives a watercolour effect at the edge of each stroke which can be very attractive.

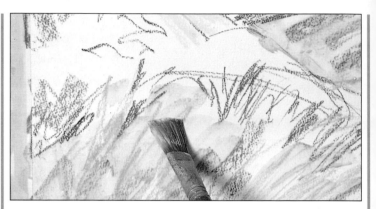

2 A transparent wash of water-thinned paint is brushed lightly over the pastel. Because the paint forms a plastic skin it fixes the pastel, allowing you to work on top with no risk of smudging.

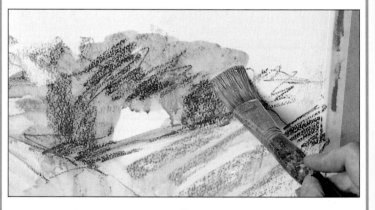

3 Further washes are now laid over the background area. The artist develops the two media together, so that the painting has a unity of technique from the outset.

4 At this stage the effect is similar to that given by the LINE AND WASH method, with paint of a watercolour consistency laid over the pastel marks.

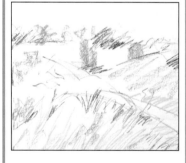

1 The composition is sketched out in soft pastel, using a combination of linear strokes and side strokes – those made with the side of a short length of pastel.

5 The artist continues to build up the painting with both paint and pastel. Because the watercolour paper has a slightly rough surface it breaks up the pastel marks to provide a BROKEN COLOUR effect.

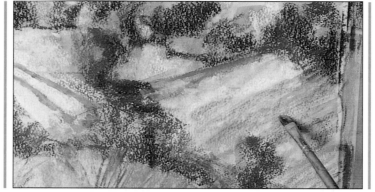

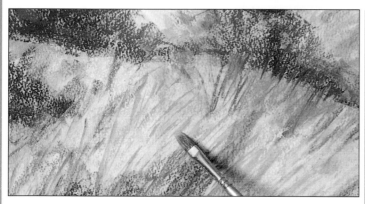

6 In the foreground, linear strokes made with the edge of a nylon brush complement the pastel marks.

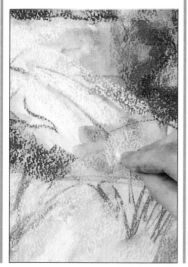

7 The side of the pastel stick is dragged lightly over dry paint, creating a subtle veil of colour. This area of the painting – the middle distance – requires a softer treatment than the foreground.

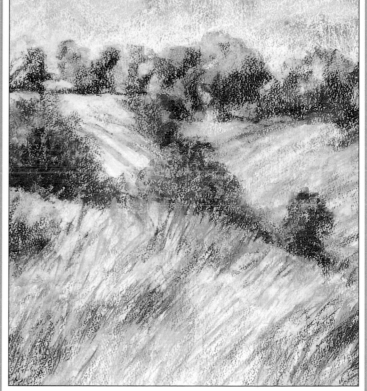

8 The finished painting is a good example of a successful "marriage" of media. Although there is a contrast of textures, no one area can be singled out as being either paint or pastel.

PENCIL AND ACRYLIC

Pencil can be used under washes of acrylic colour or on top of paint that is transparent or opaque (see OPAQUE TECHNIQUES and TRANSPARENT TECHNIQUES).

If you want a strong contrast between paint and line, try using pencil for one part of an image and paint for others. This device is sometimes used by illustrators, who deliberately exploit media contrasts and juxtapose areas of colour and monochrome in order to achieve an impact from the unexpected.

However, you need sure intentions and a degree of skill for this kind of work, so it is probably best initially to employ the two media in a more integrated way. If you are using transparent techniques, one of the problems inherent in acrylics can be turned to advantage. For watercolours and for watercolour effects in acrylic you need a good UNDERDRAWING. In actual watercolour work this can be erased after the first washes are in place, but this is not possible with acrylic, which acts as a fixative on the drawing. So try making the drawing a part of the picture from the start, laying colours over and around pencil lines and adding pencil as the picture takes shape.

Opaque paint will, of course, obscure your original drawing, but you can still use pencil on top. How much you use and in what way depends on the effect you want: you might reserve the pencil drawing for small areas of detail or pattern, or for parts of the picture which are easier to draw than to paint, such as flowers, stems, the edges of leaves, or facial features. A soft pencil is also excellent for shading to model forms, which can be tricky in acrylic because of the fast drying time.

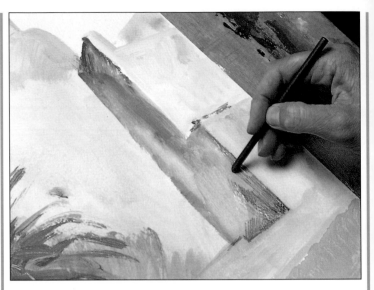

2 The artist begins to draw into the paint as soon as it is dry, using a graphite stick – a pencil without the usual wooden casing.

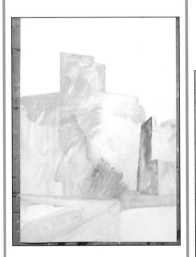

1 The shape of the building is blocked in with thin paint. A smooth-surfaced paper is used: less absorbent than watercolour paper, it doesn't even out the paint as much, allowing the brushstrokes to play a part in the composition.

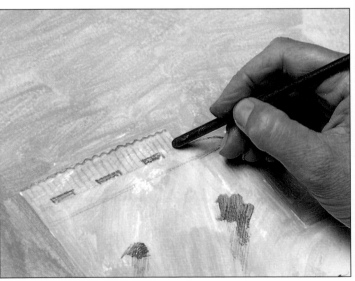

3 Having applied a loose blue wash for the sky, she now starts defining the details at the top of the tower. Graphite (or pencil) is excellent for this, and much quicker than working with paint and a small brush.

4 The shapes of the palm leaves have been built up with a combination of brushstrokes and graphite drawing. Now a small brush is used to pick out some highlights with pale blue-grey paint.

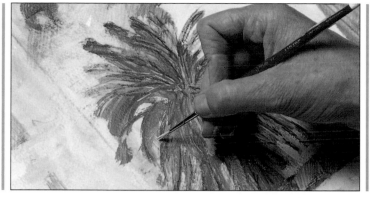

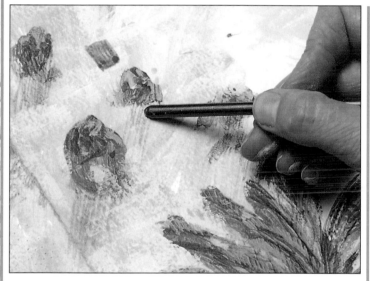

5 Touches of drawing suggest the rough stonework (on the left of this photograph) and the graphite stick comes into play again for the shadows below the small outgrowths of shrub.

6 In the final stages, more graphite drawing was done on the building, giving an accurate impression of the textures of the old plaster and stonework. The drawing, the light colours and the free brushwork in the sky all contribute to the atmosphere.

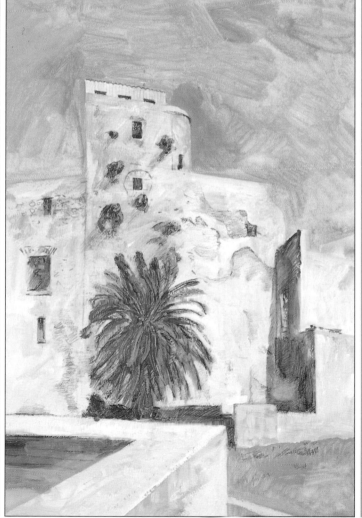

SCRAPING

Although a brush is the most natural implement for applying paint to the picture surface, it is by no means the only one. Paint can be squeezed on (see EXTRUDED PAINT), applied with the fingers, put on with a painting knife (see KNIFE PAINTING), and it can also be scraped onto the surface.

This method – which can be carried out with an improvised scraper such as a plastic ruler or half an old credit card, or with one of the metal-bladed tools sold for removing wallpaper – is allied to knife painting, but produces flatter layers of paint which cover the surface more thinly. It is thus ideal for layering techniques in which transparent paint is scraped over opaque or vice versa. You can also scrape lightly tinted acrylic MEDIUM over existing colour, producing a GLAZING effect which enriches the colour and gives it depth.

You can introduce variety by contrasting thinly scraped areas of paint with textured ones. Ridged patterns can be created with a notched plaster scraper. Or you could devise your own scraper by cutting notches in a piece of stiff board or plastic. The same method can be used for laying an under-texture modelling paste (see TEXTURING).

1 A plastic card is used to drag paint thinly across the surface. A metal paint scraper can also be used, but the flexibility of plastic makes it more sensitive. The working surface is a canvas board laid flat on a table and secured with tape.

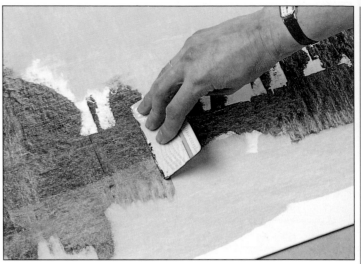

2 A darker colour is laid over the blue. Although the paint is at tube consistency coverage is thin enough to reveal the colour beneath, giving an effect almost like that of GLAZING.

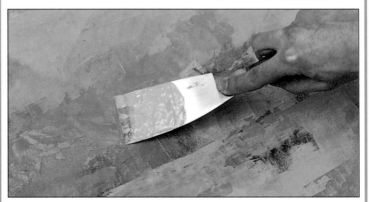

3 The greater rigidity of a paint scraper produces thicker, more irregular coverage, an effect which is now exploited to build up surface texture in places.

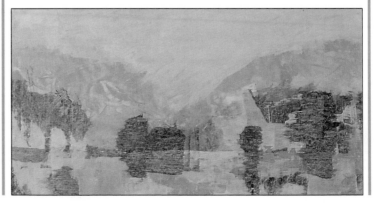

4 Here you can see the effect of the paint scraper (the areas of mountain above the trees at top left) and the transparent overlays of colour achieved with the plastic card.

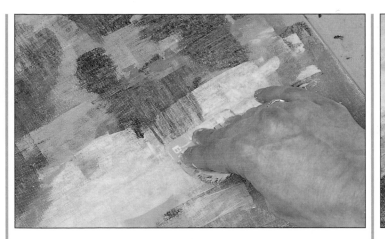

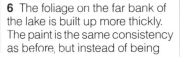

5 The card is pulled downwards to create a veil of colour which accurately suggests the reflections. The pigment used in this case is relatively transparent.

6 The foliage on the far bank of the lake is built up more thickly. The paint is the same consistency as before, but instead of being dragged across the surface it is applied in a series of short, interrupted strokes.

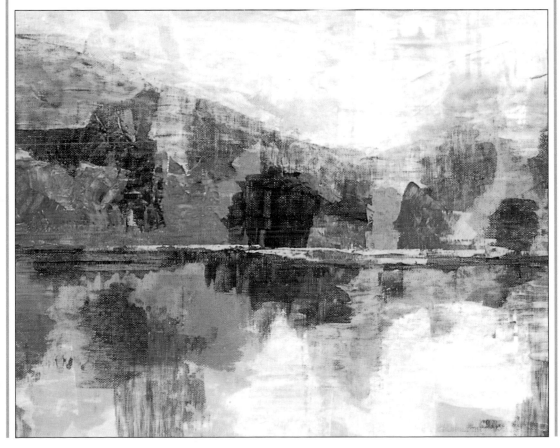

7 The finished painting shows a variety of effects which would be impossible to achieve with any conventional painting tool. Thin veils of colour contrast with discreet semi-impastos and lively edge qualities.

SCUMBLING

One of the many methods of achieving BROKEN COLOUR effects, scumbling involves scrubbing an uneven layer of paint over an existing colour. Scumbling is much used by oil painters, but since the underlying layer must be completely dry before the scumbled paint is applied, the method is even better suited to fast-drying acrylic. Indeed it is such a natural way of working in acrylic that artists will sometimes be unaware that what they are doing constitutes a "technique".

Whether you choose to scumble a contrasting colour or a similar one depends on the effect you are seeking. You might, for example, scumble several subtle colours over a base coat of mid-grey to suggest the texture of a stone wall, or you might enrich a vivid colour, such as a deep, bright blue, by scumbling over it with shades of violet or lighter blue.

The most important thing to remember is that you should not cover the colour beneath completely, so the paint is usually applied with a light scrubbing action – using a stiff brush, a rag or even your fingers. If you are working on canvas or canvas board, the grain will help you, because the paint will be deposited only on the top of the weave, but scumbling can also be done quite effectively on a smooth surface such as primed hardboard (see SUPPORTS).

Generally the paint is used fairly thick, but you can scumble with water-thinned paint provided you follow the DRY BRUSH procedure and squeeze most of the paint out of the brush (scumbling and dry brush are closely related methods). You can also make semi-transparent scumbles by mixing the paint with gloss or matt MEDIUM.

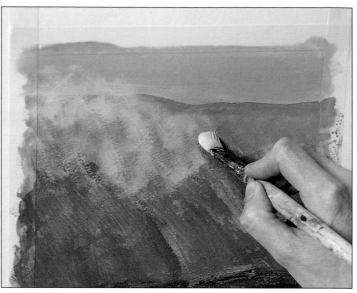

2 Using a bristle brush, the artist dabs and scrubs light, opaque paint over the darker colour, only partially covering it.

1 An underpainting of relatively flat colour provides a foundation for a painting to be built up through successive layers of scumbled colour. The surface used is watercolour paper, the texture of which helps to break up the colour.

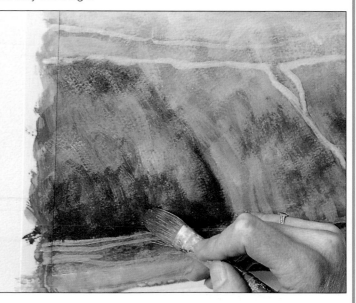

3 After the first layer of scumbling at the top of the picture, the composition has been defined with lines of light-coloured paint. In the foreground, dark red-brown is scumbled over the green.

4 Scumbling is an imprecise method, impossible to restrict to a small area, so before turning her attention to the sky, the artist has protected the area by covering it with tape.

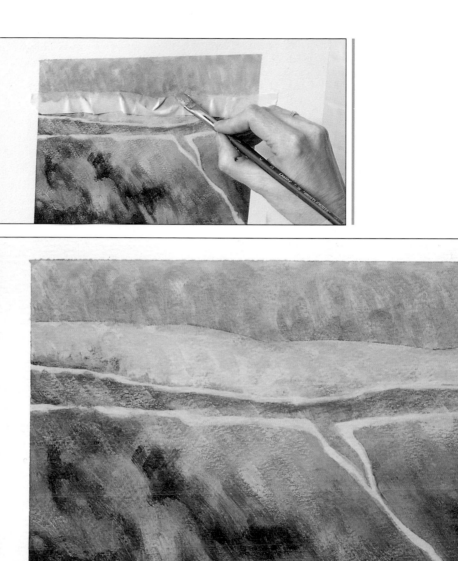

5 The tape is removed to leave a crisp edge. Masking is extremely useful for techniques such as scumbling and SPATTERING.

6 Masking tape was also used to protect the margins of the paper. This results in a perfectly defined straight edge which complements the edge qualities in the painting and contrasts with the soft broken-colour effects of the scumbling method.

SGRAFFITO

Sgraffito (from the Italian *graffiare,* to scratch) means scoring into the paint to reveal either the white of the canvas or board, or another colour below. Sgraffito is another technique borrowed from oil painting. It is slightly trickier with acrylics because they dry faster, and the paint must remain wet long enough for the scratched pattern to be made. However, if you use reasonably thick paint, or mix it with retarding MEDIUM, you should have no problems. (It is, in fact, possible to scratch into dry paint, but it is not advisable as you could damage the working surface).

The method is particularly suitable for creating areas of pattern and texture. Rembrandt (1606-69) used it in his portraits to describe items of clothing, such as a sitter's lace collar, and in at least one of his self-portraits the moustache is created by drawing into thick, wet paint with a brush handle.

You can make a variety of lines, depending on the implement you use and the consistency of the paint. If you scratch into a fairly thin top layer which has been allowed to dry slightly, using a sharp implement such as a scalpel or the tip of a triangular painting knife, the lines will be fine and crisp. Scoring into thick, wet paint with a blunter implement will yield less precise lines with ridges of paint on either side of them. This can be effective for detail and texture, for example, you might use the method to describe the bark of a tree, hair, or the pattern of bricks on a wall.

2 When painting the blue background she deliberately leaves a little of the red showing between brushstrokes. She will reinforce this colour contrast by scratching into the blue later.

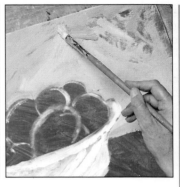

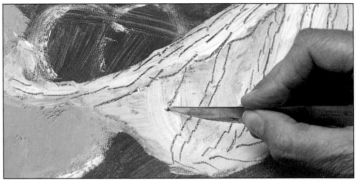

3 She has used retarding medium, so the paint is still sufficiently wet to be removed with the point of a knife. If it becomes too dry, harder pressure has to be applied, and this can remove the first layer of paint as well as the second.

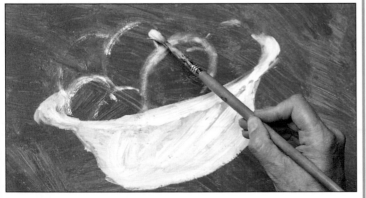

1 Paint can be scratched into to reveal the white surface, but in this case the artist intends to scratch back to another colour. She therefore lays a red ground all over the canvas board before painting the fruit and basket.

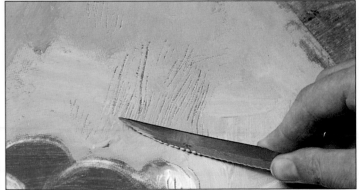

4 Both the point and the serrated edge of the knife are used to create a variety of lines in the blue background. These are echoed by the small areas of red left uncovered by the blue in the first stages of the painting.

5 With the fruit now painted, the point of the knife was used to pick out dots of red on the lemon. A light glaze was laid to create the shadow on the left side of the basket, and now the pattern is built up with further knife scratching.

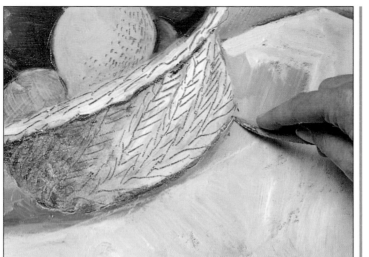

6 To echo the reds elsewhere in the painting and create foreground interest, the tablecloth is also scratched into with the knife.

7 The effect of the painting relies partly on the colour scheme, which has been well chosen to provide blue/red contrasts in each area. The red sgraffito into blue balances the bright colours of the fruit as well as giving extra impact to the scratched lines.

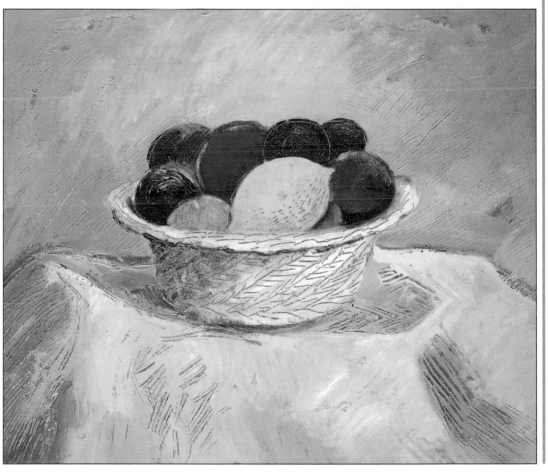

SPATTERING

Spraying or flicking paint onto the picture surface is an excellent way of suggesting certain textures, and may also be used to enliven an area of flat colour – perhaps in the background of a still life.

Watercolour landscape painters sometimes use spattered paint to convey the crumbly appearance of cliffs and sandy beaches, or spatter opaque white paint to describe the fine spray of a breaking wave. Spattering has obvious applications for TRANSPARENT TECHNIQUES, but there is no reason why it should not be adapted to OPAQUE TECHNIQUES. You might, for example, contrast an area of thinly spattered paint with one more evenly and heavily applied, or spatter a thin layer of colour over a thicker base.

An old toothbrush is the implement most commonly used for spattering. You can also use a bristle brush, which makes a coarser spatter with larger droplets of paint. Or, for a really fine spatter over a large area, use a plant spray or a spray diffuser of the type sold for use with fixative. In this case you would need to mask any areas of the work which are to remain free of sprayed paint (see MASKING).

Whichever method you use,

it is important to remember that spattered paint frequently lands in the wrong place – on your clothes, the floor and walls, and your work table – so it is essential to protect all vulnerable surfaces. Remember that acrylic is difficult or impossible to remove once dry.

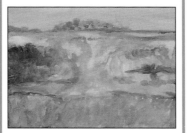

1 The landscape is blocked in simply, with little detail in the foreground, as this will be built up with spattered paint.

2 A piece of newspaper is placed over the areas to be kept free of spatter, and more elaborate masks, made from torn strips of newspaper, are positioned. Red paint is then flicked on, using the side of a large brush, which produces a coarse spatter with quite large droplets of paint.

3 The effect can be softened by blotting with newspaper or other absorbent paper. In this case it also produces variations in size, as the paper spreads out the wetter droplets.

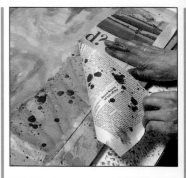

4 The bush in the middle distance is next to be spattered, again after masks have been placed around the area. Because the bush is further away, the spatter needs to be less obtrusive, so a toothbrush is used, which releases finer particles than a paintbrush. Load it with paint that is well thinned, but not too watery and quickly draw your thumb across the bristles.

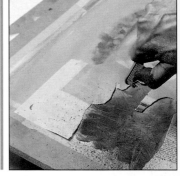

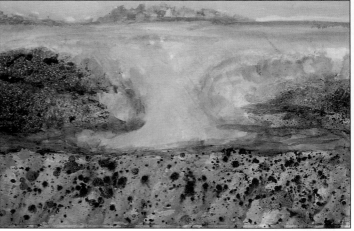

5 As a final touch, the bush was spattered again with light yellow-green and again blotted with paper to merge the drops. The layers of light brown and bright red spatter in the foreground suggest flowers and grass very effectively.

STENCILLING

Stencilling is a MASKING technique, in which paint is applied to certain areas of the image while being barred from others. At its simplest, it involves no more than cutting a shape out of a piece of thin card, acetate film or waxed stencil paper, placing this sheet on the working surface and pushing paint through the "hole". The method is often used for applying decorations to pieces of furniture or walls, and it has interesting possibilities for painting,

particularly for any work that emphasizes flat pattern or the combination of pattern and texture.

The stencil should be relatively simple – a stylized flower or leaf, for example, or one or two geometric shapes. You can repeat the stencilled shape as often as you like, perhaps varying the direction.

Paint of medium consistency is best applied with a sponge or stencil brush. (Don't use very watery paint or it may seep under the edges of the stencil.) For a raised, textured effect, use a painting knife or try the SCRAPING technique, laying out paint straight from the tube on the edges of the stencil and pulling it across. You can thicken the paint with a bulking or texturing MEDIUM. For thick-paint methods, the stencil must be removed carefully before the paint has begun to form a skin, or it will stick at the edges.

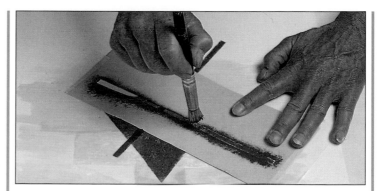

3 A third stencil, used first in one direction and then the other, gives two fine lines of red. This colour is opaque, and will cover the blue more strongly than either the yellow or the gold.

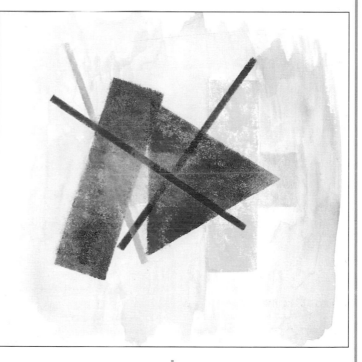

1 A shape was cut from waxed stencil paper, and colour is pushed onto the paper with a stencil brush. The stencil paper is held firmly with one hand to prevent it slipping.

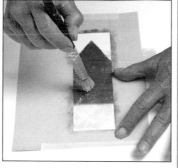

2 A new stencil has been cut and a band of yellow laid over the blue. The stencil is now turned around, and a further band of iridescent gold laid down. This only partially covers the other colours, because of its transparency.

4 One further line of yellow was added to balance the reds, and a light wash was laid over the background. The stencil brush produces a pleasing texture, and the pressure can be varied to create different effects, from solid applications to thin veils of colour.

SUPPORTS

Support is the term for the surface on which you paint, whether it be canvas, board, paper, a wooden panel, or a sheet of plastic, metal or glass (see MONOPRINTING). The beauty of acrylics is that you can work on any surface as long as it is not greasy – because acrylics are water-based they are incompatible with oil – so you are almost bound to have a suitable support to hand.

Paper
If you paint thinly, using a lot of water, watercolour paper is the best choice. Machine-made watercolour paper comes in three textures; smooth (called HP for hot-pressed), medium (called Not for not hot-pressed) and rough. Not paper is most often used for watercolour and thin acrylic, though you may find you prefer smooth. Rough can be slightly hard to handle.

There are also different weights of paper, expressed as the weight per ream, and ranging from 70lb to 300lb. The former is quite thin, and will need stretching before use, or it will buckle under the wet paint. In general, it is wise to stretch any paper lighter than 200lb if you intend to use the paints like watercolour.

For middle-thickness paint, good-quality cartridge paper makes an excellent and inexpensive surface. Either this or smooth watercolour paper is also the best choice for mixed-media work such as CHARCOAL AND ACRYLIC, INK AND ACRYLIC and LINE AND WASH. A Not surface is preferable for PASTEL AND ACRYLIC, because the rougher texture holds the pastel better.

For watercolour effects, the paper needs no preliminary sealing (see GROUNDS), but for thicker applications a ground can be put on first.

Canvas and canvas board
If you have previously worked in oils and wish to use acrylics in much the same way, you may want to work on traditional oil-painting surfaces. Nowadays, most canvases and painting boards sold in art shops are primed with an acrylic base suitable for both oils and acrylics.

If you want to stretch your own canvas – which is an economy as well as allowing you to choose the canvas you like – you can buy unprimed canvas by the metre from most large art suppliers. In fact, you can use virtually any cotton fabric, so it is worth saving old sheets, which make excellent painting surfaces.

You can either use stretchers or stick the canvas down on board – hardboard, thick cardboard or plywood – with acrylic MEDIUM, which is a strong adhesive. Whichever method you choose, you can seal the raw canvas with a further coat of acrylic medium, which retains the natural colour of the fabric, or prime it with acrylic gesso (see COLOURED GROUNDS and GROUNDS).

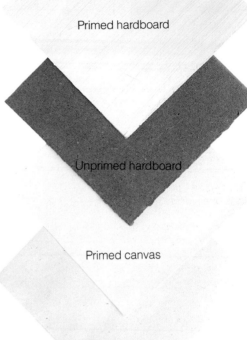

Primed hardboard

Unprimed hardboard

Primed canvas

Unprimed canvas

Watercolour paper

Hardboard
Artists who like to paint on a smooth surface – usually those who achieve their effects through a series of thin applications and GLAZING techniques – often paint on the smooth side of hardboard, or on a smooth wood panel. These surfaces can be sealed with acrylic MEDIUM or be given a white coat of acrylic gesso. White grounds are particularly suited to glazing methods, reflecting light back through the applied colours to endow them with a luminous quality.

Stretching paper

Use pencil and ruler to mark lines approximately half an inch from all the edges. Soak the paper until both sides have absorbed the water. Lift out carefully. Drain excess water and place the paper on the board. Run a length of gumstrip over a wet sponge and place the strip along one long edge of the paper. Smooth with your fingers. Glue the short sides last. Leave to dry undisturbed.

Rule lines

Soak paper

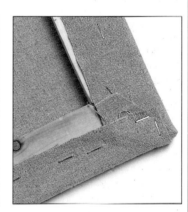

Apply gumstrip

Stretching canvas

Assemble stretchers. Cut canvas to size, allowing for a turnover. Staple or tack one side in the middle, then the middle of the opposite side and finally the other two sides. Pull canvas taut, taking care not to distort it. Working from the centres, staple to each corner. Fold corners over. Fix with two staples facing opposite directions. Insert corner wedges. Hammer gently to tighten canvas.

Cut canvas to size

Staple sides

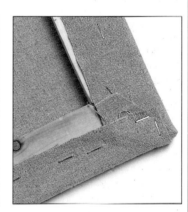

Fold and staple corners

Gluing canvas to board

Cut the canvas to size, allowing at least 2.5cm (1in) turnover. Cover smooth side of hardboard with acrylic medium or PVA glue – the latter is best for heavy canvas. Place glue side down on the canvas. Apply more medium to the edge of the canvas. Turn board right side up and smooth canvas down. Turn again and stick turnover down. You may need more adhesive at this stage if the canvas is heavy.

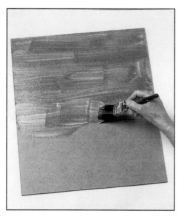

Apply medium or PVA glue

Stick turnover down

TEXTURING

Acrylic excels in the area of texture – there is almost nothing you cannot do with it. Textured effects can be created with the paint itself, by IMPASTO techniques, KNIFE PAINTING, SCRAPING TECHNIQUES and EXTRUDED PAINT, to name but a few. You can also mix the paint with other materials, such as sand, sawdust or one of the texturing MEDIUMS, or you can apply textures and paint over them.

Acrylic modelling paste, which is specially made for underlying textures – though it can also be mixed with the paint – can be applied to the painting surface in any way you choose, but you must use it on a rigid surface; if applied to canvas it will crack. You can create rough, random textures by putting the paste on with a palette knife. You can comb it on to make straight or wavy lines, or dab it on with a rag or stiff brush. And you can make regular or scattered patterns by imprinting: spreading the area with modelling paste and pressing objects into it while it is still wet.

Overall imprints can be produced with crumpled foil or a stiff brush, or you could achieve recognizable patterns with a flat embossed item, such as a coin.

In general, texture should be used creatively rather than literally, so these methods are better suited to work with a decorative or semi-abstract quality than to representational painting. Trying to mimic texture in a seen subject does not always work well, though you might use texturing in an urban scene, for example, to suggest rough stone walls or brickwork.

The underlying texture method is usually most successful when the paint is applied in thin glazes (see GLAZING) – opaque paint over texture can look lifeless. However, there are no real rules in painting, and it is up to you to discover what works best.

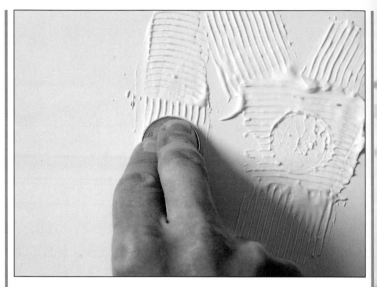

2 Next he presses a coin into the surface to make an imprint. Modelling paste will remain wet enough for such methods for some time if used thickly.

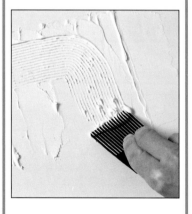

1 Working on heavy white board, the artist spreads acrylic modelling paste, first with a palette knife and now with a steel comb of the type made for texturing plaster.

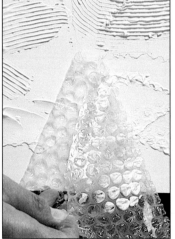

3 Bubble wrapping also produces an interesting imprint. Each area of texture is kept separate, providing what is in effect a series of individual motifs.

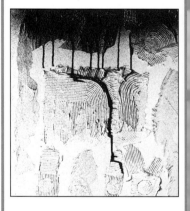

4 When all the motifs had been placed and textured, the whole picture area was sprayed with red "liquid acrylic" ink, using a mouth diffuser. Thinned paint of the same red is now laid in a thick band at the top and allowed to dribble down the surface.

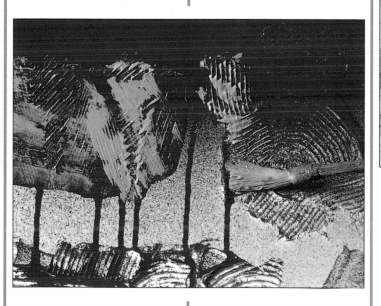

5 After the paint had begun to settle in and around the troughs of the textured areas, the flow was arrested with a hairdryer.

6 Thicker blue paint is now dragged lightly over the red. Notice that in the more heavily textured areas the colour catches only on the ridges.

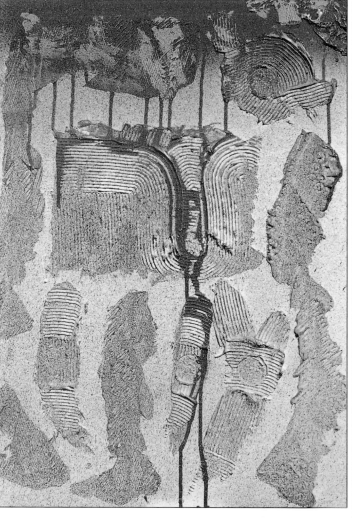

7 The final stage – and one that has completely transformed the painting – was to spray yellow liquid acrylic over the entire picture surface. In terms of colour mixing, the effect is similar to an overall glaze of colour, the yellow mixing with the red and blue to produce orange and a subtle green-blue.

TRANSPARENT TECHNIQUES

As has been mentioned earlier, acrylic can be used like watercolour, with the picture built up from a series of thin washes of colour. The advantage of acrylic over watercolour is that the former is non-soluble when dry, allowing you to superimpose any number of washes – watercolour remains water-soluble, so you can muddy the colours by applying too many layers.

But there are things you can do in watercolour that you can't do in acrylic. For example, you can't move acrylic paint around on the surface, or lift out and wash down areas of colour, nor can you always rely on achieving the translucent effects typical of watercolour unless you restrict yourself to the transparent pigments (see COLOUR MIXING).

For transparent techniques on paper, the best surface is watercolour paper (see SUPPORTS), stretched if necessary. But these methods are not restricted to works on paper; lovely effects can be achieved by using transparent overlays of colour on canvas.

The American abstract painter Morris Louis (1912-62), worked on raw (unprimed) canvas, using thin, transparent washes to build up overlapping shapes in brilliant, translucent colours, and similar techniques can be used for representational work.

Louis and others among the group of artists who first espoused the new medium welcomed the fact that acrylic colour could be laid directly on unprimed canvas (dangerous in oil painting because the oil can eventually rot the fabric). The slight absorbency causes the paint to spread a little, creating soft edges and gently diffused colours which retain their brilliance. However, this is only one type of transparent technique on canvas; it can be equally effective on a white GROUND, with the colours applied in successive layers of GLAZING.

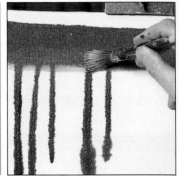

1 The primed canvas has been damped all over with a solution of warm water and washing-up liquid, which helps to spread the colour and gives a soft-edged effect. Colour is spread at the top of the upright canvas and allowed to run down.

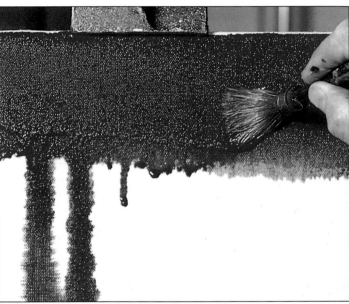

2 A further application of colour blends with the first and creates more runs and dribbles.

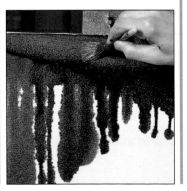

3 The pattern of dribbled colour is built up and strengthened with a dark purple. A soft brush is used to lift out some of this colour, creating bands of light and dark.

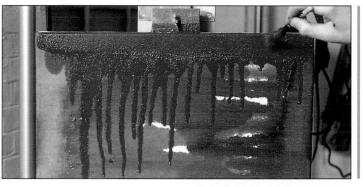

4 The canvas is now turned the other way up, and colour is applied at the top in the same way as before but rather more thickly; in this case the artist wants the paint to run right down the canvas.

6 The canvas is turned again, and a new colour is applied and allowed to run. The edge which is at the top at this stage is actually the bottom of the painting.

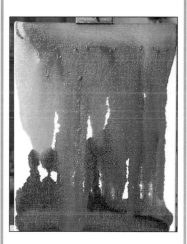

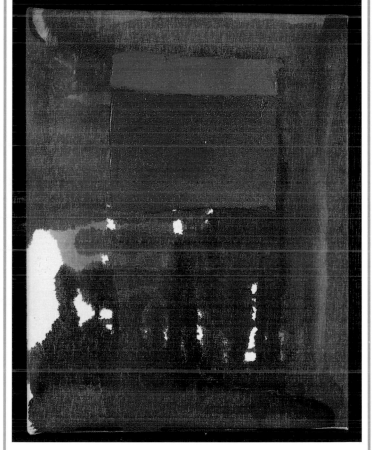

5 Because this photograph was taken when the paint was still wet, the new colours obscure the original purples and reds, but when the paint dries it becomes more transparent, as you can see in the finished painting 8.

7 In order to set up a contrast which will stress the transparency of the paint, an area of thick, opaque colour is now laid on with a painting knife (see KNIFE PAINTING).

8 Thick, opaque paint always has the effect of advancing towards the front of the picture plane, while thin, transparent paint recedes. You can see this effect very clearly in the completed painting, where the rectangle of knife-applied paint seems almost to float above the thin colours.

UNDERDRAWING

It is not essential to draw before you paint. Some artists will content themselves with a few pencil lines or marks drawn with a brush to give the main placings of the subject. However, unless you are very experienced and know exactly how you are going to organize your composition, it is wise to draw first, particularly if your subject is at all complicated or involves hard-to-draw elements such as figures.

If you are using OPAQUE TECHNIQUES the paint will completely cover your drawing, so you can draw in whatever medium you like – pencil, charcoal, or a brush and thinned paint. Charcoal may be best avoided if you intend to start with pale colours, as it can muddy them slightly – some artists like this effect, while others prefer to keep the colours pure from the outset.

TRANSPARENT TECHNIQUES need more planning. You can't paint over mistakes without losing the transparency, so you must have a good drawing. Heavy lines, though, may show through the washes, particularly in very light areas. This may not matter, because pencil lines can combine well with watercolour effects (see PENCIL AND ACRYLIC), but it could be crucial. For example, if you are painting a seascape and have drawn a horizon line which you later decide to lower, you will have a pencil line showing through an area of sky. You can't erase it, as the plastic coat formed by the paint will have sealed it in place. So keep the lines as light as possible, avoid shading, and don't start to paint until you are sure the drawing is correct.

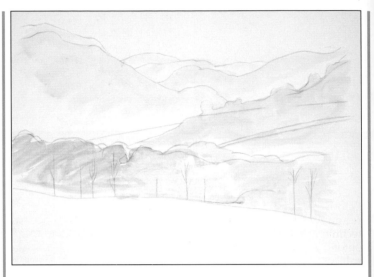

2 If a stronger drawing is needed, light washes can be laid over the pencil drawing in the areas which are to be darker in the painting.

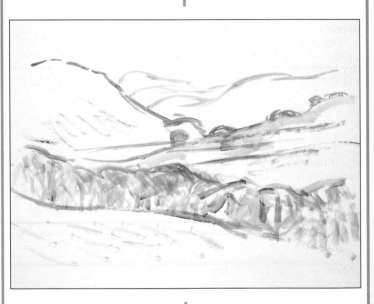

1 A light pencil drawing like this is best for transparent watercolour-style applications.

3 For more opaque techniques and bolder treatments, a brush drawing is the commonest method. If any lines threaten to show through, they can be overpainted in white.

UNDERPAINTING

Before the Impressionists revolutionized oil painting techniques by working outdoors directly from the subject, the usual practice was to paint in the studio from sketches and preliminary studies. Paintings were built up in layers, starting with a tonal underpainting – usually brown – which established the whole composition and all the modelling of forms. Colour was applied in the final stages.

With oils this is a laborious process, as each layer must be dry before the next is applied, but fast-drying acrylic is ideal for such techniques. Some oil painters work over an acrylic underpainting (see OIL AND ACRYLIC), and some acrylic painters have revived traditional oil techniques by building up a whole picture in thin layers of GLAZING over an underpainting.

The method is only suited to studio work, but for any large or complex composition, such as a figure group or highly organized still life, it can be more useful than UNDERDRAWING, because it allows you to work out the main light and dark areas.

Sometimes areas of the underpainting are allowed to show through in the finished work, so the colour must be chosen carefully, as with a COLOURED GROUND. You can make a monochrome underpainting in shades of one colour to contrast or tone with the overall colour scheme, or one in shades of grey (see MONOCHROME TECHNIQUES). However, in the latter case, if you intend to apply the colours thinly you run the risk of losing colour purity. This could work very well for a low-key colour scheme, however.

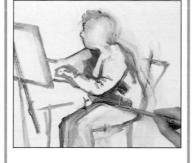

1 For a painting which is to have a strong tonal structure, an underpainting in black, white and grey can be very successful. The artist begins with a brush drawing.

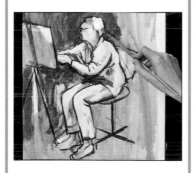

2 The figure is built up in light grey overlaid with thicker applications of white, which will allow for glazes of light and bright colour

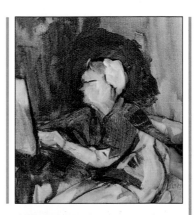

3 The heavy brushstrokes of white show through the transparent red glaze to model the forms. There is little point in making an underpainting unless it plays a part in the finished image.

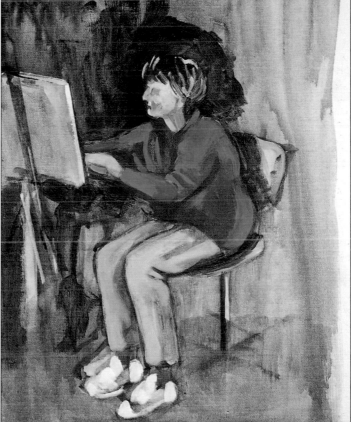

4 The top colours have been applied thinly everywhere; the modelling on the legs was also achieved by letting the thick white underpainting show through the watery blue-grey paint.

WAX RESIST

This is a technique which relies on the incompatibility of oil and water. Like MASKING AND STENCILLING, it blocks the paint from certain areas of the picture, but the effects it creates are quite different.

The basic method is simplicity itself: a candle or any waxy crayon is used to scribble over clean paper and a wash of water-thinned acrylic is laid on top. The paint slides off the waxed areas, leaving a slightly speckled area of white.

Watercolour painters often use the technique to suggest clouds, waves or ripples in water, or the textures of cliffs and stone walls, but it has many other possibilities, and is particularly good for mixed-media work, such as INK AND ACRYLIC.

You are not limited to white candle or crayon; you can use coloured wax-oil pastels, or the newer oil bars, which are excellent for wax resist, making a drawing in several colours which is then overlaid with a contrasting colour of paint. You can even build up a whole picture by means of a layering technique, scraping or scratching into the wax before putting on more paint (or perhaps ink), then adding further wax and so on. If you try this, work on tough paper or

you may damage the surface. And remember to keep the paint well-thinned – if it is too opaque it may cover the wax completely.

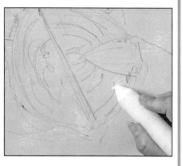

1 Watercolour paper was tinted with coloured gesso, which provides a slight texture as well as reducing the glare of white paper. A pencil drawing was then made as a guide, and wax applied lightly to the top of the cabbage.

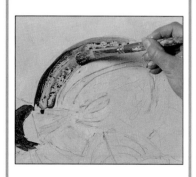

2 The thin, watered paint slides off the wax. Thick paint is less suitable for this method, as the tough plastic skin formed by opaque acrylic can cover the wax completely.

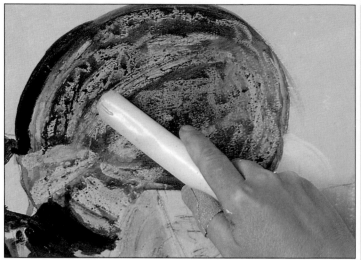

3 Further drawing is done with the sharpened end of a household candle. The coloured ground helps the artist to see where she is putting the wax; this can be rather a hit-and-miss affair on white paper.

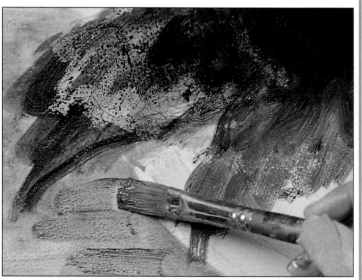

4 Another application of paint builds up the texture, with the paint creating a series of tiny dots, blobs and dribbles as it slips off the wax and settles in the non-waxed areas.

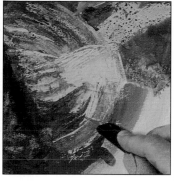

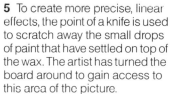

5 To create more precise, linear effects, the point of a knife is used to scratch away the small drops of paint that have settled on top of the wax. The artist has turned the board around to gain access to this area of the picture.

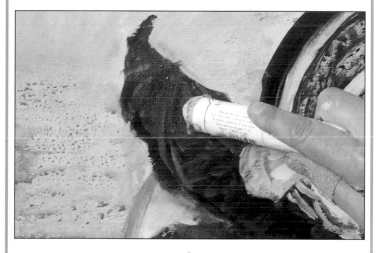

6 A white oil bar is now used to draw over the paint, giving more definition to the cabbage leaf, which was previously rather amorphous. The bar has also been used to reinforce the drawing in the centre of the cabbage.

7 Further finishing touches are made with green oil pastel. You can also use oil pastels under the paint, but they are less effective for resist than candle wax or oil bars.

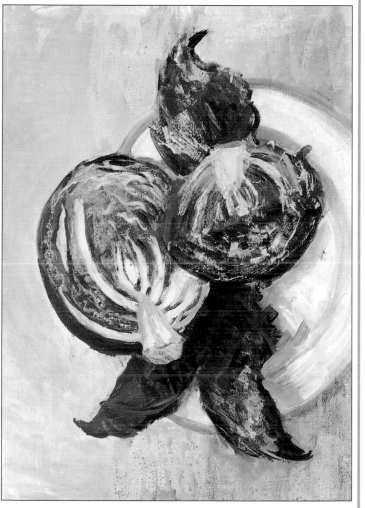

8 The finished picture shows a lively combination of pattern and texture. The oil bar, which has been used both on the cabbage and the plate, gives a painterly quality to the image.

WATERCOLOUR AND ACRYLIC

We have already seen some of the advantages and disadvantages of using acrylic as a substitute for watercolour (see TRANSPARENT TECHNIQUES). Acrylic can also be used hand-in-hand with watercolour, which is perhaps a more satisfactory way of working, as it allows you to use both media to best advantage.

Watercolour painters often use a touch of "body colour" (opaque paint) here and there, perhaps to sharpen a foreground, to add white highlights, or simply to correct a mistake. Usually gouache paint is used, or Chinese white mixed with watercolour, but acrylic is a better choice than either of these, as it does not give such a matt, dead surface.

Paintings which are officially classified as watercolour frequently include acrylic, and if the acrylic is used skilfully it is often impossible to tell which is which. The trick is to reserve the pure watercolour for any areas that need its particular translucent quality, and to use the acrylic fairly thinly – it should be capable of covering colours below, but should not stand out from the surface. In a landscape with grass and trees in the foreground, for example, you would use pure watercolour for the sky and the far distance, and acrylic – either on its own or over watercolour washes – for the foreground and perhaps any areas of texture in the middle distance, such as a wall or group of houses.

Because the slightly thicker paint has more physical presence than the thin watercolour, it will tend to "come forward" to the front of the picture. This allows you not only to describe foreground detail and texture (always difficult in watercolour) but also to accentuate the sense of space.

Hazel Harrison
View Over Ullswater

This painting was planned and begun as watercolour, and had reached an advanced stage before it became apparent that things were going wrong, particularly with the foreground and the tree on the right. Rather than abandon it, the artist decided to carry out a rescue operation with acrylic, thinned with both water and matt medium to reduce its opacity.

Acrylic was used only for the problem areas of foreground and tree, both of which lacked definition. The effect is very similar to that of watercolour thickened with white gouache, but the artist is accustomed to working in acrylic and finds it easier to handle.

WET INTO WET

When a new colour is applied before the first one has dried, the two will blend together without hard edges. This wet-into-wet technique is used in both oil and watercolour painting, and hence for both OPAQUE TECHNIQUES and TRANSPARENT TECHNIQUES in acrylic.

One of the objections sometimes raised against acrylics is that it isn't possible to work wet into wet. It is – but it is slightly trickier than with traditional paints.

In oil painting, the wet-into-wet technique was much used by the Impressionists, notably Claude Monet (1840 1926), who painted landscapes on the spot at great speed, often laying one colour over another so that they mixed on the picture surface. Thick acrylics can also be used in this way, but unless you work very fast or use the paint very thick indeed, you will need to mix the colours with retarding MEDIUM.

Watercolour wet-into-wet effects can be achieved, as in watercolour itself, by working on damped paper. As long as the paper stays damp so will the paint, so if it begins to dry before you have completed an area, simply spray it over with a plant spray – these are useful in acrylic work as you can keep the paints wet on your PALETTE by occasional spraying.

You may also find it helpful to use a water-tension breaker, which improves the flow of the paint. This can either be mixed into the water you use for thinning the paint or washed over the painting surface itself. Retarder is no use for water-thinned paint; it is made for opaque techniques only.

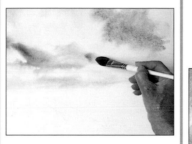

1 Working on well-damped watercolour paper and using the paint as watercolour, that is, unmixed with white, the artist drops one colour into another. As she works she changes the angle of the board to inhibit or encourage the flow of the paint.

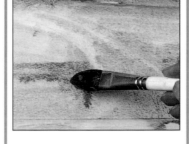

2 Before laying washes for the ground area, the paper was dried with a hairdryer to prevent the colours for land and sky merging. The paper was then damped again and further wet-into-wet painting carried out in the foreground.

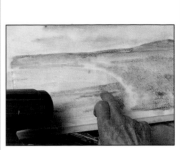

3 The wet paint is now rubbed with a finger to create smeared lines. As long as the paper remains wet, the paint can be manipulated in a variety of ways. The hairdryer is kept on hand to be used when it is necessary to arrest the flow of paint.

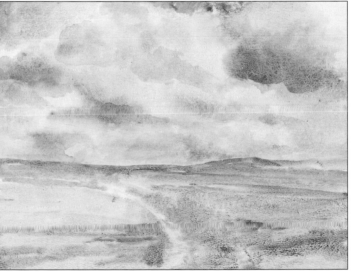

4 Some further work was done on the foreground, and then selected parts of the sky were damped again to allow the colours of the clouds to be strengthened. Notice the granular effect particularly obvious in the sky. Acrylic used with water alone is prone to "break up" in this way, though the effect also occurs with some watercolour pigments, and is often encouraged by watercolourists.

THEMES

Although techniques can be fascinating to read about and enjoyable to try out, the true potential of any medium is only realized through personal experiment and in relation to a specific subject area. The gallery of paintings shown in this part of the book, chosen to illustrate a wide variety of styles and approaches, show how each artist has adapted the range of possible techniques to interpret their own ideas. All the pictures are analysed in detail, and the captions cross-refer to the techniques section wherever relevant so that the two sections together form a comprehensive guide to the versatility of the acrylic medium.

Five main themes have been chosen – landscape, buildings, the figure, animals, and abstraction and fantasy – and each is accompanied by a step-by-step demonstration in which you can follow an artist's progress through all the stages of a painting. Looking at the work of other artists is an essential part of the learning process, and if you find you are more sympathetic to some ideas and approaches than others you will be on your way to developing your own style and way of working.

LANDSCAPE

Because acrylic presents such a wide range of technical choices, it is well suited to all subjects. For landscapes in particular, you can tailor the medium and your working method to your needs, perhaps working on a relatively small scale on paper for outdoor paintings and sketches, and choosing a larger format and a more considered use of techniques for indoor work.

Sketching The one serious disadvantage of acrylic for outdoor work is its rapid drying speed, but this can be overcome by using the special palette shown on page 57, which will keep your paint damp for as long as you want. Apart from this all you require is the basic equipment used for any location work – paints, brushes, a working surface, a portable easel, and last but not least, water. You will need a good deal of the latter, as acrylic clings to brush hairs. Unless you wash the brushes regularly you may spoil them, as well as polluting the colours.

Composing When you are working direct from the subject, the amount of time and thought you devote to the planning stages depends on how you view what you are doing. If you are making a painting that is intended to stand in its own right as a finished work, you must naturally give due consideration to the composition, deciding on your viewpoint, how much of the subject you will include, where to place the horizon, how to deal with the foreground, and so on. Because it is so easy to correct acrylics by overpainting, however, you can to some extent let the composition emerge gradually, whereas a painting in watercolour requires a good foundation of underdrawing to avoid failure.

If you are making sketches to use as reference for a studio work you can often take a less deliberate approach, because you will be carrying out the major planning at a later stage. However, such sketches won't help you if you simply make them at random. You need to have a good idea of the general character and structure of the finished painting when you are sketching, as otherwise you will find that you have not given yourself sufficient visual information.

Techniques Some landscape painters always work direct from the subject, whereas others base their paintings on a combination of sketches and photographs. The latter procedure, while being less immediate and spontaneous, is better suited to any work in which you intend to exploit the variety of techniques associated with acrylic. A collage, for example, requires not only a selection of additional materials but a degree of forethought and planning best suited to studio work.

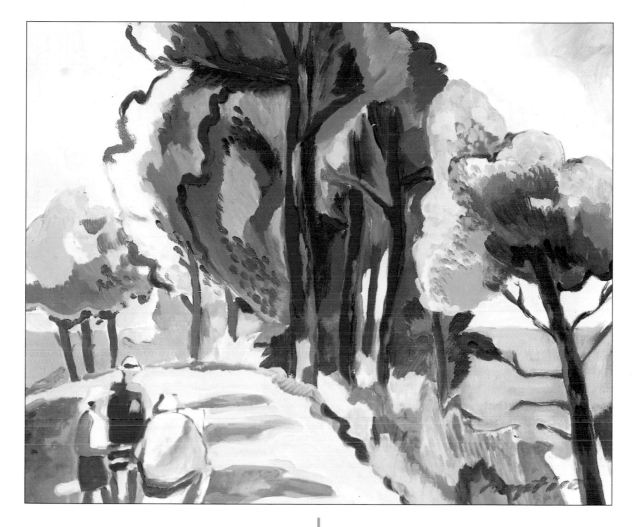

◄ David Alexander
Tree One

Brushwork plays a vital role in this painting, done on canvas with acrylic thickened with gel medium. In addition to bristle brushes, the artist uses a variety of unconventional painting implements, including hardened brushes, sponges and scrapers.

▲ Gerry Baptist
Stone Pines Near St Tropez

A wonderful evocation of the hot colours of a Mediterranean landscape has been achieved by keying up all the colours and exploiting complementary juxtapositions – notice the purple shadows on the yellow road. The trees, although simplified and not treated in a strictly naturalistic way, have been carefully observed, as has the group of figures in the foreground. The painting is on canvas board, with the paint used fairly thinly and the darker colours built up with glazes, scumbles and overlaid brushstrokes.

WEATHER

Landscape and weather conditions are inseparable. The extent to which the sky – and hence the weather – dictates the appearance of the landscape can be observed on any squally day, when rain replaces sun to alter the whole colour scheme and tonal balance of the scene. In many cases, weather can even be the primary subject of the painting, as it is in Peter Burman's *River Deben, Suffolk*, where the composition relies on the patterns and light/dark masses made by the clouds and gleams of sunshine.

Effects like these are wonderful to paint, but also difficult, as they are so transitory. You can sometimes recreate them from photographs, but it is wise to get into the habit of making small on-the-spot sketches as well. Even a pencil sketch with some written colour notes can be more valuable than photographs, which are often unreliable in terms of colour.

The changing seasons, too, affect the look of the landscape, even when the weather is technically the same – that is, sunny or overcast.

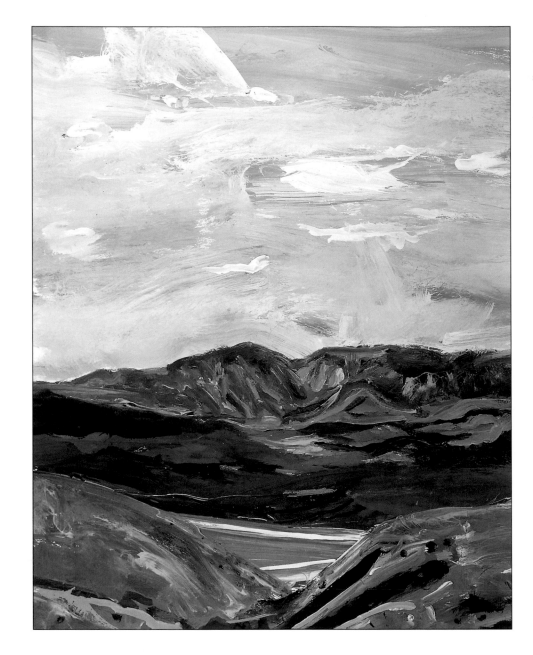

◄ ► William E Shumway
View of the Steens

In this painting on paper the artist has stressed the changeable quality of light by exploiting one of the newer inventions in acrylic painting: interference colours. These are made with tiny particles of mica, which reflect the light in different ways according to the angle of viewing, as shown in the dramatic difference between this photograph of the painting and the one on the right. The interference colours have been used both as a transparent medium and for overglazing.

◄ Here the photograph has been taken with the painting opposite the light source, while the other was photographed with the painting midway between light sources.

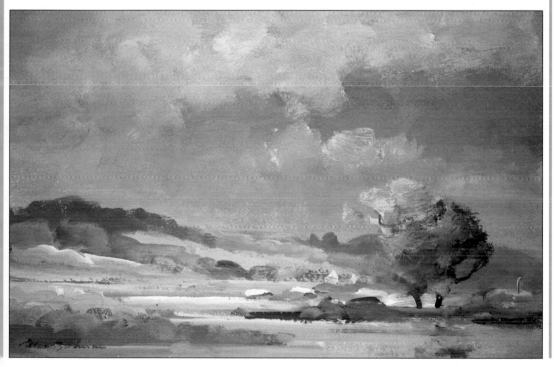

◄ Peter Burman
River Deben, Suffolk

In this painting on board the artist has used thick, juicy paint and an oil-painterly technique, capturing the effects of light with bold, sure brushstrokes. In the sky area and at the top of the tree, light paint has been scumbled over dark, with directional brush marks that create a strong sense of movement.

► **Jane Strother**
Well Street Common

The subtle colour effects of winter weather conditions are beautifully conveyed in this painting, with its carefully orchestrated grey-greens, blue-greens and touches of warm brown. The artist has worked on textured paper, allowing its grain to break up the light brushstrokes used for the tree to create delicate DRY BRUSH effects.

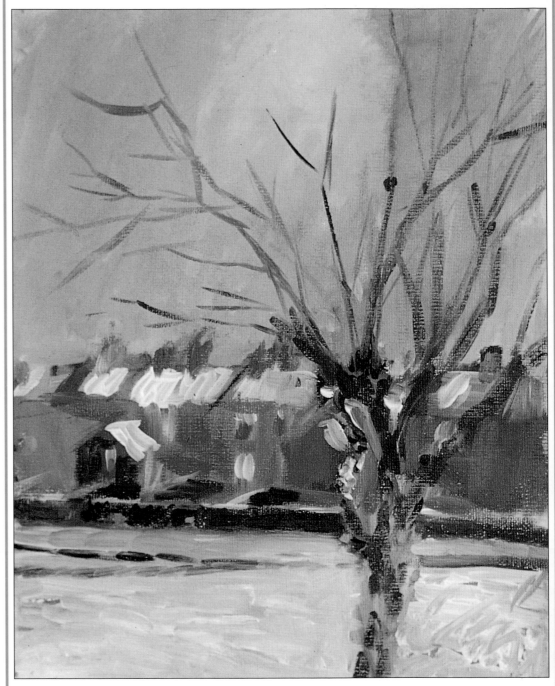

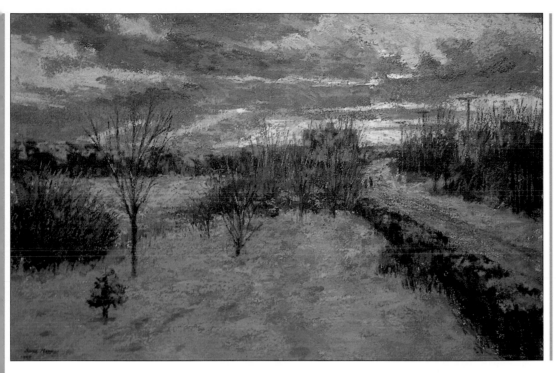

◄ Simie Maryles
Day's End in Winter

Evening light and snow on the ground have presented the artist with a rich array of colours, from brilliant yellows, oranges and turquoise to deep blues and purples. Acrylic plays a secondary role in this painting, done on illustration board; it was used to make a brightly coloured underpainting, on top of which pastel was thickly applied.

► Helena Greene
Blossom II

This painting on oil board was done rapidly on the spot, with the paint used thinly, and the white board left uncovered in places. The sweeping brushstrokes in the sky, and the overall lightness of touch perfectly convey the impression of wind-tossed blossom on a spring day.

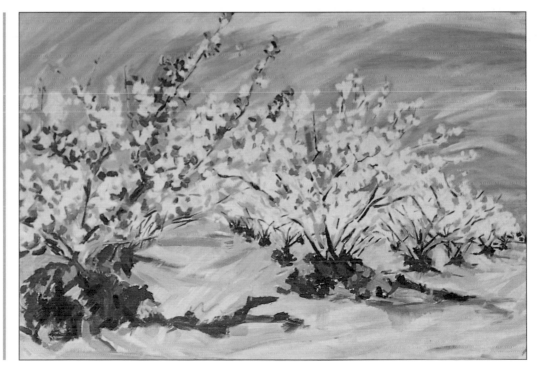

WATER

Perhaps because of its unique qualities of being both a transparent substance and a mirror, water has always fascinated artists – lakes, rivers and seas are among the most popular of all landscape subjects. A still lake, gleaming pale blue or silver-white in the reflected light from the sky, even if it is only glimpsed in the distance, can provide a centre of interest for a landscape painting (see FOCAL POINTS), while reflections, or the patterns made by moving water, can form the main subject, as in the paintings shown here.

Still water presents no special problems to the artist, but waves or ripples can be tricky, as the patterns they make change from second to second, and you will need to observe such effects very carefully. You will find that there is a logic to the movements, and that they repeat themselves, with waves curling and breaking in the same way, and the ripples in a stream flowing around a rock in the same direction. Whether you paint thick or thin, try to make your brushstrokes describe these movements so that the painting doesn't look static. A common fault is overworking the paint and thus losing the feeling of fluidity.

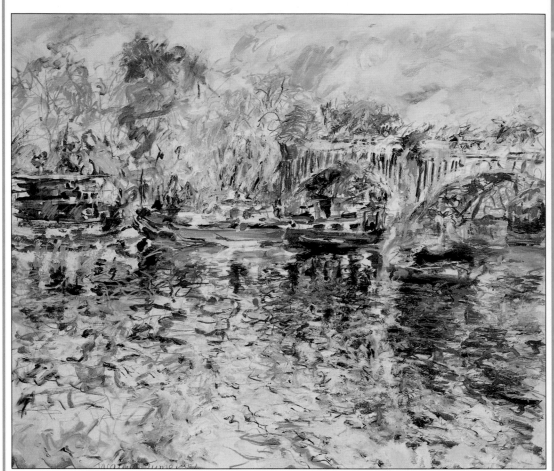

▲ Jacquie Turner
Along the Thames from Under Richmond Bridge I

Lively, active marks are used throughout the painting, integrating the water and reflections with the boats and trees. The artist has combined acrylic in both pot and tube form with a number of other media, including watercolour, chalk, wax crayon and fabric paint, and has worked on smooth-surfaced watercolour paper.

▶ Gerry Baptist
Perfect Reflections II

In this on-the-spot sketchbook study the artist has made the bold decision to leave the foreground blank save for a hint of yellow reflected from the sky and a small patch of darker ripples on the left, which bring the area into focus. There is just enough movement on the water surface to blur the reflections of the trees, which are treated with horizontal brush marks in contrast to the more energetic marks used for the trees themselves.

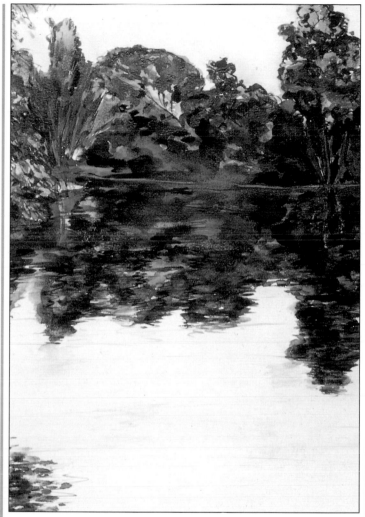

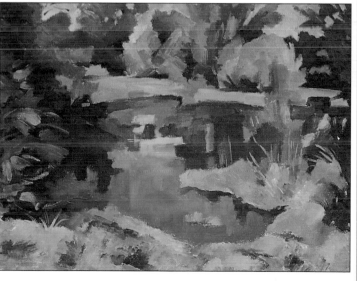

◀ Ted Gould
Autumn Scene

The brilliant blue of the water, with the contrasting red-brown reflections, form the centre of interest in this attractive painting on canvas board. The paint has been used thickly, mixed with retarding medium, and the colours have been simplified into bold blocks for maximum impact.

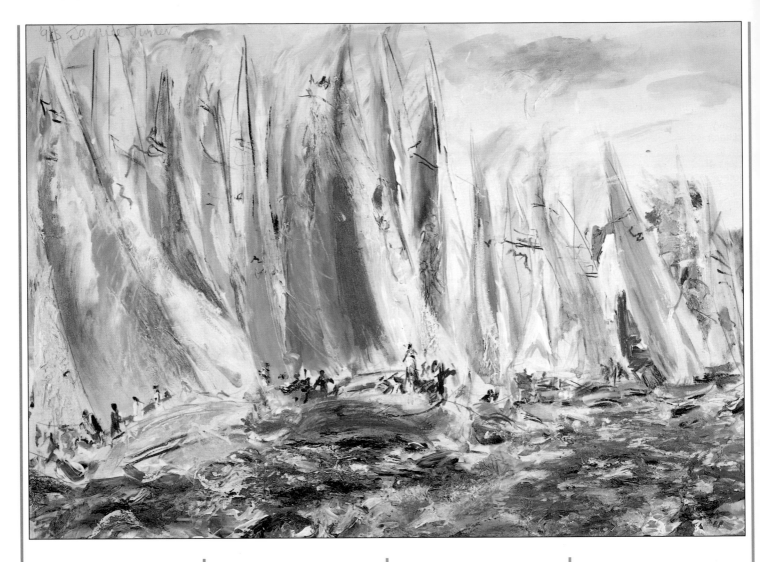

▲ **Jacquie Turner**
Sigmas Racing

The choppy water and the movement of the boats are conveyed through inventive and varied brushwork, finger-smudging and scraping. The artist likes to work on smooth paper so that she can move the paint around, and she combines standard acrylic with "liquid acrylic" inks, watercolour and touches of collage. The effect of the sprays of water and the highlights on the wavelets has been achieved by sticking on small pieces of pre-painted tissue paper, a method which she demonstrates on page 118.

▶ Simie Maryles
Lily Pads: Frog Pond in October

As in her painting shown on page 89, the artist has used acrylic as an underpainting for later applications of pastel, working on heavy illustration board. Many different colours have been used for the water, and the deep, brilliant blue in the immediate foreground helps to bring this area of the painting forward. It is worth remembering that reflections are nearly always darker than whatever casts them, in this case the sky.

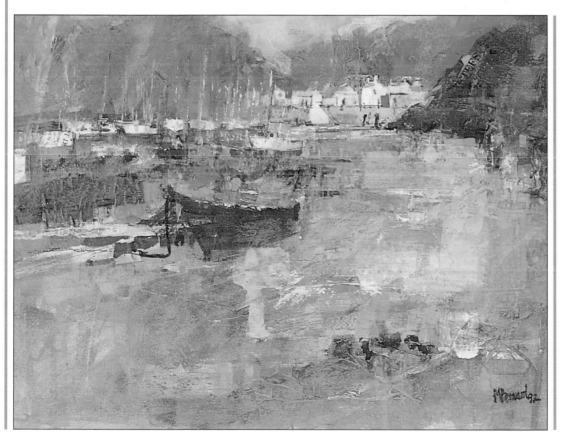

◀ Mike Bernard
Boats in Solva

Like Jacquie Turner (see opposite), this artist works on paper and mixes his media, combining acrylic with collage elements, pastel and inks. The subtle and varied colours of the reflections in the wet sand have been achieved with light scumbles of pastel over painted and collaged paper stuck down with polymer emulsion.

FOCAL POINTS

It is sometimes claimed that all landscapes should have a centre of interest, or focal point, which draws the eye into the painting, offering a kind of visual invitation. Whether this is essential is arguable, but many landscapes do have such a focal point, and the pictures on these pages are good examples of their use.

Traditionally, the focal point is placed in the middle distance, with elements in the foreground used to draw attention to it. However, it can be in the distance as in Gerry Baptist's painting, or the foreground itself can form the focal point, with other elements acting as a backdrop.

Both shape and tone (light and dark) are important in this context. The eye is always drawn by sharp contrasts of tone and by tall or angular shapes, so trees, rocks or some feature such as a white building set against dark trees are all natural focal points – the latter would also provide a contrast of shapes.

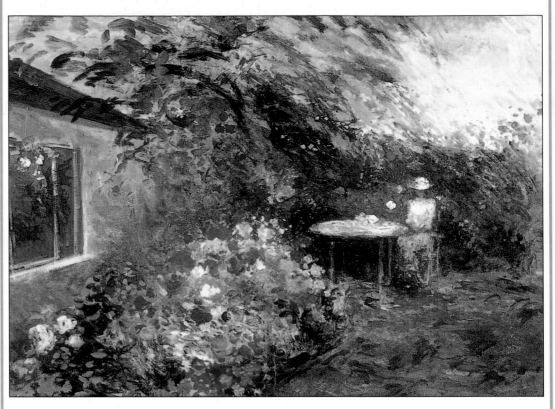

▲ John Rosser
Tea in the Garden

In spite of the brilliant colours in the foreground, there is no doubt as to what forms the focal point in this picture – the eye is immediately drawn to the figure at the table. This is not only because of the strong tonal contrasts and the fact that our attention is always taken by a human figure; the artist has also exploited the contrast between quietness and activity. In every other part of the picture the brushwork is vigorous and full of movement, but in this still heart of the painting the figure sits immobile, an anchor for the ever-changing elements of the landscape.

▶ Brian Yale
Sentinel

A dominant landscape feature such as this could not fail to become the subject and focal point of the painting, but care must still be taken with the placing of it. The artist has allowed enough sky above the rock to give it "breathing space", and has arranged the foreground features so that they lead the eye in to it; the tall grasses and upward-pointing rocks act almost as signposts.

◀ Gerry Baptist
Italian Trees

The focal point in this landscape is the distant hills, and the artist has employed a classic compositional device to emphasize it: using the dark foreground trees as a frame within a frame. This also increases the sense of space, as the cropping of the trees at the top brings them to the front of the picture, pushing the hills back.

TREES

Apart from their uses in creating a focal point, as explained on page 94, trees can be some of the most exciting features of landscapes. They invite a number of treatments. Tall trees in the foreground of a landscape, for instance, allow you to introduce a pattern element, contrasting verticals and horizontals, while massed trees in the middle distance create satisfying tall or bulky shapes and often an array of contrasting colours.

Trees can also be appreciated for their varying textural qualities, and painted from a close viewpoint – tree barks, for example, provide a wealth of fascinating detail as well as rich variations in colour.

But however you choose to integrate trees into your landscape, do study their shapes carefully or they will not look convincing. Each species of tree has its characteristic formation, some being tall and thin with upward-pointing branches, while others are almost as broad as they are tall, with the branches sweeping out into an umbrella shape. You don't need to know their botanical names, but guidebooks to trees might back up your own observations.

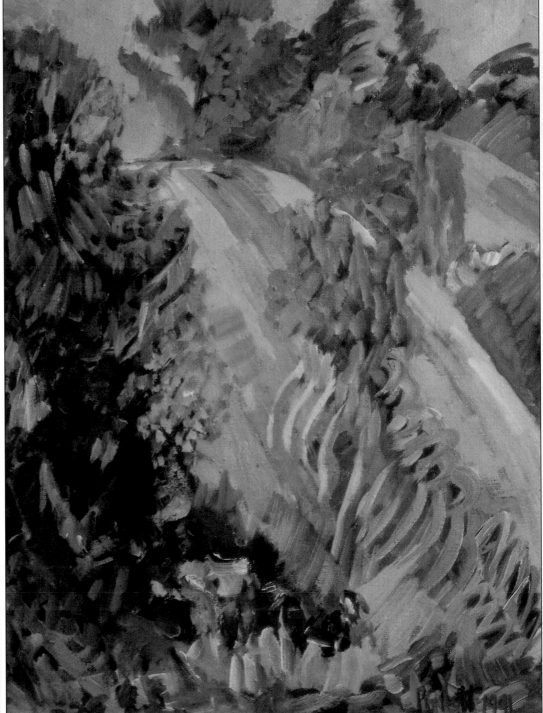

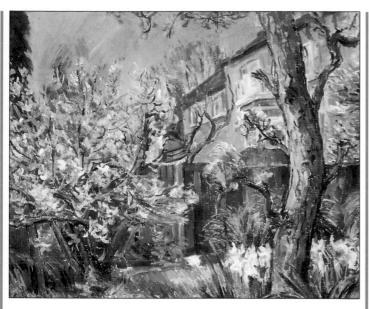

◀ Ted Gould
Spring

The tree trunk which forms a dramatic foreground to this painting on canvas has been beautifully observed and described – notice the variety of colours in this one area, and the fine marks made with a small brush to suggest the texture. The foliage of the left-hand tree has been painted with small brushstrokes of IMPASTO over thinner paint.

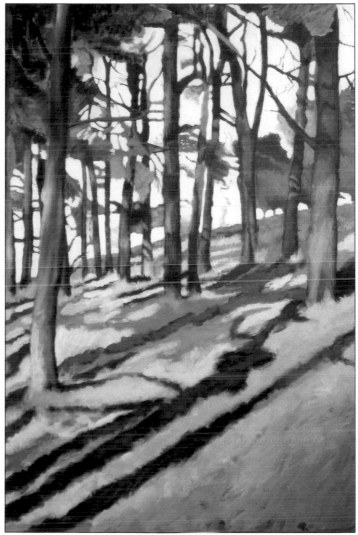

▶ Paul Powis
West Malvern Spring

This artist does not restrict his outdoor work to the summer months, and these evergreen trees were painted on the spot during winter. There is a strong pattern element in the picture, done on Brazilian plywood, with an exciting interplay of diagonals and verticals offset by intricately shaped areas of bright and dark colour. The clumps of foliage were defined by painting the sky around them last, light over dark.

◀ Geoff Pimlott
Hillside Fields

Although there has been no attempt to describe the trees in detail they are completely convincing, with the impression of the foliage built up through directional brushstrokes. The painting, on primed canvas, was worked in the studio from sketchbook drawings. The artist's method is to block in basic areas and then build up with broken brushwork and WET-INTO-WET techniques.

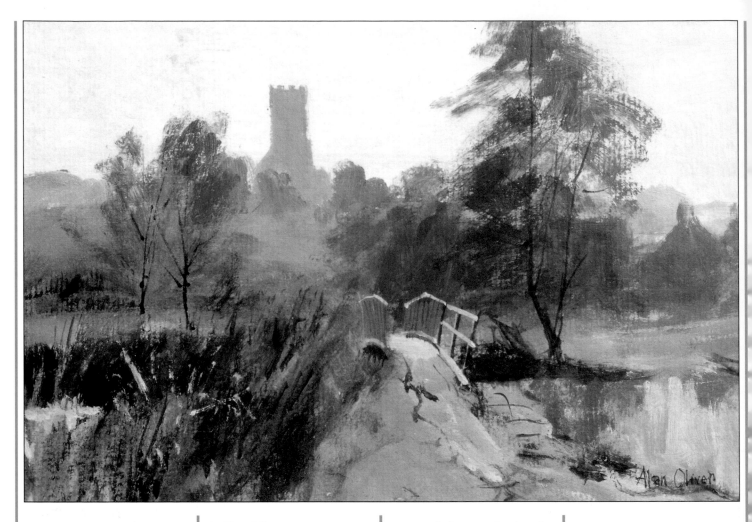

▲ **Alan Oliver**
Glandford Church

Coloured and textured mountboard without priming was used for this painting. The artist likes a slightly absorbent surface which allows him to exploit DRY BRUSH techniques; notice how the paint has been dragged lightly over the surface to achieve the soft effect of the trees. Apart from the sky, which is a thin wash of colour, the paint has been used straight from the tube, that is, with no water or medium added.

▶ Ted Gould
Pont d'Arc, Ardèche Gorge

Both trees and rocks have been simplified and treated as broad areas of colour, making an almost abstract pattern across the picture surface, but there is just enough detail in the foreground tree to pull it forward. The artist has tied the whole painting together by repeating the yellow of the left-hand tree in other areas, notably on the canoe, which provides an understated focal point. The painting is on canvas board, and the paint has been used unthinned but mixed with a little retarding medium.

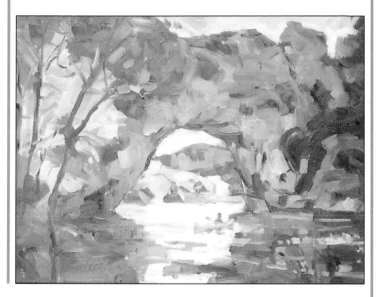

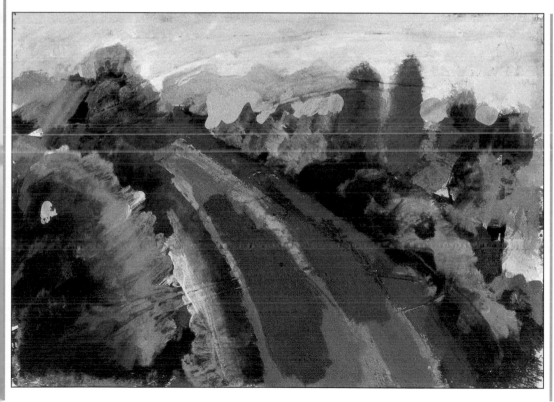

◀ Paul Powis
Railway

Here too the trees have been generalized as broad shapes – too much detail would have reduced the impact of the curving band of red. The painting is on hardboard given a heavily impasted texture, and the artist has used large brushes as a deliberate ploy to avoid detail. This can be a useful strategy when you want to take a bold and broad approach to a painting.

HILLS AND MOUNTAINS

In flat landscapes, the sky often plays a major role in the composition; indeed this pre-eminence of sky is part of their appeal. Hills and mountains, however, will always dominate the composition, with the sky playing a minor part, if any. The shapes they create are a gift to the artist, from the gentle curves of downland to the jagged formations seen in cliffs or high mountain ranges.

Fast-drying acrylics are ideal for crisp, positive effects, allowing you to exploit edge qualities to the full, either with successive overlaid thin washes or thicker applications of paint laid on with a brush or knife (see KNIFE PAINTING) and left unblended. For the softer effects of hills, try letting your brush follow the direction of the curves, both to build up the forms and to create a feeling of movement, as Judy Martin has done in *Downs View I*.

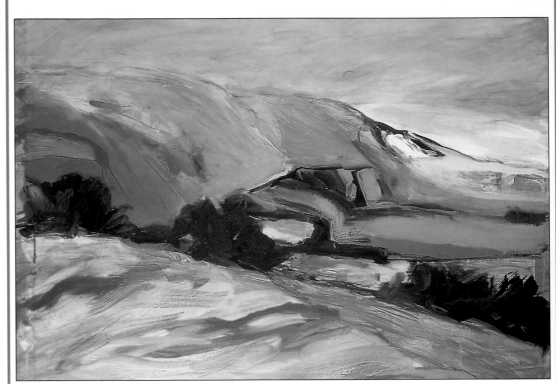

▲ Judy Martin
Downs View I

This large painting on paper was done in the studio from sketches, which allowed for a more personal and interpretative use of colour than is usually possible when working on the spot. It can be difficult to paint a sky yellow, for example, when faced with the blue or grey reality, but in this case it was the right choice, as it echoes the foreground yellow to unify sky and land without in any way interfering with our perception of the landscape. The artist has used large brushes, letting the brush marks follow the forms of the hills and trees, and has built up considerable depth of colour by means of transparent glazes of water-diluted paint. Water can be more suitable than acrylic medium for glazing over large areas.

▶ Jill Confavreux
Himalayan Poppyscape

This painting, in acrylic and collage with oil pastel, evolved from the idea of exploring the colour blue through many different textures of paint and paper. Working on watercolour board, the artist began with a series of acrylic glazes, encouraging the colours to run and mingle. The paper for collaging – Japanese Hokai paper and tissue paper – was then painted in turn before being stuck down with gloss medium, left to dry, and scumbled over with oil pastel. The artist then added more acrylic glazes, and cut back into the board in places to create a different surface for further applications of paint and oil pastel.

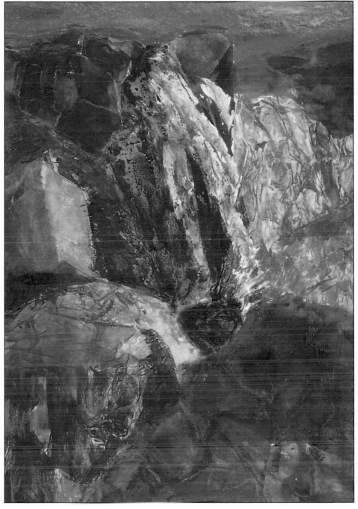

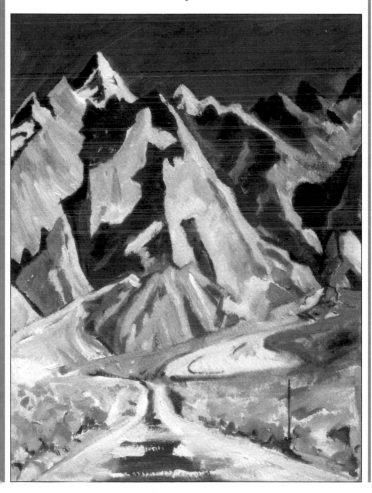

◀ Helena Greene
The Karakorum Highway

Working on watercolour paper, the artist has concentrated on the pattern of angular shapes made by the play of light on the mountains. The deep purple-blue of the sky forms a dramatic backdrop, and the dark shape in the centre of the road echoes those of the mountains, providing a lead-in to the picture's focal point.

DEMONSTRATION
LANDSCAPE

A marriage of acrylic and soft oil pastel has been skilfully exploited in this lovely evocation of a woodland landscape by *Debra Manifold*. It has been done from photographic reference, but with a considerable input of memory and experience.

1 A ground of tinted acrylic gesso is laid on white canvas board to "cut" the white and provide a slight texture, always important for work involving pastel.

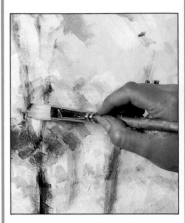

4 The brush is drawn lightly down the canvas in a dry-brush method to achieve a delicate broken-colour effect. This thin coverage of paint also facilitates the later application of pastel.

2 Working initially in only two colours, the artist establishes the "skeleton" of the composition and sets a key for the colour scheme. The yellow and purple, although they will be modified later, will both play an important part in the finished painting.

3 An irregular horizontal band of white has been scumbled lightly across the painting over the original colours, and transparent blues and greens are now applied on top, using bold directional brushstrokes.

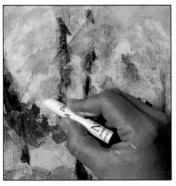

5 Strokes of white pastel are now applied, taking care that the marks of the pastel stick complement the earlier brushstrokes. This very soft oil pastel creates a painterly rather than a linear effect.

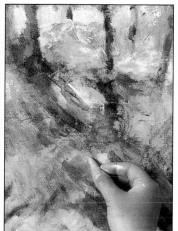

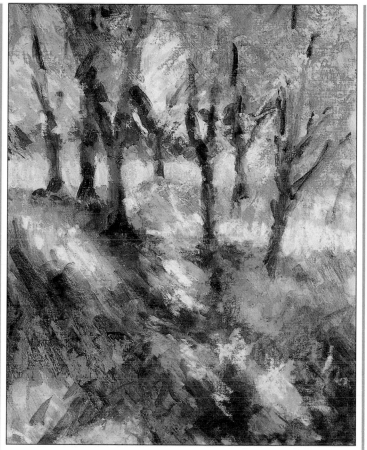

6 Transparent paint has been laid over the pastel in places, and now more pastel is applied, gradually building up the effect of dappled light by means of a layering technique.

7 This detail shows the effect of the layering method. The oil pastel acts as a resist for thin paint applied on top; you can see this in the area on the left, where the green pastel is visible through the indigo paint.

Finished picture
The combination of transparent acrylic glazes and oil pastel has achieved a wonderful depth of colour, and the lively brush and pastel work gives a sense of movement, evoking the ephemeral qualities of over changing light and shade.

Palette
This disposable paper palette offers an interesting reflection of the way in which the artist uses her brushes – the marks made in the process of mixing the colours are similar to those she employs for the painting itself.

BUILDINGS AND TOWNSCAPES

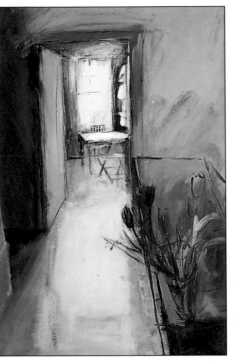

All the subject areas in painting overlap to some extent, and townscapes are really only another kind of landscape painting. However, while landscape might be said to consist of mainly natural features, in a town you are surrounded by a man-made environment. This doesn't of course mean that there are no natural features – many cities are well endowed with rivers and trees, and it can be this very contrast between nature's work and that of humankind that makes townscape such an exciting subject.

Viewpoint There are some problems associated with painting in urban environments, however, one being that it isn't always easy to find a suitable place to work. If there is a handy seat, the chances are it won't give you the viewpoint you want, and it can be nerve-wracking to stand at an easel in the middle of a busy pavement, trying to ignore the comments of passers-by.

You will become accustomed to these as you gain confidence, but for initial attempts you might try finding a vantage point at the window of a public building, or in a café whose proprietor doesn't mind you lingering. Some artists like to paint from high viewpoints, such as church towers, which provide an exciting vista of rooftops.

Perspective and proportion The idea of having to cope with the intricacies of perspective puts many people off urban subjects, but it is not really so difficult provided you remember the basic rule that all receding parallel lines appear to meet at a point on the horizon. The important word here is horizon, which is an imaginary line located at your own eye level. If you are painting from a high viewpoint, such as a tower or hilltop, the lines will slope upwards, while if the viewpoint is low they will slope downwards. The only real problem is that because perspective is dependent on viewpoint, it changes as soon as you move, even from a sitting to a standing position, so when you make the preliminary drawing for the painting, keep as still as you can.

Although a building won't look convincing if the perspective is wrong, an even more important factor in conveying its character is proportion: how tall it is in relation to its width; how many windows there are and how much space between them; and so on. You can check proportions by holding a pencil up at arm's length and moving your thumb up and down it to take measurements. In this way you can immediately see whether a building is twice as high as it is wide, or check the relative sizes of door and windows. Such measuring techniques are essential for architectural subjects, and are used by most artists.

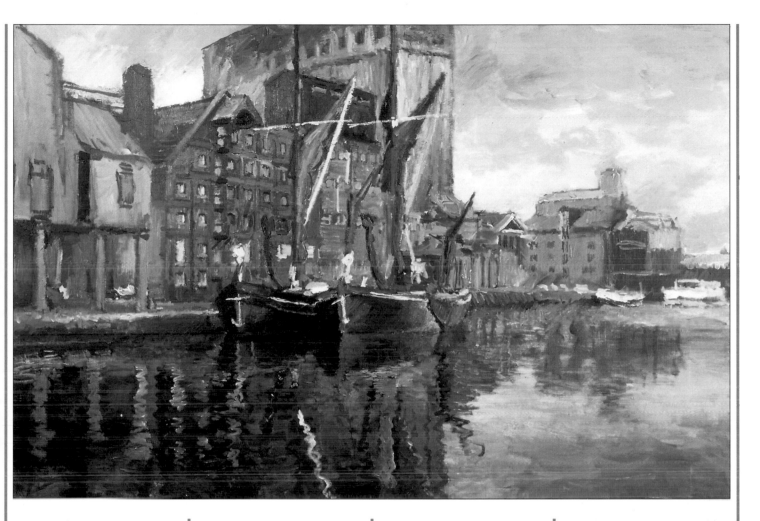

▲ Gary Jeffrey
Ipswich Docks

This lovely painting shows urban landscape at its most appealing – a true marriage of man-made and natural features. The artist has worked on canvas and his painting technique is similar to an oil-painter's, with the paint built up from thin to thick, and some use of WET-INTO-WET techniques, particularly in the reflections.

◄ Jane Strother
Upper Flat

Buildings, whether interiors or exteriors, provide an opportunity to exploit the interplay of geometric shapes. In this simply constructed but powerful painting, strong diagonals and verticals are counterpointed by the curves of the foreground flowers.

PLACE AND ATMOSPHERE

All towns and cities have their own particular feeling, so if you are painting townscape rather than "portraits" of individual buildings, try to analyse what this feeling is and find ways of creating a sense of place by giving visual clues. In an exotic location, for example, people's clothing and characteristic postures will be strong indicators, while in a busy modern city you can make cars and typical "street furniture" part of the composition.

It is often possible to convey a sense of place through colour or texture alone, making a play of light, bright colours or strong tonal contrasts in a sunny Mediterranean town, and exploiting "low-key" colours, such as greys and browns, in a northern industrial setting. Or you could make a feature of rough stone or peeling plaster on old buildings or the smooth or reflective surfaces of new ones.

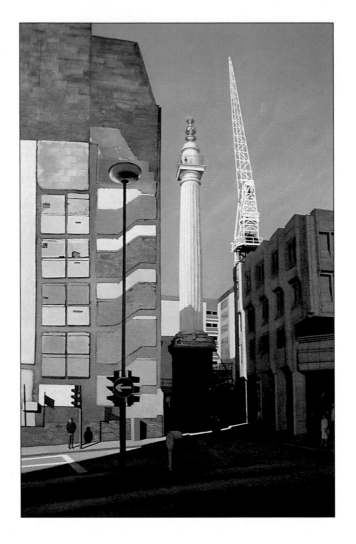

◀ **Brian Yale**
The Monument

In this painting of London's Monument and the surrounding buildings, the approach is almost photographic, with minute attention paid to every detail and texture. The composition is beautifully worked out, with the diagonal line formed by the edge of the dark shadow leading the eye up the right-hand building and the crane that forms a balance for the Monument itself.

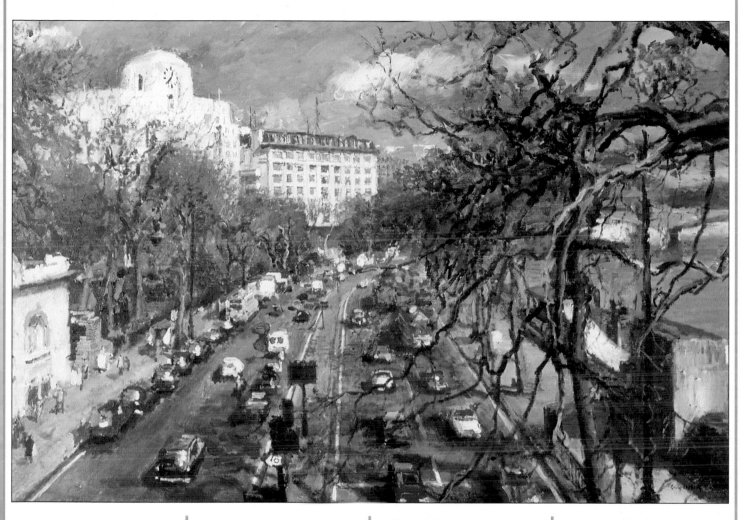

▲ Gary Jeffrey
Spring on the Embankment

Cityscapes are often avoided by amateur painters, but the pictures on this page demonstrate that they can be a rewarding and stimulating subject. For this painting on canvas board the artist has chosen a high viewpoint, which has allowed him to treat the cars as a vivid area of colour and pattern contrasting with the solid white slabs of the buildings behind.

◀ Richard French
The New City

One of the most exciting visual phenomena in modern cities is that of reflections in the many large expanses of glass, often distorted in intriguing ways. Here the artist has mimicked the effect of such reflections by using multiple layers of acrylic glazes, working on a smooth-surfaced acid-free mountboard known as museum board. The painting is a large one, and to facilitate handling it was painted in three separate sections.

► Neil Watson
Broad Street, Oxford

This painting is full of atmosphere and movement, the latter quality accentuated by the strong brushwork and the motion of the cyclist in the foreground. The surface is canvas board, and the paint has been used thinly – notice that it has been allowed to dribble down the board in the sky area. The artist began with washes of acrylic mixed with gloss medium, after which he "fleshed out" the painting and developed some linear detail using inks, which were sealed in with more gloss medium.

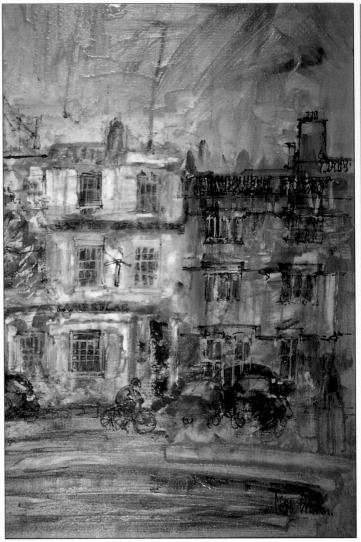

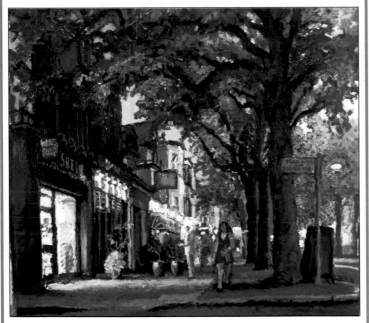

◄ Gary Jeffrey
Restaurants, Kew Road

The signpost, the just-legible names of the shops, the figure and the horse-chestnut trees all combine to give a feeling of place; this scene would be immediately recognized by most Londoners. The time chosen, early evening with the lights just coming on, has provided a wonderfully rich colour scheme, with the brilliant reds and yellows standing out against the buildings and pavement blued by the fading light. The painting is on cartridge paper primed with shellac.

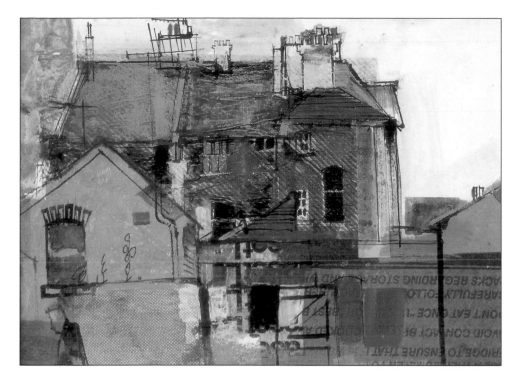

◄ **Mike Bernard**
Backs of Buildings, St Mary's Road, Southampton

Collage is a technique particularly well suited to architectural subjects, and here it has been skilfully used, in conjunction with acrylic, inks and pastel. The varieties of paper used for collaging give an impression of textures without attempting to imitate reality. The printed paper in the right-hand area of the foreground has been placed upside down to prevent it from being over-obtrusive.

► **Jeremy Galton**
St Paul de Vence

This delightful painting of a hilltop village in the South of France also has a powerful sense of place, derived not only from the typical style of the buildings but also from the colours – deep, rich greens, ochres and whites. The painting is a small one, done on mountboard, with the paints used very much as oil paints.

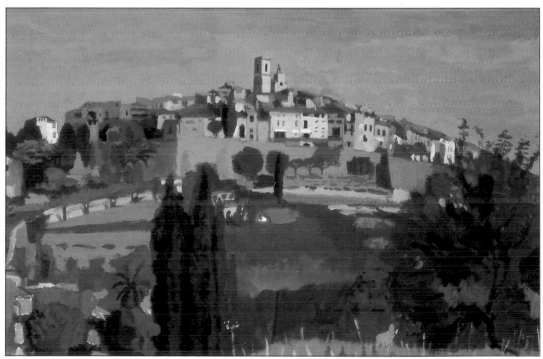

INDIVIDUAL BUILDINGS

It is sometimes the hustle and bustle of a townscape, with people and cars, different colours, and the interaction of shapes provided by walls, rooftops, doors and windows that provide the stimulus for a painting. But some buildings invite a closer, more portrait-like approach, either because they are beautiful in themselves or because they possess some striking quality of shape or texture.

If shape is the important element, as it is in Walter Garver's dramatic painting, you will obviously want to show the whole of the building, choosing the viewpoint that sets it off to best advantage, and perhaps simplifying or omitting other features in the scene. But texture, which can be one of the most attractive and painterly aspects of architectural subjects, can often be treated by taking a closer view and "cropping in" so that these surface qualities become virtually the subject of the painting.

Acrylic is particularly well suited to creating texture, either by brush or knife strokes, or by methods such as DRY BRUSH and SCUMBLING.

◀ Neil Watson
The Radcliffe Camera, Oxford

This famous building has been painted quite loosely and sketchily, and yet this is an excellent "portrait" because the proportions and major characteristics have been so well observed. The artist has adopted a technique similar to that employed for his painting on page 108, but in this case he has also used some coloured inks for the linear drawing. To prevent any possibility of fading – there is a concern that some coloured inks may not be lightfast – the whole picture was sealed with acrylic medium.

▶ Jill Mirza
Woman and Dark Doorway

Here the artist has taken a close view and made the texture of the flaking wall and the interplay of darks and lights the joint subjects of the painting. Working on canvas, she has used the paint both thick and thin, sometimes SCUMBLING very thin colours over thicker applications.

◄ Walter Garver
The Tourist

Industrial architecture, although it may lack the immediate appeal of old cottages and whitewashed Mediterranean houses, has its own fascination, and here the artist has made the most of the imposing shape of a grain elevator by taking a low viewpoint. The intensity and depth of colour has been achieved by a series of transparent washes, one laid over the other to produce subtle blends and graduation.

► Nick Harris
Openings 46 – Wooden House

Texture is the main preoccupation here, and it has been portrayed with skill. Working on watercolour paper, the artist has built up the painting in a layering technique, with a succession of thin washes.

STREETS AND MARKETS

Unless you are painting portraits of individual buildings, or a far-off view, people will nearly always form part of a town or village scene. Indeed the daily ebb and flow of human beings going about their business is one of the attractions of such a setting.

Markets, cafés and streets all make good subjects, particularly markets, as the stalls, with their colourful piles of produce, provide a fascinating array of shapes and textures.

Such paintings will usually have to be made from sketches, or from a combination of sketches and photographs, as people will not remain still long enough for you to complete a painting on the spot. This has the advantage of allowing you to compose the painting more thoughtfully and to use a variety of techniques. Mike Bernard, for example, has chosen collage for his exciting evocation of a bustling London market scene.

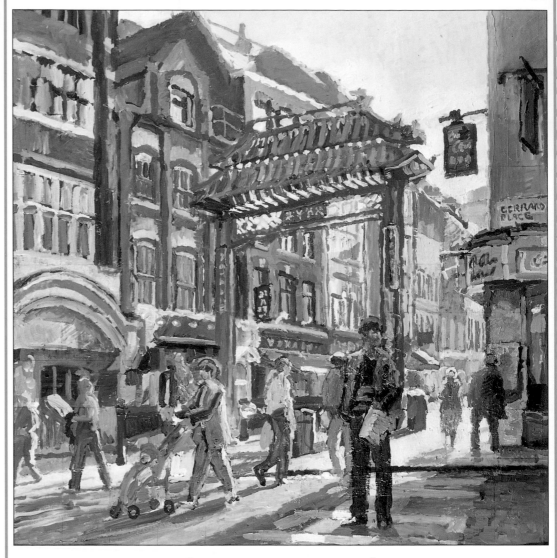

▲ **Gary Jeffrey**
Chinatown

Full of life, colour and movement, this painting of London's Chinatown has been painted with bold, thick brushstrokes on paper primed with shellac. The figures are treated with the minimum of detail – even the foreground figure has only the suggestion of facial features – but they are completely convincing because careful attention has been paid to their postures, clothes and the way they move.

▼ Judy Martin
Bandstand Study III

This painting on paper, done from
sketches, is one of a series in
which the artist pushed an idea
further and further towards
abstraction. The subject initially
attracted her because of her love
of vivid colours.

▲ Mike Bernard
Fruit Boxes

Collage has been used with
acrylic for this atmospheric
market study, in which the figures
form a generalized background
to the strong geometric shapes.
Notice how the collaged tissue
paper, stuck to the hardboard
support and painted over, forms a
slightly crumpled texture – most
clearly visible in the background.

113

INTERIORS

It seems almost too obvious to point out that buildings have interiors as well as exteriors, but it is surprising how many amateur painters overlook this subject. Perhaps the problem is that the interiors of our own homes are too familiar, but in fact room settings provide a wealth of compositional possibilities, with the shapes of furniture and objects contrasting with the linearity of architectural features such as doors and windows.

An alternative approach is to paint an interior much as you would a still life, focusing on one part of the room – perhaps a mantelpiece or window. Or you can bring in an element of landscape painting, using part of the room as an "introduction" to a view through the window, as in Daniel Stedman's painting.

Light can play an important part in the composition also. For example, light coming in through a window creates a marvellous interplay of light and dark colours which allows you to introduce a pattern element. Artificial light can also be used to advantage; a lamp casting a soft glow on surrounding objects can be the ideal focal point in an interior painting.

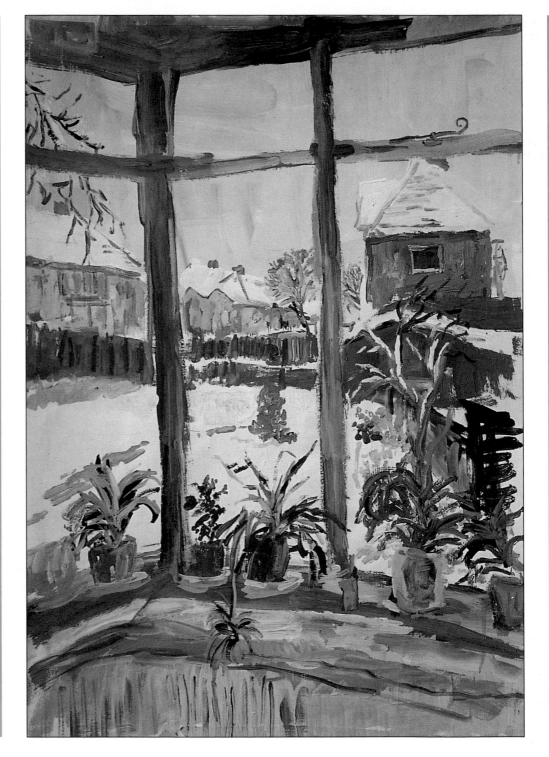

◀ **Daniel Stedman**
Winter Morning

The "inside-outside" theme requires careful control of tones and colours. Too much contrast in the landscape part of the painting or too little in the foreground will destroy the sense of space. Also, the painting will fail to hang together as a composition if the colours used for the inside element are too different from those of the landscape. Here the subject has been handled with confidence – the red brown of the house is echoed on and below the window frame, and the dark tones of the plants, bars and top of the window bring this area forward.

▶ **John Rosser**
Teatime View

Light is the major theme of this lovely painting, which is reminiscent of the works of Pierre Bonnard, one of the greatest painters of domestic interiors. Here the view through the window has been merely hinted at – what matters is the light, illuminating the figures and enriching the colours of the furniture and fabrics. The window also serves a compositional function, providing a geometric anchor for the gentle curves made by the white-clad figures.

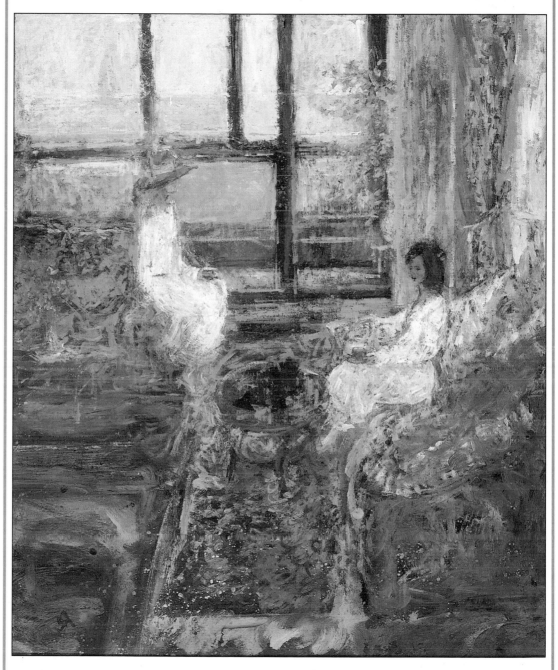

◄ Roy Sparkes
Corridor to Sound Studio Under Construction

This starkly geometric composition painted on card is one of several inspired by a visit to a converted wharf in Liverpool. Looking along the corridor, the "flats" at the end repeat the rectangular shape of the painting, while the horizontals and verticals complete the structural theme. The careful arrangement of light and dark tones and the well-balanced colours give the work a strong abstract quality; it can be "read" both as an arrangement of shapes and colours and as the representation of an interior.

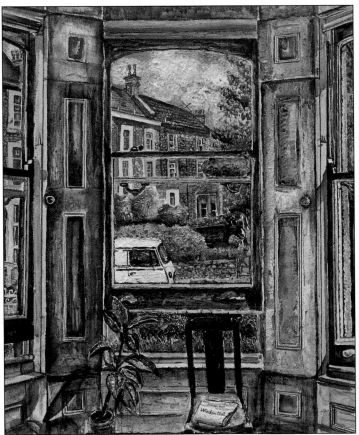

► Paul Bartlett
From My Brother's Flat, Bristol

Surface texture is an important element in this painting on canvas, and the artist has employed a number of different techniques – including knife IMPASTO, drawing into dried paint with a biro, and MASKING – to achieve the straight edges of the window frames. Although at first sight the paint appears uniformly thick, overlaid transparent washes have been used for the cast shadows on the window frames.

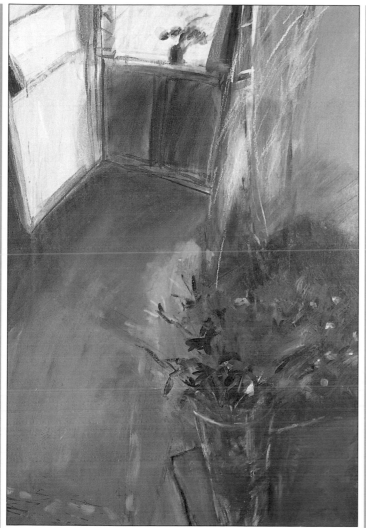

In this exciting painting on canvas board, the artist has taken liberties with perspective in the interests of her composition, bending the line of the floor to provide a curve sweeping inwards to the window. The vase of flowers on the windowsill, although small, is important to the picture, providing an echo for the foreground flowers, and also preventing the viewer's eye from being led out of the window.

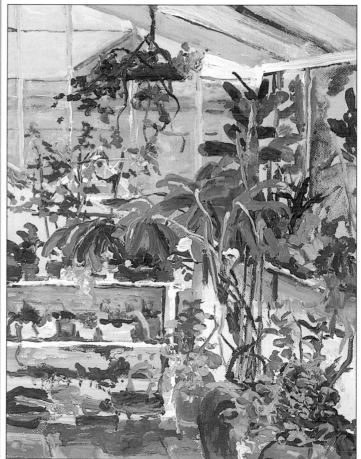

► **Don Austen**
Barbara Hepworth's Greenhouse With Hanging Basket

Greenhouses and conservatories make fascinating painting subjects, combining elements of architecture, landscape and still life. Here the verticals, horizontals and diagonals of the shelves and windows provide a framework for the luxurious forms of the plants. The painting is on canvas, with the paint built up thickly in places by means of successive layers of brush application.

DEMONSTRATION
BUILDINGS AND TOWNSCAPES

This mixed-media painting by *Jacquie Turner* is one of a series of the city of Florence, made from a church tower. High viewpoints such as this are much favoured by painters of urban landscape, as they provide an exciting vista of rooftops and other features not visible from ground level.

Palette

Artists' palettes give a fascinating insight into their way of working. An unusually large range of colours has been laid out here, including several iridescent and metallic hues. The artist does very little colour mixing on the palette, preferring to obtain her effects by layering and overlaying colours on the picture surface.

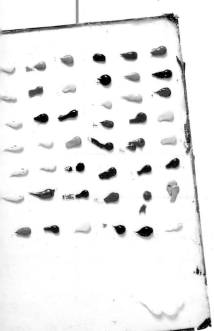

1 The texture of the surface is an important feature in the artist's work, and she uses smooth (hot-pressed) paper, which makes it easier to move paint around and smudge it with her fingers. Having made some light lines of drawing she begins to build up textures immediately, with finger-applied acrylic gesso.

2 More drawing is now done with a watercolour pencil, held very loosely to give a fluid line. She sometimes paints without a drawing, but for a subject such as this she likes to bring in a linear element from the start.

3 Paint is incompletely mixed on the palette and brushed on lightly, with one colour layered over another. Notice that the lines of the drawing are not covered by the paint; the integration of linear drawing and brushmarks is a central element in the painting.

6 Iridescent acrylic colours and interference colours (those which change according to the direction of the light) have both been used in places, and now a small patch of colour is applied with iridescent chalk pastel. This mixture of media helps to build up a "busy" picture surface.

4 The dropper of a bottle of concentrated watercolour is used to dribble colour over the light layer of paint, producing a series of calligraphic squiggles. The most vivid colours are established first, as the artist's method is to begin with strong colour and work down.

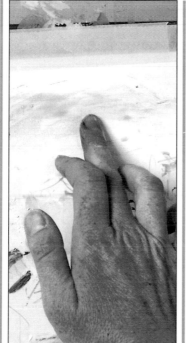

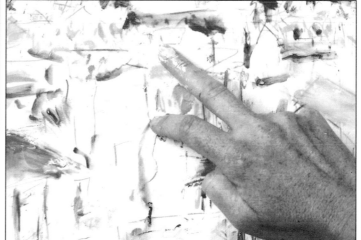

5 For the sky area, a light scribble of wax crayon has been used as a resist, with thinned paint laid on top and smudged with a finger. The artist likes to keep the sky lines fluid, and often overpaints with white.

7 Many of this artist's paintings include collage elements, which take the form of pieces of pre-painted tissue paper stuck on with PVA glue and then painted over to provide an extra element of texture. One such is being applied here.

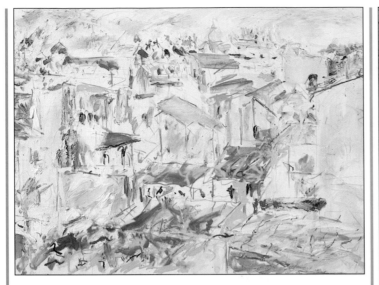

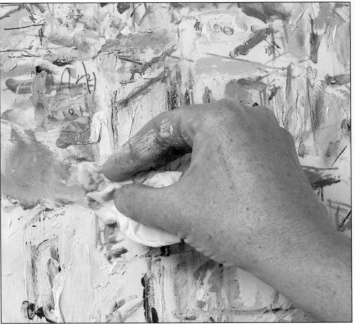

8 At this stage the basis of the composition is firmly established, with a lively interaction between linear drawing, brushmarks and textures already evident. Further definition is required, however, particularly in the foreground and background.

9 The foreground is always important in a landscape or cityscape, because it must lead the eye into the picture while providing some interest in the form of colours, shapes or textures. Here thick paint is smeared and smudged with a finger to produce intriguing but inexplicit areas of texture.

10 The walls of the building on the left have been built up thickly with overpainted collaged pieces, and a softer effect is now produced on the roof by dabbing on paint with a rag.

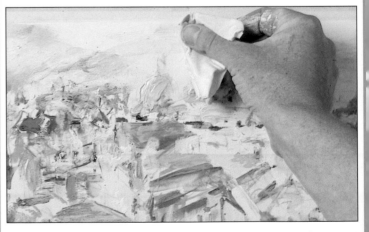

11 A rag is again used to spread colour in the sky, creating a gently windblown effect. Although the sky occupies a small part of the picture area it plays an important role in enhancing the sense of movement.

12 In this detail you can see the build-up of textures, with blobs, swirls and smears of thick but transparent colour overlaying the concentrated watercolour and thin paint applied earlier (see steps 3 and 4). On the right, fine lines have been made by scratching into the paint.

Finished picture
Although nothing is overly explicit and there has been no attempt to render the cityscape with the precision often associated with architectural painting and drawing, the picture conveys a powerful sense of place.

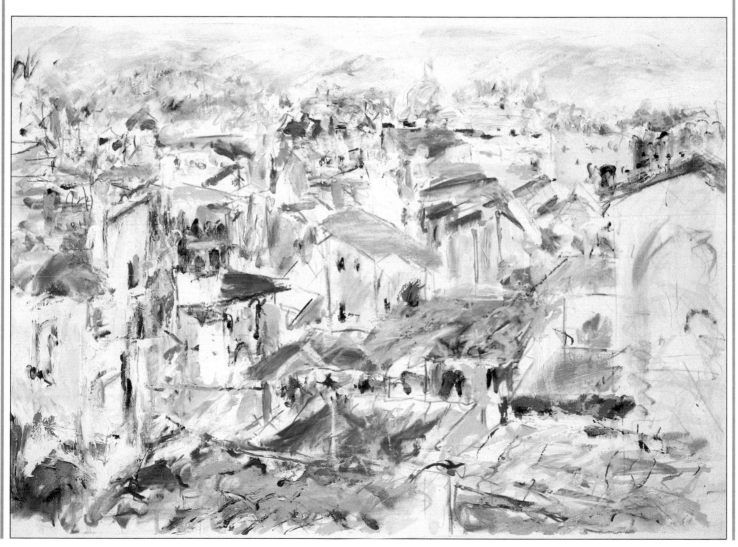

THE FIGURE

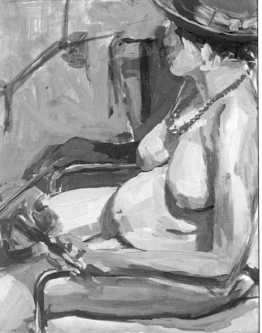

The human figure presents a considerable challenge to the artist, demanding a high degree of observational power as well as sound drawing skills. You can't get away with "fudging" as you sometimes can with landscape work – mistakes such as a figure with unlikely proportions, or a portrait in which the features are askew are immediately noticeable.

This is not to say that you can't distort deliberately – you can, but you have to know what you are doing and why. The paintings of Amedeo Modigliani (1884-1920), with their elongated, simplified forms, are not realistic portrayals of people, but they are extremely beautiful. The German Expressionist artist Max Beckmann (1884-1950) distorted his figures in an intentionally unbeautiful way to express the savagery he saw around him as well as his own feelings of deep anxiety.

Drawing practice In order to distort – or even to use the figure as a pattern element in a painting, as did Henri Matisse (1869-1954) – you must first be able to draw faces and figures as they really are. You will only acquire this skill by practising as much and as often as possible. You don't have to join a life class – unless you want to paint the nude. You can draw yourself in the mirror, make studies of friends and family, and sketch people on buses or trains and walking in the street. Even if you only want to paint figures well enough to include an occasional person in a landscape or urban scene, this kind of practice will stand you in good stead, and if the sketches are good enough you can use them as visual reference for paintings.

The medium Because figure work and portraiture are difficult, acrylic is ideal for initial experiments. Its opacity and speed of drying allow you to correct any mistakes as soon as you spot them simply by overpainting, and you can do as much of this as you like without harming the picture surface.

Teachers in life classes often recommend acrylic for this reason, but it has many other, more sophisticated advantages for figure work. Because it can be used both thick and thin, in IMPASTO techniques as well as transparent glazes, you can create a range of expressive effects. The translucency and subtle colour nuances of skin, for example, are notoriously hard to emulate, but GLAZING techniques allow you to achieve very delicate effects – this was the method traditionally used by oil painters. You can also ensure that the drawing is correct before laying on colour by working over a monochrome UNDERPAINTING, another time-hallowed oil-painting method.

▶ Gerry Baptist
Arnette With Flowers

In this colourful painting on paper
the figure has been seen
primarily as pattern, although a
hint of modelling has been given
to the arm and face. There is slight
intentional distortion of the figure,
with the left shoulder raised in
order to create the dark shape
which balances that of the right
shoulder and arm.

◀ Michael Wujkiw
Life Study

This small work on card was
painted rapidly with broad, free
brushstrokes, but is nevertheless
very carefully composed. The eye
follows the composition in a
series of curves and semi-
straight lines, from the hat
cropped at the top corner to form
a curved triangle, to the line of the
upper arm, and through the lower
arms and violin to the bright
splash of red. From here, the
curve of the breast leads
upwards to the head, thence
returning to the dark hat.

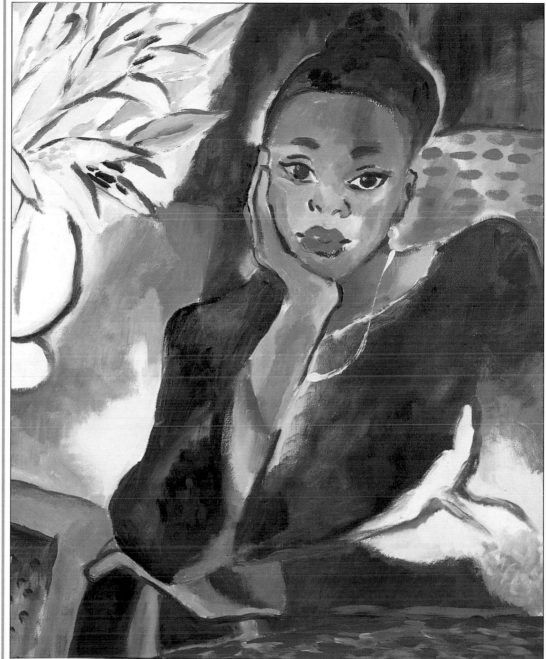

PORTRAITS

The primary task of a portrait is to produce a likeness of the sitter, but it doesn't end there, because a portrait is a painting as well, and to succeed in terms of art it must meet the usual criteria of composition, balanced colour and successful rendering of three-dimensional form.

Even if you are painting a head-and-shoulders portrait, where you don't have a variety of elements to juggle with, you must consider composition, deciding what angle to paint the head from, where to "crop off" the body and how much space to allow above the head. For a three-quarter or full-length figure you will usually have to include some of the room, though a common convention for standing figures is to leave the background vague to prevent it from competing with the figure.

If you choose to make the setting a part of the composition you have the advantage of being able to provide visual clues about your sitter's interests. A portrait is not just a description of features; it should convey something of the character and atmosphere of the person as well.

A device which has been used by portrait painters from Renaissance times onwards is to show the sitter with a selection of his or her personal possessions. This can take the form of a "mini-still life" of objects, but another approach is to paint people in their own homes rather than asking them to come to yours. The colour schemes and furnishings people choose are highly expressive of them, as are the clothes they wear.

It is usually taken for granted that portraits are painted indoors, but they don't have to be. Someone who leads a mainly outdoor life, such as a farmer, a gardener, or a landscape painter who works out of doors could be painted in this natural setting, with the portrait treated in a more informal manner. Artists who habitually work together often paint each other in this way, and often produce a convincing "likeness" when the face is not even visible, simply by accurate

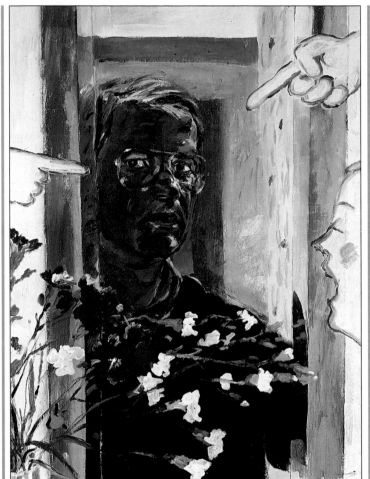

◄ **Gerry Baptist**
Self Portrait

The hands and head at the top and right side of this unusual selfportrait on canvas board represent an audience – the viewers of the painting process. Most portrait painters are familiar with the experience of would-be helpful remarks made as they work, and here the artist has "painted in" the comments, bringing the viewer into the portrait. The hands and head play a part in the composition also, as they focus all our attention on the face, whose rich colours have been achieved by laying both opaque paint and transparent glazes over a brilliant red underpainting.

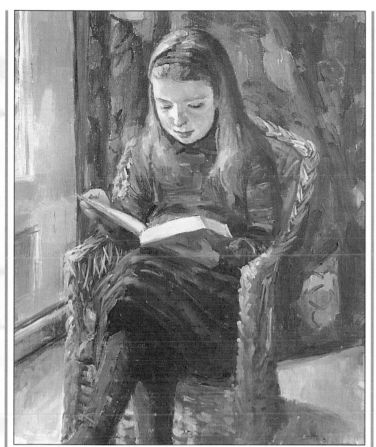

▲ Ted Gould
Girl Reading

Children are not the easiest of portrait subjects, but can often be painted in short sessions when absorbed by some favourite activity, as in this charming study. The artist has worked on canvas board, starting with a thin underpainting and building up gradually to thick IMPASTO. He uses retarding medium to enable him to manipulate the paint for a longer period.

▼ Gerry Baptist
Jean's Father

In this portrait on canvas board, the artist has used a traditional compositional arrangement, cropping the head on the right and thus allowing more space in the direction of the sitter's gaze. The dark background accentuates the vivid red of the jacket and the bright colours used for the face itself.

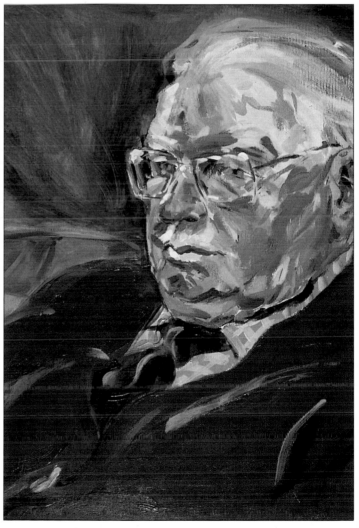

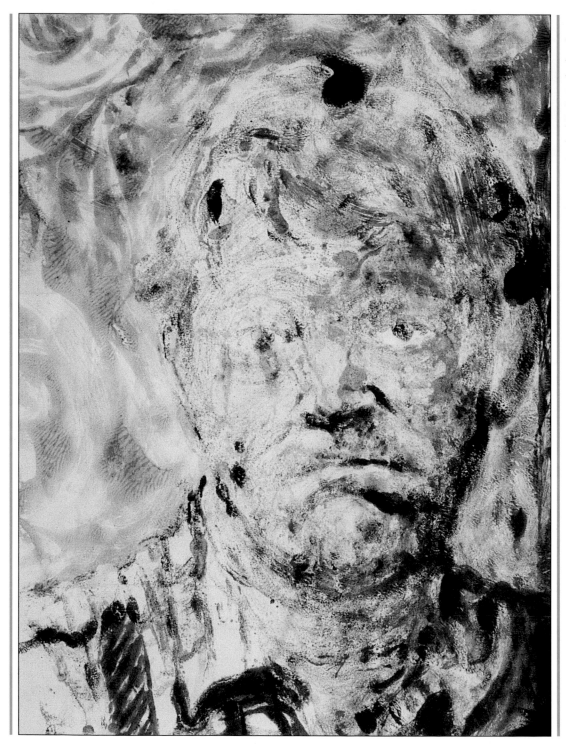

◄ Paul Bartlett
Smoker

The artist has used the MONOPRINT technique for this unusual portrait, a perfect method for creating the soft effect of the smoke swirling around the head. The paint dried out slightly before the print was taken, giving an attractive scumbled effect on the head. Although monoprint can be unpredictable and sometimes imprecise, the depiction of the features in this case is extraordinarily accurate and convincing.

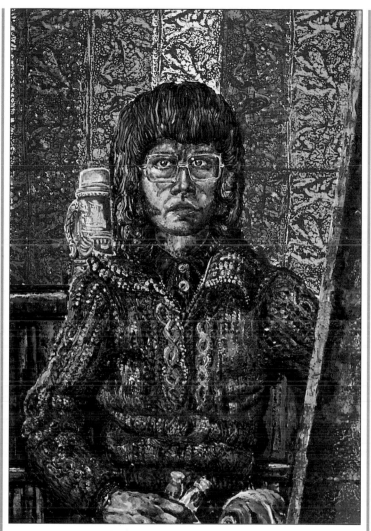

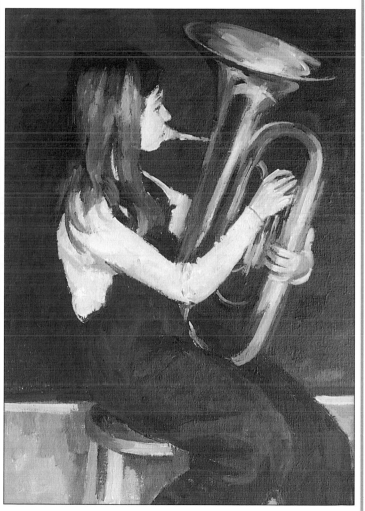

◄ Paul Bartlett
Self Portrait at Sixteen/Seventeen

This artist enjoys experimenting with different techniques, and here has combined acrylic with gouache and screenprinting, which he used for the underpainting and the wallpaper respectively. The heavy textures were built up in a number of ways, including KNIFE PAINTING and EXTRUDED PAINT, and the shirt buttons were modelled in acrylic, allowed to set, and then stuck onto the painting surface.

► Ted Gould
The Musician

This painting on canvas board began with a drawing in thinned acrylic, after which thicker strokes of pure colour were applied, using bristle brushes. The painting is beautifully composed, with the tuba balancing the slight backwards lean of the body, and enough of the left leg shown to create a sharp curve at the bottom of the picture. Notice also how the colour of the hair echoes that of the brass instrument, creating a visual link between the two.

THE NUDE

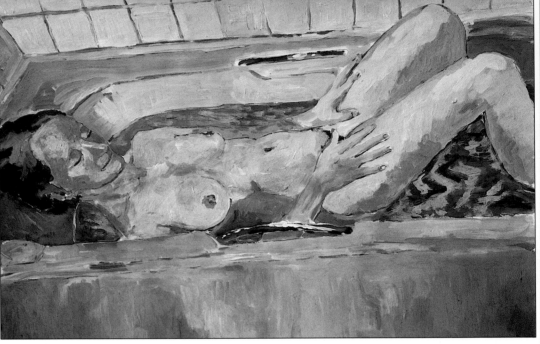

The unclothed human figure has featured in paintings ever since the Renaissance, though the manner in which it has been depicted has changed radically over the centuries. Until the late 19th century, when the French Impressionists changed the course of art, the nude was acceptable only in the safe context of classical mythology. Naked gods, goddesses and nymphs disported themselves in often far from seemly ways, but to paint a living model and call it a work of art was unthinkable. Manet's famous *Olympia*, painted in 1863, was condemned as an outrage to public morality.

However, drawing from the nude was considered an important discipline, and was part of every art student's education. There is no doubt that it is an exciting challenge, and after a period of eclipse earlier in this century when representational art was unfashionable, life drawing and painting is resuming a central role in art.

Although it is widely believed to be very difficult, it is perhaps less so than portraiture, as you don't have to worry about details of facial features – in all the paintings shown here the faces have been treated very broadly. The important thing is to understand the "dynamics" of the pose – the directional thrust of body and limbs and the way the model is distributing his or her weight – and to get the proportions right.

Proportions can be checked by holding up a pencil or paintbrush at arm's length and sliding your thumb up and down it to check one measurement against another. This is particularly helpful when you are dealing with foreshortening, which can cause distortions that are hard to believe unless you make checks of this kind. You can see the effect of foreshortening at its most extreme in Daniel Stedman's painting.

▲ Daniel Stedman
The Bath

Nude women washing or taking baths are a popular subject, painted by Edgar Degas and Pierre Bonnard, among other famous artists. In this painting the bath frames and encloses the figure, with the dark water enhancing the warm flesh tints. The colours are carefully orchestrated, with the pink of the face picked up in the foreground bath panel, and the creamy yellows on the legs finding their echo in the tiles behind the bath.

▼ David Cuthbert
Studio Nude

In this quick study on paper the artist has used the bed and bedclothes as a compositional factor to frame the figure, and has given a sense of movement to the subject through bold, swirling brushstrokes. The paint has been used quite thinly, and the flesh colours built up with a series of overlaid transparent glazes of water-diluted colour.

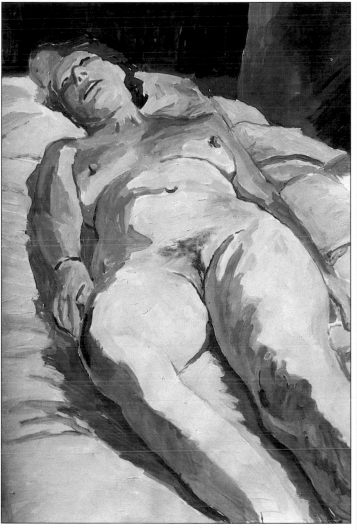

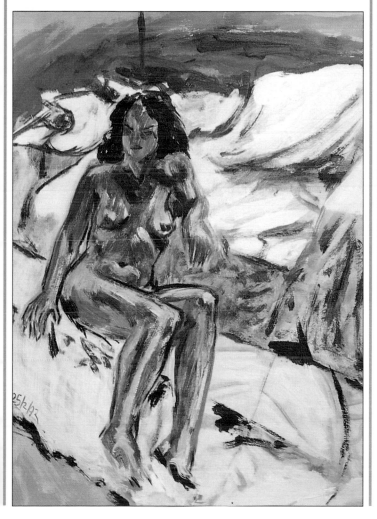

▲ Daniel Stedman
Lying Nude

A foreshortened reclining figure, although it can present problems of drawing, often makes an exciting composition, as in this case, where the diagonals of the legs sweep up and into the picture, leading the eye towards the torso and the slanted head. The colour of the dark background, which is the perfect foil for the warm skin colour and subtle hues of the bedcover, has been echoed in the shadows below the legs. Repeating colours from one area of the picture to another helps to preserve compositional unity.

FIGURE GROUPS

Once you are confident in drawing and painting individual figures it is a small step to composing groups. Your priorities here will be somewhat different, however, because you must consider not only how to make each figure convincing but also how to cope in compositional terms with the interactions between the figures. Groups of people usually have a reason for being together. They may be sharing an activity, or simply be linked by being in the same place – perhaps shopping or standing in a bus queue. You can express these unseen links by creating visual ones, such as a figure leaning across or towards another, or the arm of one person overlapping the body of another.

Paintings of figure groups usually have to be done from sketches, though photographs can also provide ideas for paintings. If you have made drawings in a life class or sketches of people out of doors, you might try some initial experiments with these, putting them together in different ways until a composition begins to emerge.

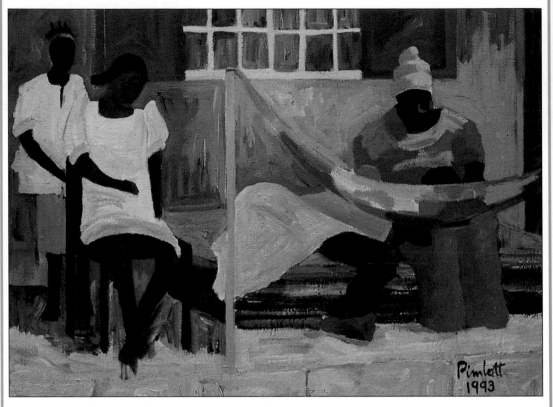

▲ Geoff Pimlott
Mid-day Rest in Gunjur

This powerful painting relies for its impact on the pattern of light and dark against golden brown. Although no attempt has been made to describe the people in terms of individual faces and features, the picture is full of atmosphere and a strong sense of place, deriving from the colours and the carefully observed postures of the figures. The painting is on primed canvas, and was developed from a series of colour studies made in the studio from sketchbook drawings. The paint has been used undiluted, and built up with broken brushwork, allowing areas of underpainting to show through where appropriate.

▶ Robert Burkall Marsh
The Fish Market

Here the figures are linked by a common purpose – the purchase of fish. The painting is full of movement, with the eye led around the composition from the diagonal slant of the fish to the arms and faces of the figures. Although the colour scheme is muted – almost monochromatic save for the dash of orange – the strong light-dark contrasts create a feeling of vitality.

◀ Ray Mutimer
Paddlers

This highly organized and decorative painting was composed in the studio from sketchbook studies – nearly always necessary for figure groups. The colours and textures of the fabrics are a key element, and the artist employed some unusual techniques to achieve them. The paper was first coloured and then textured by spattering fixative into an acrylic wash. The figures were drawn on this prepared ground, colours were laid on, and the patterns on the clothes were made by impressing embossed wallpaper into the paint while it was still wet.

FIGURES IN LANDSCAPE

Figures in landscape can be a branch of portraiture, or a figure can be used simply to provide a focal point or to explain the scale. A small figure in the middle distance of a panoramic scene, for example, will emphasize its depth and help to create the illusion of space and recession.

The way you treat the figure or figures obviously depends on which approach you are taking. A distant figure can often be treated quite sketchily, perhaps with a brushstroke or two of colour, but when the figures are in the foreground, as in the paintings here, you must engage with them in more detail. Photographs and sketches can again provide useful reference, particularly for moving figures. If you are making sketches with a particular painting in mind, however, make sure that you give some indication of both the direction of the light and the scale of the figures in relation to the landscape, as otherwise you will find it difficult to integrate the two elements of the painting.

▲ Ted Gould
Woman With Cat

The figure has been cleverly integrated into the landscape so that figure and trees form a continuous pattern across the picture surface. The artist has been more concerned with the interplay of colours and shapes than with creating space or building form – there is the bare minimum of modelling on the figure. Notice how the repetition of colours from one part of the picture to another creates visual links. The red of the jacket also appears in the foreground flowers and left-hand tree trunk, while the dark blue of the jeans is repeated behind the figure and on the hair. The artist likes to use a restricted palette, as he finds this helps him to achieve unity of colour.

▲ Bart O'Farrell
Daffodil Pickers

Here the figures dominate the landscape, which is treated in detail only where it surrounds and explains the activities of the men – the distant hills are merely suggested by slight tonal variations. The composition is masterly, with the first three figures forming a sharp triangle from which the eye is led along the light line of grass by the fourth tiny crouched shape. The colours, too, are scrupulously controlled; the yellow of the garments has been "knocked back" so that it does not stand out too strongly against the misty background.

DEMONSTRATION
THE FIGURE

By painting his craftsman sitter in his own home, holding one of his creations – a carved angel – and surrounded by characteristic clutter, *David Cuthbert* has achieved an "in-depth" likeness that has as much to do with atmosphere as with facial features.

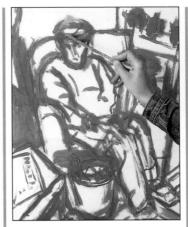

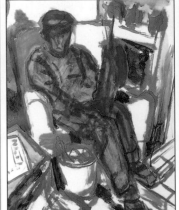

2 Using a deep olive green which will also play a part in the final colour scheme, he now sharpens up the drawing and clarifies the composition.

3 Next he lays a glaze of transparent colour over the whole of the figure and the angel – the latter will be the brightest area of colour in the painting. This underpainting will also provide a base colour for the skin tones, the cap and clothing, though much of it will be covered by subsequent applications of paint.

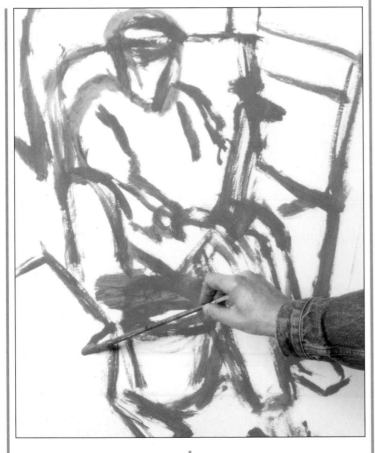

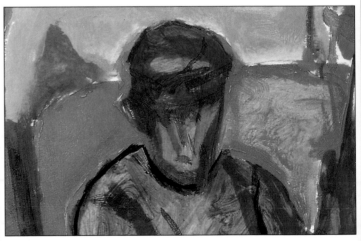

1 Working on watercolour paper, the artist begins with a brush drawing. His choice of this brilliant magenta is not accidental; his method is to start with vivid colours and modify them as the work progresses.

4 Greens and blues have now been introduced to balance the hot red-orange, and darker paint is used to focus the drawing of the cap and sweater.

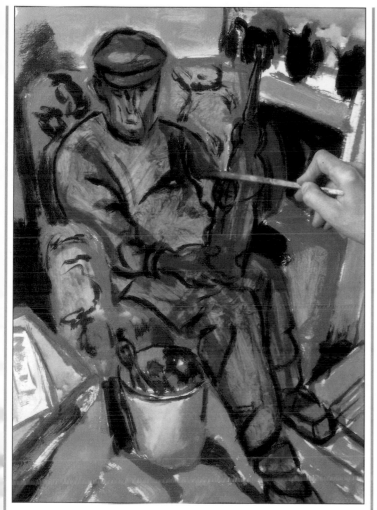

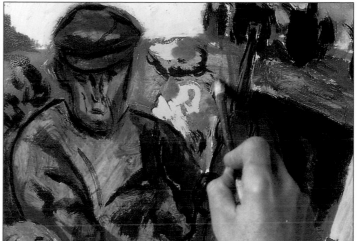

5 Both the tones and the colours are constantly reassessed and adjusted. It is interesting to compare this photograph with that of the finished painting shown overleaf, where the blue foreground has been overpainted and the green of the chair back plays a less dominant role.

6 The blue background has been overpainted with near-white, and the pattern on the chair back is built up with light opaque colours. These two areas of the painting are important, as they will balance light colours to be introduced in the foreground.

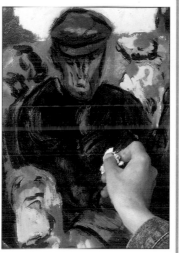

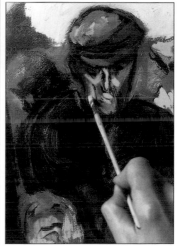

7 To continue the process of establishing the tonal structure of the painting, the artist now works on the sweater, laying dark colour over the underpainting and wiping it with a rag to give a loose, uneven coverage.

8 Because he likes to develop the whole picture at the same time, definition of the face is left until a relatively late stage. Opaque paint is now used to give the first suggestions of modelling on nose and cheekbones.

135

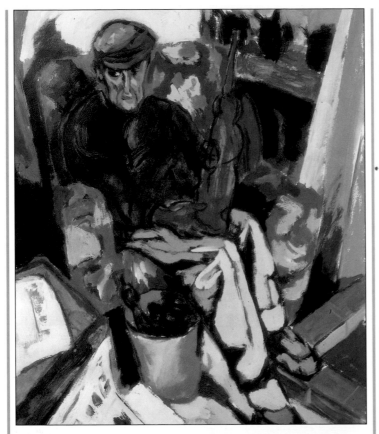

11 The rough texture of the sweater has been built up with a light scumble of opaque colour, while directional brushstrokes describe the form of the arm beneath the sleeve. The tiny patches of orange underpainting left uncovered create a link between the garment and the wooden angel.

9 The painting is now at roughly half-way stage. The colours and tones, although they will undergo further modification, provide a satisfactory basis for building up more detail.

10 This detail clearly shows the artist's method of working over a transparent underpainting. Even in the finished painting small patches of the magenta underdrawing will be visible.

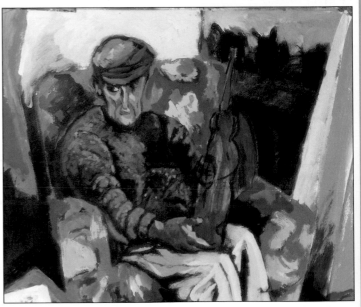

12 Although the artist has continually revised the colours, no one layer of colour has been completely obliterated; patches of the original blue can still be seen in the foreground; much of the green remains on the chair arms, and the orange underpainting is clearly visible on the side of the cap.

13 The finishing touches are given to the wooden angel. The body and head have been very lightly modelled with dark transparent glazes, and highlights are now added in opaque paint with a fine bristle brush.

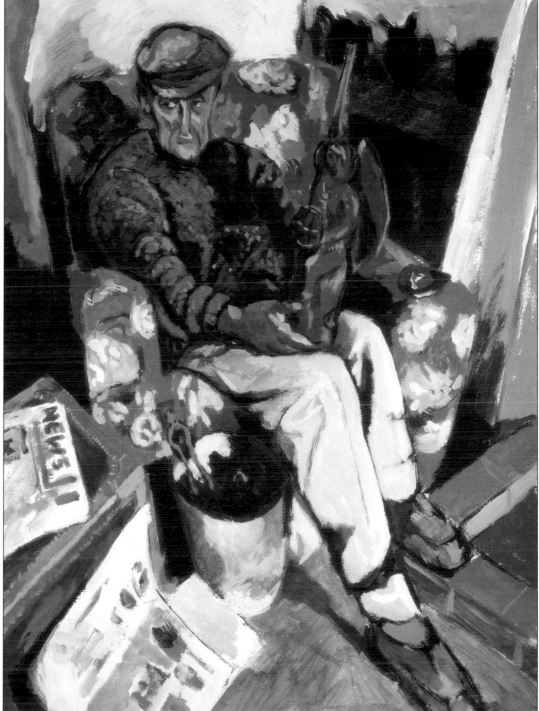

Finished picture
Finally, light yellow glazes of paint well thinned with water were laid over the foreground and background to "warm up" these areas and thus unify the overall colour scheme. If you look back at step 12 you will see the dramatic difference this has made.

ANIMALS

To some degree, animal painting is a specialized branch of art. There are painters and illustrators who make it their primary field, often as the result of a deep fascination with wildlife – some wildlife painters are also qualified zoologists or ornithologists who spend long hours observing and photographing their subjects before painting them.

But while it takes considerable skill, experience and practice to produce paintings of scientific value, correct in every detail, many fine artists, notably Théodore Géricault (1791-1824) and Edgar Degas (1834-1917), included animals in their repertoire, and there is no reason why you should not do the same. Both these artists painted horses and jockeys, Géricault because he was a passionate horseman and Degas because he enjoyed the atmosphere of the racecourse and was fascinated by movement.

Gathering Information The main problem with animals is that they don't stay in one position for long, which makes it difficult or impossible to complete a painting in one session. There are exceptions, such as cats sleeping in the sun; sheep, which don't move far unless you frighten them; and cows lying or grazing in a field. But in general you should get into the habit of sketching animals so that you can work your sketches up into a composition at home. You can also work from photographs, but this may give your painting a static quality unless you compensate by using the paint in an expressive and energetic way.

You can sketch in pencil or pen, but if you want information for a painting you will need colour reference too, so it is wise to use paints from the start. For speed, you could use thin washes of acrylic on paper, strengthened with pencil or charcoal (see PENCIL AND ACRYLIC, CHARCOAL AND ACRYLIC). Apart from their value as references for painting, such sketches will help you become familiar with the forms and characteristic movements of animals, and may even turn out to be pleasing works in their own right.

Texture The texture of an animal's fur or hair is one of its most pleasing qualities, and acrylic is highly suitable for rendering a wide range of textures, from the sheen of a well-kept horse to the shaggy coats of some dogs. You can use BLENDING techniques, or directional brushstrokes of thick paint; you can build up textures with DRY BRUSH techniques or SCUMBLING; or you can combine paint with other media. PASTEL AND ACRYLIC, for example, is ideal for textures and also helps to impart a lively feeling to the image.

◄ Robert Burkall Marsh
Past the Post

Movement is wonderfully well suggested in this painting by the loose brushwork used for both the sky and the horse and jockey. The composition also plays a part in the depiction of movement, the way the horse's body has been cropped on the left seems to impel it forward, following the line of the jockey's back.

▲ Michael Kitchen-Hurle
Peaceful Waters

The swans' bodies against the dark grass form a pattern of light on dark, a theme carried right through the painting by the inclusion of the white flowers on the left and the dark foliage at top right. The latter is also important for its role in explaining the dappled shadow cast on the birds' plumage and the points of light on the grass.

ENVIRONMENT

If you are sketching animals for practice you need not worry about the setting, but in a finished painting you will usually want to show the creature in its characteristic environment, whether domestic interior, garden, farm building or landscape. When making sketches for a finished painting, try to give yourself sufficient information about the setting – you might make separate studies of any feature which will play a part in the composition.

The way you treat the setting depends on your overall approach. It is vital to marry the two elements of the painting, so if you intend to portray the animal in a broad, impressionistic manner, don't introduce too much detail into the surroundings – you may be able simply to suggest them with a few brushstrokes. If you prefer a more descriptive approach to your subject, the setting must be painted with equal attention to detail, as in Michael Kitchen-Hurle's delightful painting of a fox.

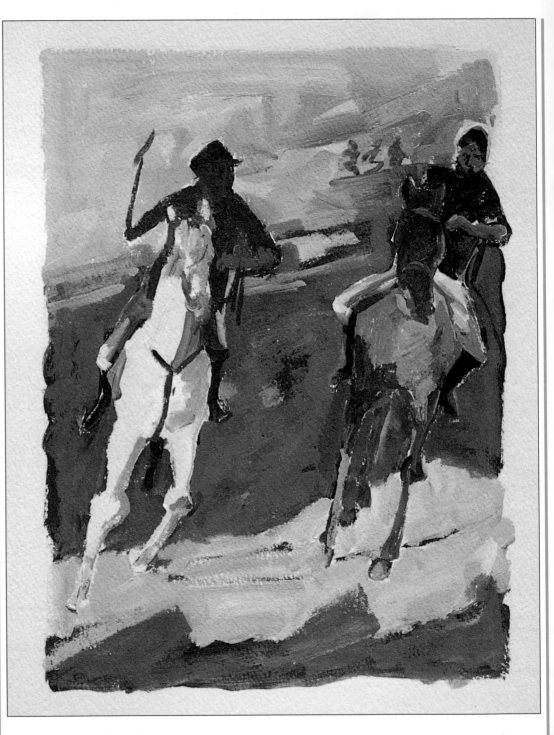

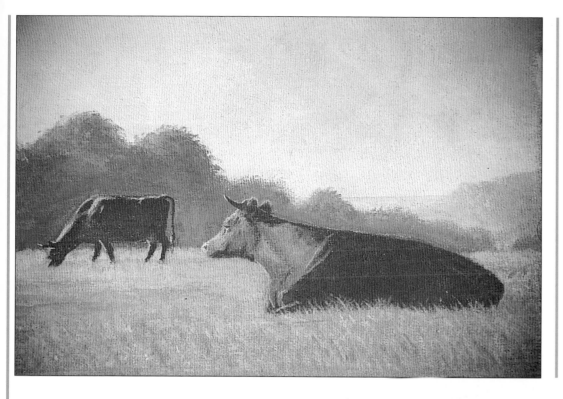

◄ Bart O'Farrell
Evening Light

A more detailed approach has been taken to both the animals and their landscape setting in this tranquil painting, but the evening light silhouetting the forms has allowed for a degree of simplification. The painting surface is muslin stuck onto hardboard, and the paint has been used thinly enough for the texture to be clearly visible.

▼ Michael Kitchen-Hurle
Sleeping it Off

This beautifully painted study is reminiscent of Victorian watercolours in its delight in detail and texture. The fox's fur and the grass have been built up in a series of tiny brushstrokes of medium-thick paint, while transparent washes have been used for the shadows on the cart.

◄ Helena Greene
Gilgit

In this exciting painting on watercolour paper, detail has been kept to a minimum in order to express fully the all-important sense of movement. Although polo players and background are treated with no more than a few bold brushstrokes, their actions and positions are so well observed that they carry complete conviction.

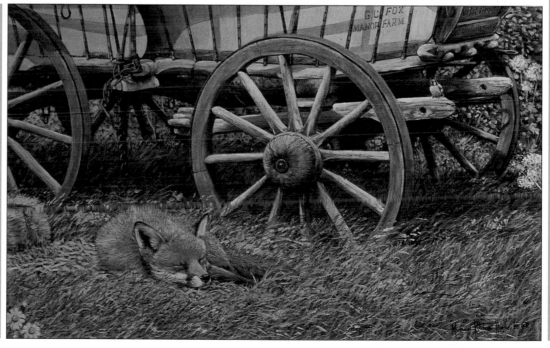

BIRDS AND FISH

Birds and fish may present special problems, as they cannot usually be sketched in their natural surroundings. There are notable exceptions – such as geese, ducks and swans on lakes and ponds, or garden birds feeding from a bird table, all of which make attractive subjects – but for fish or birds in the wild, you may have to rely mainly on photographic reference. There is nothing wrong with this – most wildlife artists make use of the camera – but it is important to observe the subject carefully as well as photographing it, or your paintings will lack the first-hand experience that gives them feeling and authenticity.

In order to familiarize yourself with the structure, colours and plumage of birds, and the shapes and forms of fish, you could also try making studies from museum exhibits or consulting the drawings and paintings in natural-history books and magazines. The latter will also provide information on habitat.

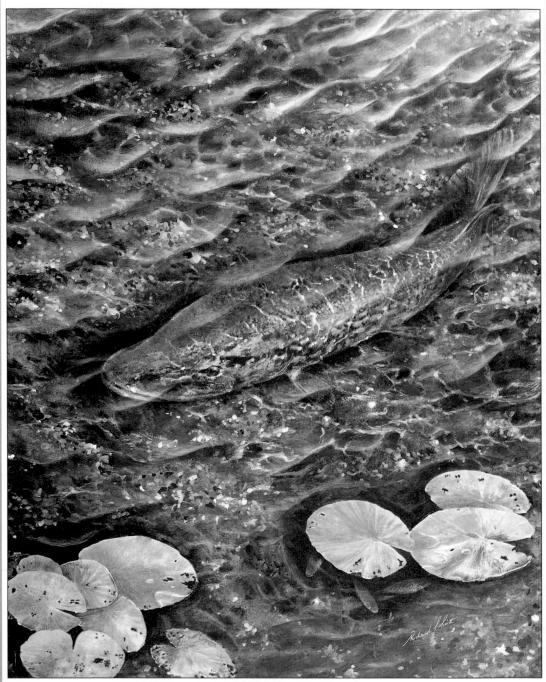

◀ Richard J Smith
Over the Shallows – Pike

Smith is a professional wildlife artist, and his paintings are evidence of how thoroughly he has observed his animal subjects and their habitats. The painting is on hardboard, primed with acrylic gesso to provide a smooth surface, and the paint has been diluted with gloss medium. The effect of the water surface reflecting light was achieved by brushing a thinned blue-white glaze over the surface with single strokes of a large household paintbrush.

▶ Richard J Smith
Trafalgar Square

A primed hardboard panel was also used for this painting, but here the colours were thinned with matt medium rather than gloss. Relatively thick paint has been used for the plumage of the birds – notice the individual brushstrokes of white and near-black on a thinner, mid-toned underpainting. The puddles have been built up in a series of glazes, opaque in the centre and becoming more transparent towards the edges.

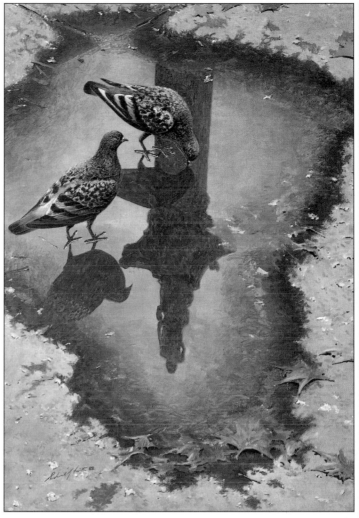

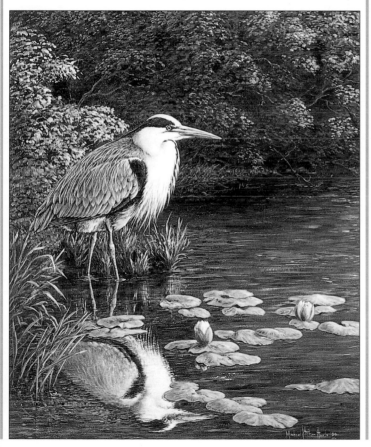

◀ Michael Kitchen-Hurle
Silent Sentinel

The painting captures the colour, texture and characteristic stance of the heron, a bird which remains immobile for long periods while waiting for fish to catch – a habit that makes it easier to observe and paint than most other birds. The waterlilies in the foreground and the sunlit foliage on the left provide a compositional foil for the brilliant white of the bird's breast, repeated in the reflection.

DEMONSTRATION
ANIMALS

The basis for this composition by *Judy Martin* was a black-and-white photograph, which allowed the artist freedom over the choice of colours. As a long-time cat owner she is familiar with feline subjects, and has studied and sketched her own cats extensively.

3 This vertical line is important, as it provides a balance for the diagonal formed by the body of the cat, so an edge of paper is used as a ruler to ensure that the line is straight.

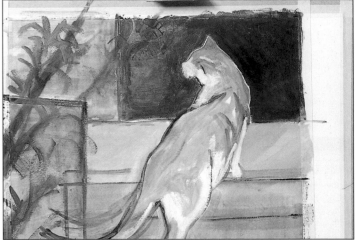

4 The first colours are now laid over the underpainting. The orange provides a key for the painting, but will be modified as the work progresses.

1 Working on watercolour paper, the artist begins with a brush drawing to establish the placing of the cat; the emphasis is on strong curves sweeping diagonally across the centre of the picture.

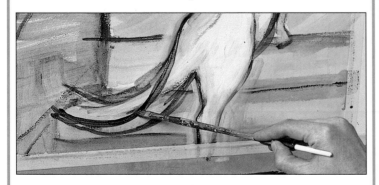

2 A monochrome underpainting is made next, and at this stage the drawing is amended by bringing the tail lower down and placing masking tape across the bottom of the picture to give a tighter crop. Previously, the leg had been cropped just above the foot, which looked awkward.

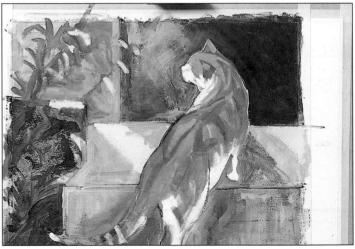

5 The colours of the cat are now built up more richly, beginning to define the forms of the animal, and greys and yellows have been lightly scumbled over the wall.

This same broken-colour effect has been applied to the background, contrasting with the crisper painting of the animal's head.

6 The markings and texture of the cat's fur have been accurately depicted by a combination of dry brush and lightly applied wetter paint. Further modelling is now given to the animal's body, with a rag used to push the dark paint into place and hold it away from the white area.

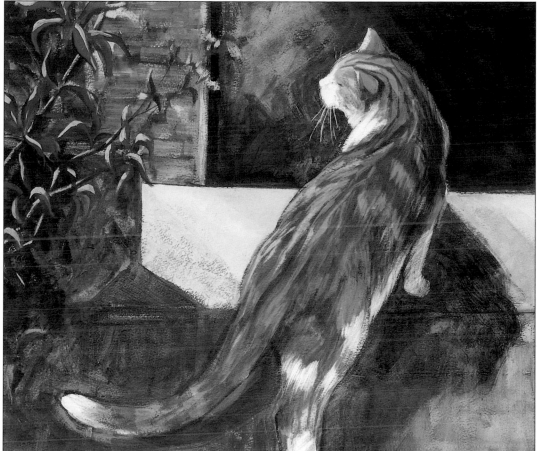

7 With the cat completed, the artist can now assess how much detail and definition is required elsewhere in the painting. Thick, light-coloured paint is applied with a nylon brush to create highlights on the leaves and branches.

Finished picture
The definition of the left-hand side of the painting plays an important part in the composition, as a focus is needed in the direction of the animal's gaze. The dark and light rectangles are equally vital in compositional terms, providing a geometric framework for the long curves of the body and tail.

STILL LIFE

From a purely learning point of view, still life has many advantages. You can paint whatever you choose, arranging the group as you like to provide an interesting composition and combination of colours. You are not reliant on weather, as you are on location, and you can paint at your own pace, experimenting with different techniques and approaches. Still life offers the best opportunity for getting to know your medium, but it is more than just a means of practising your painting skills. Because you exert complete control over your subject, it is also a highly satisfying branch of painting.

Subjects If still life is less popular than it should be – and it is certainly less favoured than landscape painting – this may be simply because the breadth of choice makes it difficult to know where to begin. Floral groups, fruit and vegetables, rich textures and reflective surfaces are frequent choices, and rewarding to paint, but many more commonplace objects can form the basis of a still life. Examples might be a pile of books on a table, a pair of shoes in the corner of a room, kitchen utensils hanging on hooks, or your paintbrushes left in a jar after a working session.

You will sometimes happen upon an arrangement of objects that suggests a painting, such as glasses and crockery left on a table after a meal, or some knitting and colourful balls of wool in an armchair. This kind of still life, which is not deliberately set up – though you may have to make some minor adjustments – is known as "found", and is by no means restricted to indoor subjects. Outdoor found groups could include garden tools leaning against a wall, garden chairs or deckchairs, plant pots in a greenhouse, or perhaps a group of stones on a beach, which could provide an intriguing exercise in rendering different textures.

Lighting If you are painting outdoor still life you will have to take the light "as it comes", as in landscape painting, but lighting for indoor set-ups needs consideration. If you have arranged a group by a window, remember that the light will change, particularly if the window faces in any other direction than north. To avoid extremes of sun and shade it can be helpful to place a diffuser, such as a net curtain or some tracing paper, over the window.

In general you want to avoid a hard light coming from in front of the subject, as this flattens out the forms and only casts shadows behind the objects, where you can't see them. Shadows can be important, not only in creating a pattern of light and dark but also in helping you to set up links between objects. It is worth trying out different lighting effects while you are arranging the group, by taking one or two objects and placing them in different parts of the room. If it is a small group you may even be able to carry your entire arrangement around until you find the light that suits it best.

◄ Ray Mutimer
Market Pots

This intriguing painting is a good example of a subject seen by chance rather than deliberately set up in the artist's studio. The treatment is interesting also; instead of dealing with each of the objects in detail, the artist has simplified them and woven them into a pattern of shapes and colours, carrying the predominant blue-yellow theme right through the painting.

◄ Sara Hayward
Shapes II

Here again, as the title implies, the artist's interest is in the juxtaposition of shapes, and a child's toy has provided a subject which seems tailor-made for the theme. Notice how the objects have been arranged to form a lively composition, with the triangle of the table top at the bottom of the picture echoing and balancing the smaller triangles and other shapes on the toy.

FLORAL
STILL LIFE

Flowers are among the most popular of all still life subjects. They can be painted on their own, or used as one element in a group which might include fruit or some other objects that complement the flowers in terms of colour.

A flower group, however simple, needs care in the initial arrangement and equal care in the composition of the painting (see following pages). In both the paintings shown here the flowers have been treated as an overall mass of colour, the detail of individual blooms being of secondary importance. In such cases the shape made by the flowers in the vase and the orchestration of the colours is of primary concern, but if you prefer to focus on individual forms a simpler arrangement, with fewer flowers, would be appropriate.

Try to limit the colour scheme so that you don't have too many flower colours all fighting for attention. Many of the most effective floral groups have one predominant colour, for example, blue, with perhaps one or two yellow flowers for contrast. This creates a harmonious effect in keeping with the delicacy of floral subjects.

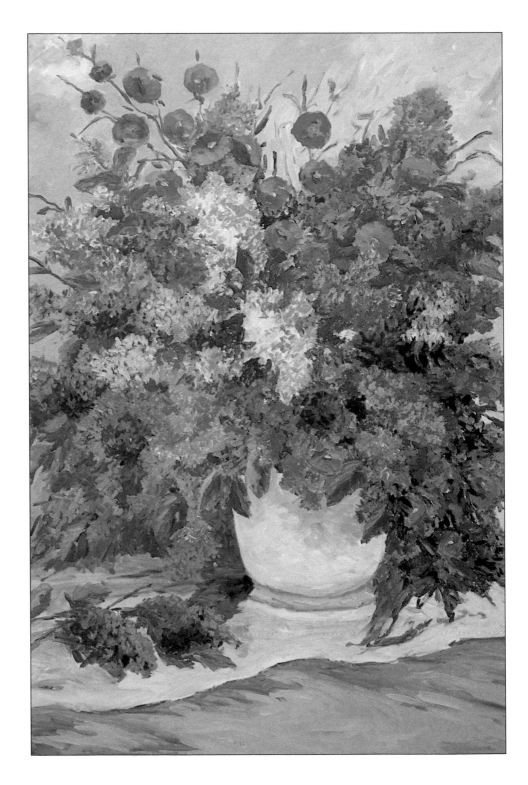

◄ **Valentina Lamdin**
Lilac Time

This lovely painting on canvas derives much of its impact from the broad mass of glowing colour, though there is sufficient detail to enable the viewer to identify the flowers. The colours have been chosen with care to provide both an overall harmony and touches of contrast, and the warm pinks and violets have been carried through into the background and foreground to unite each area of the painting.

► **Jacquie Turner**
Bluebells and Other Spring Flowers

Both these paintings have a similar subject matter and arrangement, but the treatment could not be more different. Here the artist has taken a more impressionistic approach, expressing the brilliant colours and living quality of the flowers through lively brushwork and inventive use of paint and surface texture. The painting is on smooth watercolour paper, with various media, such as wax crayon and chalk, used with pot and tube acrylic. There are also touches of collage – small pieces of pre-painted tissue paper stuck on with acrylic medium.

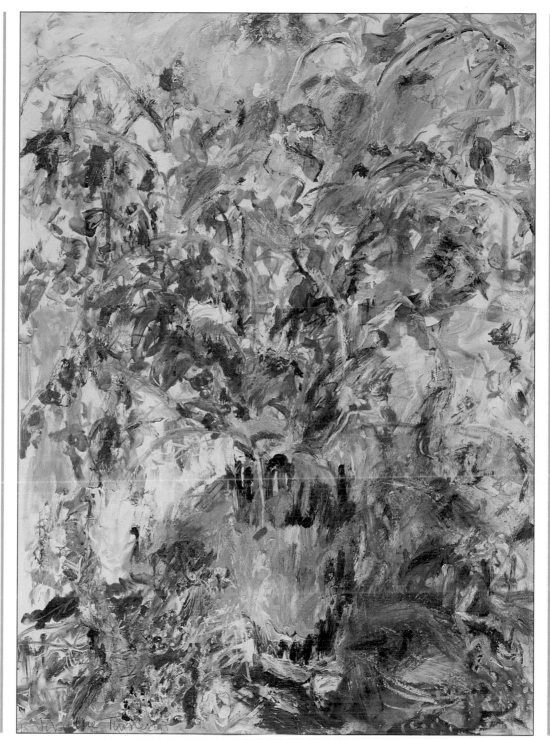

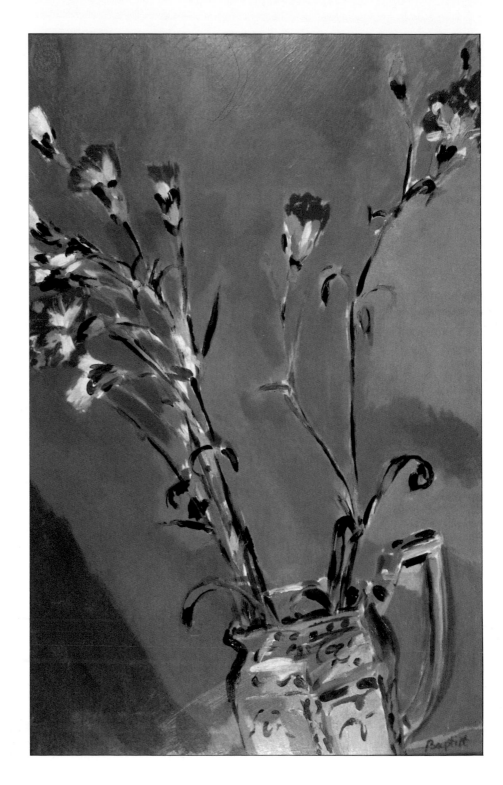

COMPOSING FLOWER GROUPS

Once you have arranged the flowers, think about how you will place the group on the paper or canvas. You will sometimes find that you have a blank space at either side of the vase, and you may need to introduce some additional element to create interest in the foreground. A frequently used device is to place one of the blooms on the table beside the vase, or to scatter a few petals.

It is not usually good practice to place the flowers right in the centre of the picture or to allow the front of the table to form an uncompromising horizontal in the foreground. If you want to view the group from directly in front, however, you could break this horizontal by arranging some drapery to hang partly over the front of the table.

If you are painting tall flowers or a wide-spreading arrangement you may be able to create a better composition by "cropping", that is, allowing one or two blooms or stems to go out of the picture at the top or sides. This suggests that the group has its own life, continuing beyond the confines of the picture area, whereas showing the whole of an object "freezes" it at a certain point in space.

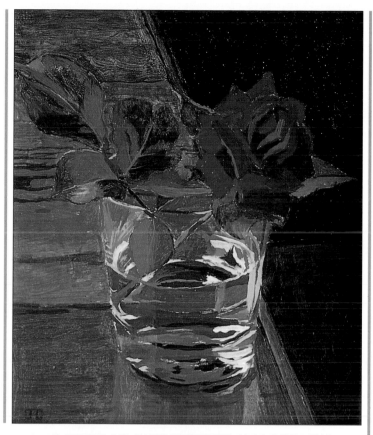

◀ Jeremy Galton
Red Rose

Contrasts of tone play an important part in this beautifully balanced composition, with the near-black background making the perfect foil for the glowing colour of the rose, and the dark leaves and brilliant highlights on the glass standing out against the brown of the table top. The painting is a small one, done on smooth mountboard with a yellow-brown priming.

◀ Gerry Baptist
My Mother's Jug

Clever use has been made of the cropping device in this painting on canvas board, and the sense of movement is enhanced by the deliberate tilting of the jug and the broad brushstrokes in the background which follow the direction of the stems.

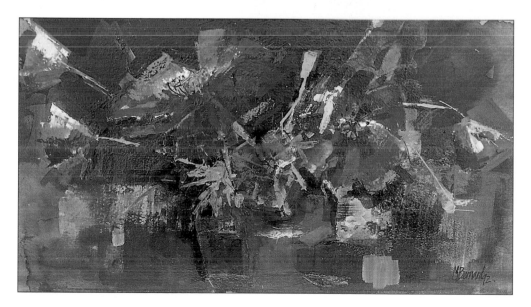

◀ Mike Bernard
Poppies

The wide horizontal format chosen for this collage-and-mixed-media flower group has allowed the artist to make the most of the flowers and stems while reducing the vase to little more than a suggestion of a shape. The background is always an important element in still-life compositions, and here has been fully integrated into the painting, with the shapes, colours and textures echoing those of the flowers.

TEXTURE AND PATTERN

Texture can form an integral part of still-life painting, with objects chosen to exploit contrasting surfaces – smooth, shiny vegetables contrasted with matt ones, for example, or metallic objects juxtaposed with light-absorbing velvety fabrics or rough open-weaves. The Dutch still-life painters of the 17th and 18th centuries were particularly fascinated by this aspect of their subject.

Still life also provides opportunities for exploiting pattern, either that created by the arrangement of objects or the patterns of fabrics and decorated pottery and china. Using this element of ready-made decoration not only enables you to create richly colourful paintings but also helps you to describe form while retaining an element of flat pattern. By reproducing the way in which the pattern curves around a cup, or that on a fabric is broken by folds, you can describe forms and structures without undue reliance on tonal modelling, as Jill Mirza has done in her colourful and lively painting.

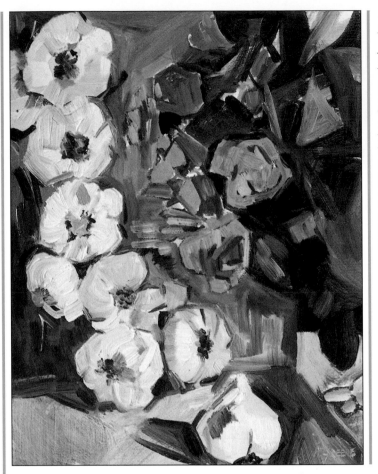

◄ Helena Greene
String of Garlic

The cloves of garlic curving from the top to the bottom of the painting make a lively pattern of light on dark, balanced by the orange-reds of the flowers on the right. The artist has not attempted to describe the objects literally or to mimic their textures – the painting has its own pattern and surface texture and exists independently of the subject matter. It was painted on oil-sketching paper, and was begun in acrylic and built up in oils (see OIL AND ACRYLIC).

► Doreen Bartlett
Fruit Still Life

Texture plays a major role in this delightfully simple but carefully composed still life. The smooth surface of the apple has been achieved by blending methods, overlays of colour, and transparent washes, while DRY BRUSH has been used for the tablecloth and areas of the orange. The painting is on paper.

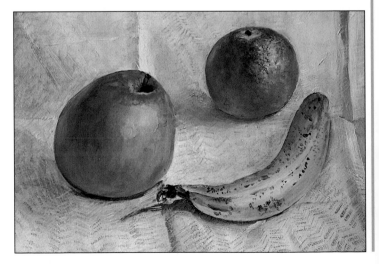

◀ Jill Mirza
Souvenirs Old and New

When there are so many pattern elements it is sometimes necessary to provide a "resting place" for the eye, and in this artfully contrived composition the artist has used one plain piece of fabric to contrast with the riot of colour and pattern. Interestingly, this upright rectangle of bright yellow drapery becomes the focal point of the picture. The painting is on watercolour board, and the artist has used both opaque paint and transparent washes.

▶ David Cuthbert
Vessels

This large painting on canvas (15.25m/5ft width) gives the impression of being a collage, but all the printed matter has been painted, with considerable use of MASKING tape to ensure accurate lines and edges. Textures, notably that of the tall vase, were built up by mixing sand into the paint, and glitter and palette scrapings were also used in places.

UNUSUAL SUBJECTS

The commonest type of still-life painting is a group of objects arranged to look as natural as possible, and usually with some theme – the objects are linked by association and thus appear to belong together. Culinary groups, with fruit, vegetables and kitchen equipment such as knives and plates, are an example of this kind of painting, as are arrangements of similarly shaped and textured objects such as bottles and glasses.

More unusual effects can be created by deliberately juxtaposing objects which don't have this natural relationship, thus creating a sense of tension and slight unease. This was an idea exploited by the Surrealist painters, and John Sprakes has used something of the same approach in *Still Life with Wedding Doll*.

You can also depart from still-life norms by focusing on a single object, whether outdoors or in. Surprisingly, although floral still lifes often portray a single flower in a vase, it is less usual to find objects dealt with in this way. The pictures reproduced on these two pages show how effective such treatments can be.

▶ Paul Bartlett
Fragment of a Demolished Church

The simple subject, with its gentle colour scheme, is enlivened by attention to texture. The painting is on brown paper, with some charcoal drawing over the paint, and the textures on the drapery were achieved by scraping a comb through wet paint and applying thin glazes over the top.

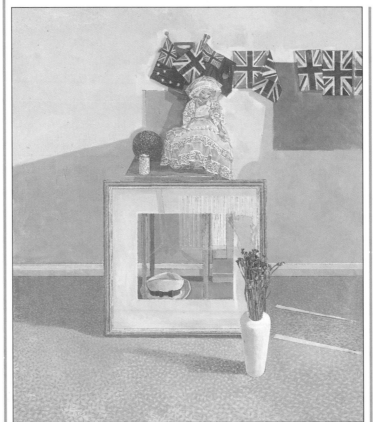

◀ John Sprakes
Still Life With Wedding Doll

This artist is interested in unusual juxtapositions and the way in which ordinary objects can be made mysterious by the artist's interpretation of them. In this painting, as in the majority of his still lifes, he has created a feeling of slight bewilderment by both the choice of objects and their arrangement. The painting is on canvas, with a substantial amount of underpainting, allowed to show through in places to create light and texture.

◀ Paul Bartlett
Sixth Form Refraction

As in John Sprakes's painting, the eye is arrested by an oddity in the subject – scissors are not usually left in jars of water. However, in this case, the still life was set up principally in order to explore the effects of reflected and refracted light rather than to create a surreal effect. The painting is on paper, with the paint used mainly in transparent washes.

▶ Earl Grenville Killeen
Mammoth Squid

This artist is fascinated by the shapes, colours and textures of machinery, and has made an exciting and unusual composition from bolts, clamps and twisting copper pipes. He works on linen mounted on hardboard, using his paint thinly and smoothly to emulate the textures. The colours and tones have been skilfully controlled to create both solidity and dramatic light-dark patterns.

DEMONSTRATION
STILL LIFE

A still life of fruit on a metal plate, a glass of wine and dried flowers in a raffia container provides *Ted Gould* with a colourful subject and an interesting and challenging contrast of textures

3 The paint is now made more opaque and slightly thicker by the addition of white, which had not been used previously. At this stage more colours have been laid out on the palette, but the range is deliberately restricted, with only seven colours plus white used throughout the painting.

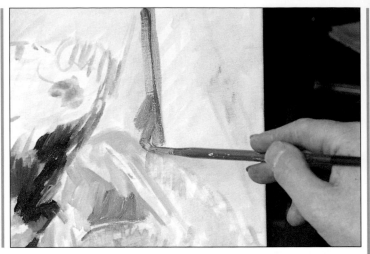

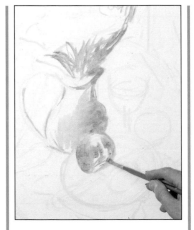

1 The support is a white primed canvas, on which a line drawing was first made in yellow. The next step is a thin underpainting in mixtures of crimson and two shades of yellow. The colours, mixed on a disposable paper palette, are sprayed with water to keep them moist.

2 The technique is the classic oil-painting one of building up from thin paint to thick. This underpainting establishes the basic drawing and composition as well as the colour scheme, with its predominance of warm hues.

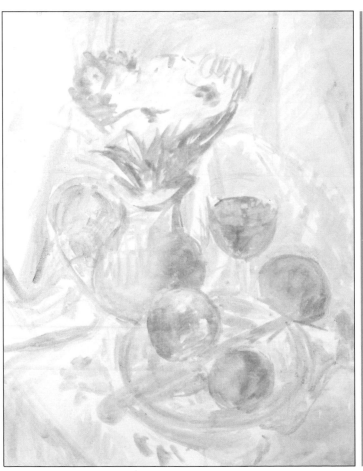

4 The artist works from the back to the front of the painting, viewing it as a series of planes. With the dark and light tones of the background drapery in place he can more easily assess the strength of colour and variations of tone needed in the foreground.

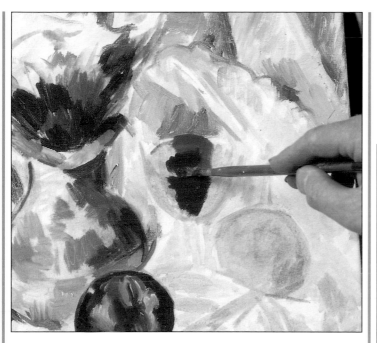

6 With the deep reds and greens of the background in place, he now has a key against which to judge the foreground colours and tones. The area is now in turn built up with thick paint. The greys are kept warm by admixtures of crimson and violet.

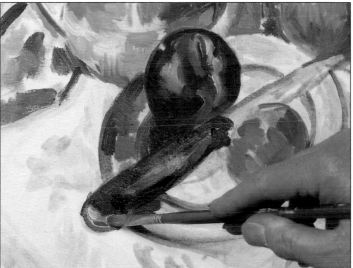

5 As he works he constantly assesses one patch of colour against another. The reds he is using for the flowers, the wine and the nectarine are intentionally similar, as he wants to maintain a unity of colour throughout the picture.

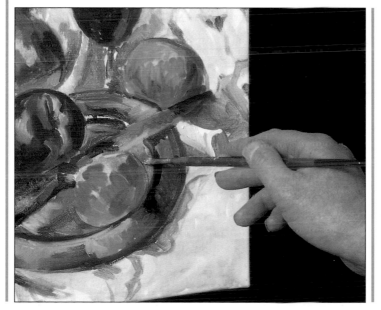

7 Further work is done on the plate with a small brush, paying particular attention to the contrast of tones and colours caused by the reflections in the metal. Notice how many different colours have been used in this area alone.

8 The texture of the raffia container now needs attention. This is initially established as an area of broken colour made up of small directional brushstrokes.

10 The most important detail is the rim of the glass, previously left unpainted in order to maintain the continuity of the drapery seen through the top of the glass. The rim is now painted very carefully with a small sable brush – ellipses are always tricky.

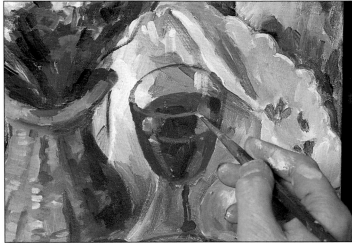

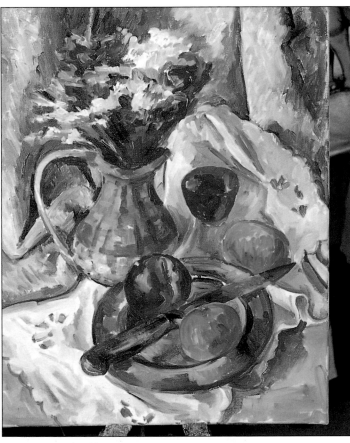

9 The painting is now more than half completed, with all the colours in place and the textures convincingly suggested. In the final stages the artist can concentrate on small details.

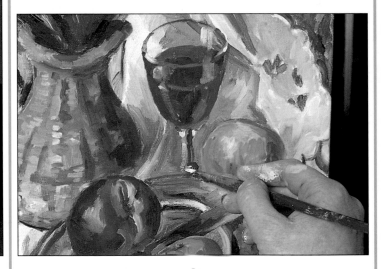

11 One of the joys of leaving the details until last is that you can save up the pleasure of putting in the highlights and seeing the whole painting come to life.

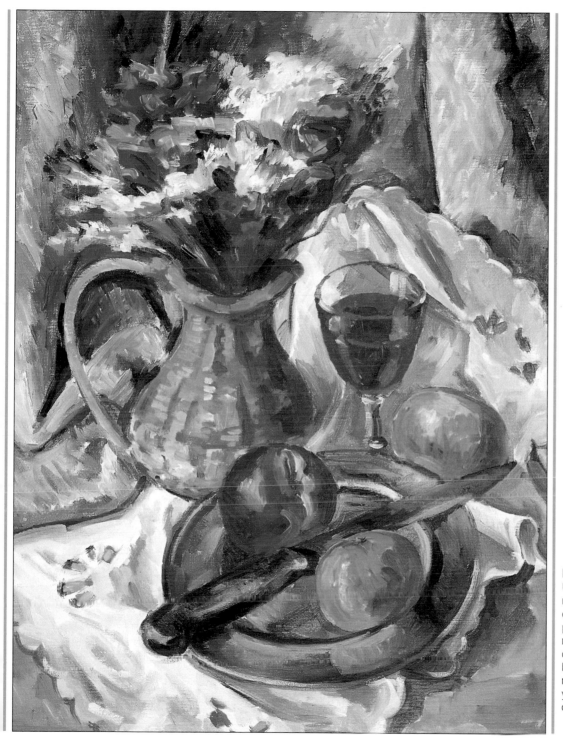

Finished picture

The brushwork is vigorous as well as descriptive, and the painting glows with colour. The greens of the background and the deep purplish greys of the plate and drapery provide the necessary touches of contrast to offset the predominant reds and oranges.

Palette

Using a restricted palette can make it easier to achieve unity of colour, as you don't have endless possible permutations for mixtures. The colours used in this case were titanium white, Mars black, deep violet, cobalt blue, naphthol crimson, cadmium yellow light, cadmium yellow and chromium oxide green.

ABSTRACTION AND FANTASY

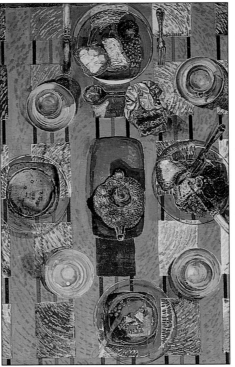

Although purely abstract paintings often appear unrelated to the real world, they nearly always have their starting point in something seen and experienced in the artist's life. The same applies to paintings that we would describe as fantasies, or works of the imagination. The human mind has a limited capacity for pure invention – reality appears even in dreams, although these may produce strange juxtapositions as well as distortions of time and space.

Because dreams play tricks with reality, dream imagery can be an important source for imaginative painting. The Surrealist painters, who drew heavily on contemporary theories of the subconscious, explored the incongruity and irrationality of buried images. In the words of André Breton, the purpose of Surrealism was "to resolve the previously contradictory conditions of dreams and reality into an absolute reality – a super-reality".

But Surrealism is not the only kind of imaginative painting, nor did the Surrealists invent the idea of working from dreams and the imagination. The great poet and painter William Blake (1757-1827) and the equally great Spanish artist Francisco de Goya (1746-1828) both produced works in which imagination and reality are fused. It is no accident that these two artists were almost exact contemporaries – at this time there was a reaction against the increasing tendency to explain everything in terms of scientific fact, reducing the significance of what had been thought magical and mysterious.

Abstract shapes Abstraction has a different starting point – here it is the arrangement of shapes and colours that forms the visual "message". The word abstract tends to alarm people, because it seems to imply that a painting will be impossible to understand. But paintings are not made to be "read" like books – they must be appreciated in their own terms. Most good paintings have an abstract quality, and you will often hear the phrase "abstract shapes" applied to a landscape, a portrait or a still life. This simply means that the relationship of shapes in the painting has its own importance, regardless of what the shapes may represent. Sometimes if you turn a painting upside down, making it unfamiliar, you will see this abstract pattern emerge. Pure abstraction is outside the scope of this book, but on the following pages you will see some examples of how the visual world can provide a stimulus for semi-abstract treatments.

▶ Paul Bartlett
*Contemplating the Great
Outside II*

In this small painting the
dominant theme is the interaction
of curving, rippling shapes,
anchored by the boats in the
centre. Textures, which play an
important part in the composition,
have been built up by laying
washes over EXTRUDED PAINT as
well as by scraping and pen
drawing over the dry paint.

◀ Paul Bartlett
Tabletop Sequence of Amounts

By taking a high viewpoint the
artist has been able to view the
still life as an arrangement of
shapes and colours rather than
as individual objects. He has not
treated them as flat shapes,
however, and has used texture
as a positive element in the
composition, contrasting trans-
parent washes with thick areas
of IMPASTO and EXTRUDED PAINT.

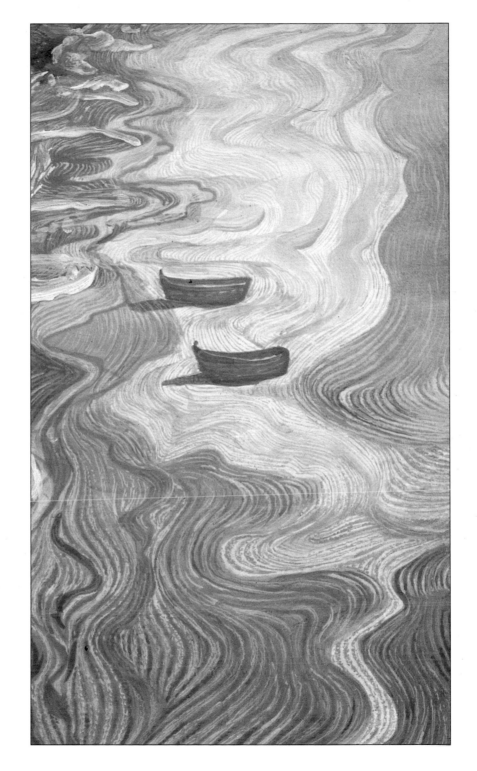

ARRANGING SHAPES

Still life and interiors can both form useful starting points for exploring abstract shapes and relationships. You could arrange a still-life group as you like and choose a viewpoint that makes a strong pattern of shapes. For example, looking down from a high viewpoint – you could arrange the group on the floor – reduces the objects' familiarity and lets a pattern of shapes emerge. You can see this effect in Paul Barlett's painting. Another approach is to silhouette objects against a strong light by placing them on a windowsill, for example, so that they form a pattern of dark shapes against light.

In interiors, especially sparse and uncluttered ones such as empty rooms or corridors, the intersecting vertical and horizontal shapes will often suggest an abstract treatment. Roy Sparkes's painting is not an abstract, but it relies for its impact on abstract qualities.

Texture can be important in abstract and semi-abstract treatments. When you depart from the strict representation of objects you often need to compensate by providing surface interest, and by manipulating colour, shape and texture you can stress the existence of the painting as an object in its own right.

◄ Robert Tilling
Evening Still Life

A still life of objects silhouetted against the light could be a good starting point for a semi-abstract treatment, as backlighting cuts out much of the detail and allows you to see shape rather than form. Here the composition is seen entirely as an arrangement of shapes and colours, with thick impastos achieved by thickening the paint with sand contrasting with areas of flat colour.

▲ David Ferry
Sizewell Series

In this painting, one of a series based on a nuclear power station, the artist has made a semi-abstract composite from various objects seen while working on the site. The dark, curving shape at top left, for example, was derived from a technical drawing of part of a reactor. Acrylic, used on thick paper, has been combined with collage; the bottom of the picture is a collaged photocopy of a photograph, stuck on with PVA medium (glue) and glazed over.

PVA diluted with water has also been used as a glazing medium. Ferry prefers this to ordinary acrylic medium, as it imparts gloss and transparency to the colours.

◄ Paul Powis
Still Life

Although most of the objects here are clearly recognizable, the painting can be read as an arrangement of abstract shapes. The painting is on paper with a precoloured ground, and the artist has combined a brightly coloured chalk line drawing with acrylic applied wet with large brushes – notice how it has been allowed to dribble down the paper.

▼ Roy Sparkes
Music House, Liverpool

This painting, on textured mountboard, is one of a series inspired by a visit to a wharf then being converted into Liverpool's Music House; another of the paintings is shown on page 116. The artist was attracted to the subject largely because of the abstract quality of the unfinished and unfurnished building, and the painting emphasizes the interaction of geometric shapes.

VISUAL STIMULI

Abstraction (as opposed to pure abstract painting, where there are no recognizable references to actuality) involves choosing those elements of the visual world which create an effect, regardless of whether they are descriptive in the usual sense of the word. More or less anything – with the possible exception of the human figure – can provide the stimulus for semi-abstract paintings. You will often see powerful abstract shapes in landscape, for example, or in the man-made environment – buildings are a common subject for such treatments. The reason for excluding the human figure is that it is very difficult to dissociate ourselves from fellow humans to the extent of treating them as a set of shapes. It can and has been done, but it is not the best subject area to begin with.

Abstracting can in any case be quite difficult, particularly if you are painting direct from a subject. It is usually more satisfactory to work from sketches, or to use a painting you have already done as the basis for an abstraction or series of abstractions. Many artists work in this way, pushing an idea further and further to distil what they see as the essence of the subject.

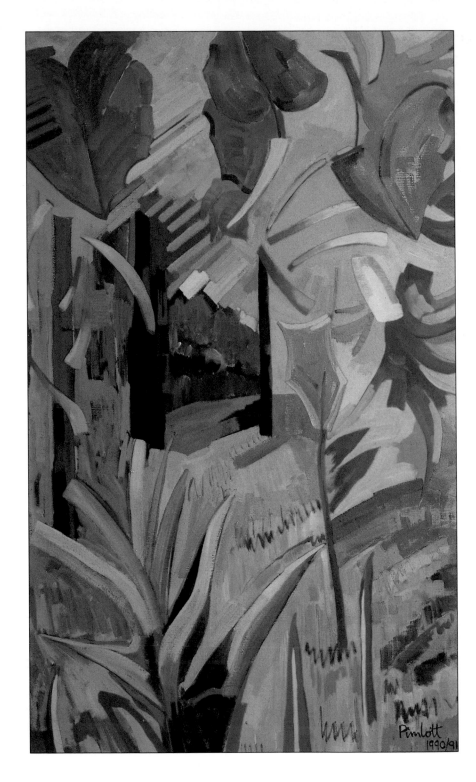

◄ Geoff Pimlott
The Dancing Garden

Natural forms are a rich source for abstraction, but it is easier to consider how to rearrange shapes and colours when you are not working direct from life. This powerful painting on canvas was painted in the studio from colour studies and sketchbook drawings.

▲ Mike Bernard
Abstraction of Boats

Textures feature strongly in this painting also, but here the artist has used COLLAGE – a technique that encourages a non-representational approach – together with inks, pastels and acrylic. He has explored the theme of boats in a number of his paintings, and in this work has pushed the subject further towards the realm of the abstract.

◄ Robert Tilling
Summer Harbour

As in the arrangement of bottles shown on page 162, the artist has used a variety of IMPASTO texture for this dramatic semi-abstraction in which the landscape and building are reduced to their "bare bones".

IMAGINATION

Letting your imagination dictate how and what you paint can be very satisfying, but it can't be done to order. Indeed many people find it impossible. Children use their imaginations naturally, perhaps because their minds are less cluttered with seen images and direct experience than those of adults. Certainly the ability is often lost as they grow older.

There can be many sources for imaginative painting, dreams being one, as mentioned on page 160. Music and literature, especially poetry, can provide initial inspiration, and so can memory which – like dreams – often plays tricks with reality. It can be interesting to try to recreate a scene, perhaps a landscape or townscape, from memory, as you will often find you have overlaid your impressions of shape, colour and so on with more personal and subjective feelings, which will emerge in the painting.

Objects can form the starting point of an imaginative treatment also. A strangely shaped tree, for example, might suggest a monster, as in Ray Mutimer's painting, while a favourite ornament or object with particular associations could spark off a fantasy with a visual "storyline".

If you find it difficult to let your mind roam free, a change of media may help. Collage, for example, invites a non-literal treatment, and you could find that removing the restrictions of accurate representation enables you to develop a painting in a different way.

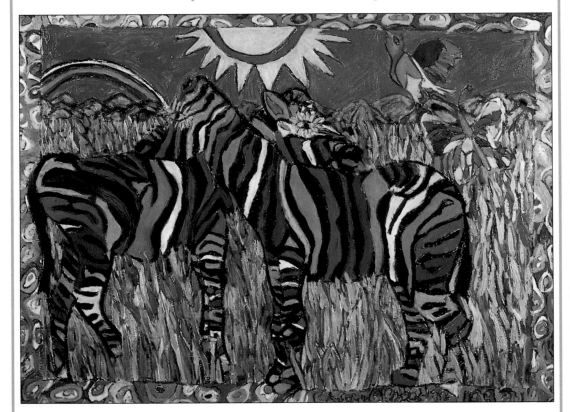

◄ Cheryl Osborne
Fluorescent Zebras

A mixture of media has been used for this highly individual painting in which the artist has given free rein to her love of brilliant colours and decoration. Each of the zebra's stripes is painted in a different fluorescent acrylic colour; the sky is oil pastel, acrylic, coloured pencil and inks, while the grass is a mixture of pearlized inks, gouache paint and oil pastel.

► Ray Mutimer
Tree Dragon

The idea of turning a natural feature such as a tree or rock into a mythical or imaginary animal has a long history, and such fantasies are often seen in children's books, science-fiction illustrations and animated films. The artist has treated the subject very cleverly, with the naturalistic representation of the surrounding woods enhancing the menace of the dragon forcing its way towards us.

◄ Roy Sparkes
The Intruder

This painting also gives a sense of unease, though more subtly than in Ray Mutimer's painting. The two figures in the foreground have turned to look out of the painting at the intruder, unseen by us, but in fact the viewer of the painting – ourselves. Their expressions suggest that although they are aware of being watched, they do not know by whom. The strange colours and ambiguous shapes, particularly the amorphous forms between the figures, add to the dreamlike quality of the image.

DEMONSTRATION
ABSTRACTION AND FANTASY

Poetry is a productive source of inspiration for *Rosalind Cuthbert*, and so is memory. She sometimes bases her compositions on a poetic idea combined with sketches, photographs and real objects to produce highly personal interpretations, often using mixed-media techniques.

1 The visual reference material is spread out on a drawing board, and compositional ideas are worked out in a sketchbook. The photographs of figures were too specific, so the artist has rejected them in favour of a more stylized treatment.

2 This all-over brilliant red ground would be an unusual choice for a purely naturalistic painting, but in this case it helps the artist to create her own visual world. The figure, which is not intended to play a dominant role, is drawn very lightly in charcoal.

3 To enhance the illusory quality of the image, the paint is applied in light veils of colour, scumbled over the red. The brushwork is deliberately non-descriptive.

4 The artist continues to build up colour effects in the background of the painting, now beginning subtly to define the large tree and the band of light running across the picture.

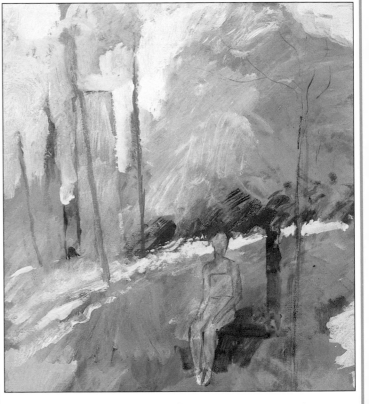

5 The framework of the composition is established, with the trees, tower and figure loosely suggested. The red ground shows through the overlaid colours, creating a luminous effect.

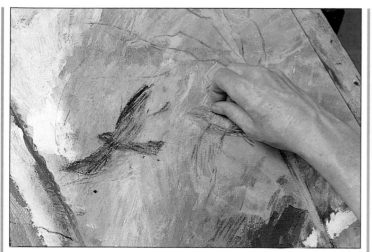

6 Charcoal is used to sketch in the birds, with the drawing kept light because it will be overlaid with paint at a later stage.

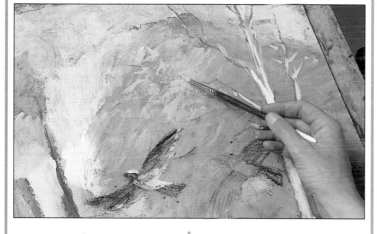

7 The form of the left-hand bird has now been built up with white paint over the charcoal, and attention is given to the tree, which is the dominant shape in the composition.

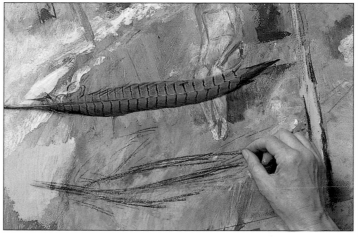

8 The foreground is as yet undefined. Here two feathers are to be placed, painted realistically in contrast to the more amorphous treatment of the figure. An actual pheasant's feather is placed on the picture to enable the artist to recreate its shape.

9 The same procedure is followed for the white feather, which is first drawn in charcoal and then painted carefully with a sable brush.

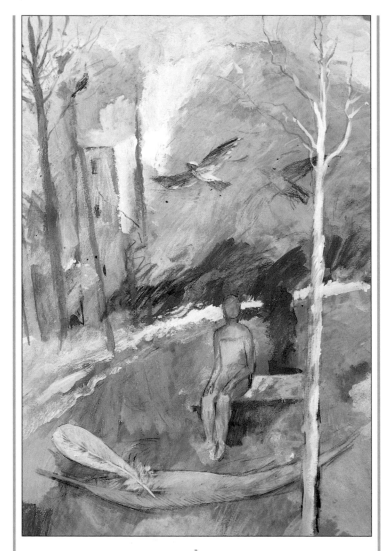

10 At this stage the painting is assessed to see how much work remains to be done and which areas need to be strengthened and defined.

11 The foreground is given attention first. Details are added to the pheasant feather with black ink and a sharpened reed pen, a sensitive drawing implement capable of producing a variety of lines and marks.

12 The birds, which provide a balance for the feathers by association, have been painted red, and blues are now introduced into the foliage of the tree.

13 The artist continues to strengthen the tones and colours of the tree with a heavier application of charcoal than previously. Powerful contrasts of tone are required in this area, as the tree is the focal point of the composition.

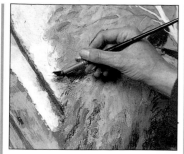

14 White paint is now used to "cut in" over the edges of the tree, giving a clearer outline as well as increasing the tonal contrast.

Finished picture

The juxtaposition of realism and fantasy creates a dream-like impression. The feathers, although painted in detail, have no spatial context; they appear to float above the undefined foreground. The simple treatment of the figure, eclipsed by the strong shape of the tree, gives it a ghostly quality – we almost wonder whether it is there at all.

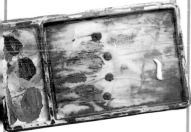

Palette

A Stay-wet palette may look messy after a day's work, but these palettes are very convenient when the paint is used at medium consistency. The compartment at the end is intended for filling with water to keep brushes moist, but in this case has served for mixing colours.

INDEX

Page numbers in *italic* refer to the illustrations and captions

ACKNOWLEDGMENTS

The author would like to give special thanks to Laura Bangert, whose tireless and expert research has been largely responsible for the variety and high quality of the paintings in this book.

Quarto would like to thank all the artists who contributed paintings to this book; the artists who demonstrated the techniques – Rosalind Cuthbert, David Cuthbert, Ted Gould, Hazel Harrison, Debra Manifold, Judy Martin, Jacquie Turner; and Christine Shuttleworth for the index.

Quarto would particularly like to thank *Liquitex*®, who kindly donated the paints used in the demonstrations and *Langford & Hill* for donating art materials.